The Complete
PHOTOBOOK

The Complete
PHOTOBOOK

by

RONALD SPILLMAN, A.I.I.P.

FOUNTAIN PRESS : LONDON
MORGAN and MORGAN : NEW YORK

Fountain Press
46-47 Chancery Lane
London, WC2A 1JU
England

Morgan and Morgan, Inc. Publishers
400 Warburton Avenue
Hastings-on-Hudson
N.Y. 10706
USA

First Published 1969
Second Impression 1970
Second Edition 1971
Second Impression 1972

Third Impression 1972

© Fountain Press 1971

ISBN 0 852 42084 6

Printed in Great Britain by
Clarke, Doble & Brendon Limited

Contents

5

You and your Camera

Photography is the pastime that adds pleasure to all other pastimes. At race meetings, out sailing, at tournaments and displays of every kind, millions of cameras are busily recording memories for millions of enthusiasts.

Who, today, would go on holiday without a camera? Who would want to come home without dozens of photographs and transparencies to recall the golden moments of travel and leisure? Cameras have become as common as fountain pens, and automation is rapidly making them just as easy to use.

Would Keats, Shelley and Ruskin have used the pen if photography had been invented in their day? Perhaps 'The Stones of Venice' would have been a book of pictures. Perhaps the author of the immortal 'Ode To A Nightingale' would have become a bird photographer instead. Perhaps. . . .

But the purpose of this introductory chapter is not to speculate on what might have been, but to tell you how this book is going to help you to enjoy *your* photography, to make the most of your camera.

I'm certainly not going to try to 'sell' you on sophisticated and expensive equipment, though a great many people get a great deal of pleasure out of owning the very best apparatus. Just as you don't need a Rolls Royce to visit and enjoy a place of beauty, so you don't need a high-priced camera to take satisfying and even beautiful pictures.

What you do need, is a good eye for a picture – that, and the knowledge of how to make your camera obey you. I'd like to point out, right here at the outset, that cameras don't take pictures. Photographers do. Most advertisements for cameras would like to have us think differently. 'Buy the Super-Click and win competitions', 'Nikolta for your exhibition prints' – we see advertisements like those every day. And just in case you, too, have fallen victim to this kind of consumer indoctrination, let me repeat – cameras don't take pictures. Photographers do.

The most important part of your camera, though you never see this in the advertisements, is the eye *you* put to the viewfinder. In this book, therefore, I am going to do two things. First,

9

teach you all the mechanical things you need to know in order to operate the camera properly because, if you can't do that, all those wonderful faces and places you see in your viewfinder may not come out. For most novices, camera work is very much a hit-and-miss-and-hope-for-the-best affair. Nobody would dream of buying and 'trying out' a car without first learning to drive it, but a great many people buy a camera and expect it to work without any knowledge on their part.

The hit-and-miss brigade spend needless hours, with pumping heart and great expectations, waiting for their films to come back from the processer. They buy films as they would lottery tickets, with just about the same chance of success.

That, as I said, is the first thing we have to get rid of. We're going to remove chance from your photography – and it's quite easy.

Having taught you to produce clear, properly-exposed photographs, we shall then move into phase 2, which is how to make your photographs pictures. The two words are often confused. Any print made by the photographic process qualifies as a photograph, but in order that it should also qualify as a picture something else is needed – a knowledge of composition, subject arrangement, and so on.

I know you are enthusiastic about photography. If you weren't, you wouldn't be reading this book. I intend to keep your enthusiasm at a high pitch, inform you about the few (*very* few) factors which turn failure into success, and, by the time we've travelled through a few of the chapters together – we'll have your pictures singing!

Very few factors, I said, and I mean it. In Chapter Two, you'll be surprised to learn just how few things you will need to understand about the mechanical side of things.

Many amateurs try to choose a camera that will cope with any subject under the sun. The universal camera, one that will do every job perfectly, is rather like the philosopher's stone – it just doesn't exist. Most of the moderately-priced and even expensive cameras on the market are by way of being a compromise. They will do most things superbly, some things well, and a few things not at all.

A specialized subject like architecture, for example, calls for a technical camera with 'movements' that are not possible (or even desirable) on the handy little instruments that most of us like to carry around. But that doesn't mean that you can't take fine pictures of buildings without a technical camera. Most amateurs are interested in a wide variety of subjects. They set out

10

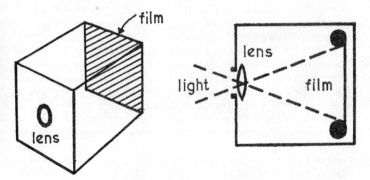

Fig. 1. Box-camera demonstrates simple principle of basic photography. Lens projects light-image onto film. Camera sophistication consists of devices to focus lens and expose the film.

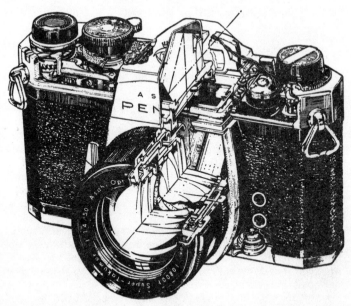

Fig. 2. Cross-section through Asahi Pentax Spotmatic camera shows some of the complexity of the sophisticated modern single-lens reflex.

happily to produce eye-catching pictures of subjects that professionals use special equipment for, and are disappointed when the results are less than professional.

The fact is, any modern camera will take excellent pictures of the usual subjects that concern us – portraits, landscapes, events, children, animals. Many cameras have ancillary equipment (which one can buy at a later date) further enlarging their scope to take in such specialised subjects as close-ups of bees on flowers and long-distance shots of jumping events at gymkhanas.

If you are just about to buy a camera, or have bought this book to help you to choose the right instrument, you will find Chapter Three of considerable value. In it, the various types of camera will be discussed. You will be able to see what subjects each is ideal for, what it can be adapted to do (and what the accessories cost!), and for which kinds of work it is least suitable.

A final point before we get on with the job (painless and pleasurable, I assure you) of learning to use the camera – no textbook, not even this one, can turn a student into an expert. The missing ingredient is experience, and I leave it to your enthusiasm to supply that.

<div align="center">CHAPTER TWO</div>

How a Camera Works

However simple, or however complicated, the function of all cameras is the same – to throw a picture of whatever is in front of it on to the light-sensitive film inside it. It is even possible to make a photograph without a camera, simply by placing a piece of film inside and at one end of a light-tight box, and making a tiny pin-hole at the other end. The tiny pin-hole acts as a lens, casting an image on to the film.

If you only wanted to take one photograph, of a landscape or other static subject, and could put the box on a firm support and wait ten minutes or so for the film to get sufficient exposure – why, you wouldn't need to buy a camera at all. Any old shoe-box or biscuit-tin would serve.

Simple box cameras are only one stage removed from the basic instrument I have described. Instead of a pin-hole, a simple lens is used. This projects a brighter picture on to the film, which thus receives the required amount of exposure more quickly. So

Fig. 3. In a twin-lens reflex, two lenses of identical focal length are used. The viewing lens throws an image onto the viewing screen via an inclined mirror. Below, an almost identical image is thrown by the taking lens onto the film.

quickly in fact, that a normal film requires to be exposed for only one-thirtieth of a second instead of ten minutes. This means that a firm support is no longer needed, and the camera may be held steadily in the hands.

Nobody could move fast enough to uncover the lens and cover it again in one-thirtieth of a second, so a simple spring-loaded shutter is introduced, either in front of, or behind, the lens.

At the back of the camera, provision is made for a film to be moved into position, one frame at a time, on rollers. And that is all there is to it.

All the gadgets you find on modern cameras are developments from the basic requirement. Lenses are bigger and better made, so that a brighter, sharper image can be projected on to the film. Shutters allow variable speeds of up to one-thousandth of a second and even faster, so that rapid action subjects can be arrested. Rangefinders and ground glass screens enable the photographer to focus quickly, while built-in exposure meters measure the brightness of the light falling on the subject, and thus determine the amount of exposure required for a given type of film.

Shutters

There are two kinds in general use. These are known as lens, or leaf shutters, and focal-plane shutters. The lens shutter (*Compur*, *Prontor*, *Seikosha*, are some of the best-known) is a series of concentric blades, usually arranged between the front and rear components of the lens itself. When the shutter release is pressed the blades fly open from the centre until the whole diameter of the lens is reached, then close again rapidly. Such shutters usually have a top speed of 1/500 of a second.

A focal-plane shutter is placed at the back of the camera, immediately in front of the film. It consists of a curtain, or 'blind', on spring-loaded rollers. In the curtain is a slit of variable width, which travels across the film when the shutter release is pressed. If the slit is one-tenth the width of the film and travels across the film in 1/100 of a second, it will be seen that each part of the film receives an exposure of 1/1000 of a second.

Apart from fully automatic cameras in the lower-to-middle price range, where the photographer has no control over the mechanism, most shutters allow the setting of a range of speeds beginning with 'T' (time) or 'B' (bulb), where the shutter is opened and closed manually, then going on to mechanically-controlled speeds starting at one second and progressing geometrically to

Fig. 4. Zone focusing helps you get into action fast. (a) focus set to about 7 ft. will give an area of sharpness from approximately 6 to 9 ft. allowing for subject movement. *(b)* Focus set to **12 ft.** gives an area of sharpness from 9 to 16 ft. very useful for near-to-middle distance subjects. *(c)* Provided a small aperture is used for distant views, camera may be set to Infinity.

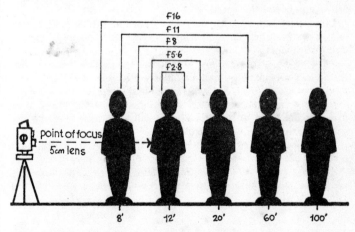

Fig. 5. The more you stop down the lens, the greater will be the depth of field (area of sharpness) on either side of the actual point focused on. The shorter the focal length of the lens, the greater the depth of field at a given stop and distance. The longer the focal length of the lens, the shorter the depth of field at a given stop and distance.

1/500 or 1/1000 of a second. These speeds, which one aligns against an arrow or pointer, are arranged as follows:

T (or B) 1 2 4 8 15 30 60 125 500 1000
or, on some older cameras:
T (or B) 1 2 5 10 25 50 100 250 500 1000

Note that these are the denominators of the fractions.

Diaphragm or 'Stop'

While the shutter determines for how long light is allowed to pass through the lens and affect the sensitive film, the diaphragm or 'stop' opening controls the *size* of the lens aperture and thus regulates the *intensity* of the light admitted. These apertures are marked in *f*/numbers. The larger the aperture, the smaller the *f*/number, and *vice versa*.

f/1·4 is a very 'fast' lens aperture indeed, though even faster ones are obtainable. *f*/2, passing half as much light as *f*/1·4, is still very fast, and even *f*/2·8 (half as fast as *f*/2) is adequate for most subjects even in dim lighting conditions, provided a very sensitive (fast) film is used.

The distance between the lens and the film, when the distance setting is at 'infinity', is known as the focal length of the lens, and by dividing this distance by the diameter of the lens, we arrive at the *f*/ number of the aperture.

Low-priced cameras usually have a maximum aperture of *f*/8 or *f*/11, while the bigger apertures appear only on more expensive instruments.

A word of warning. An *f*/1·4 lens of a certain price is not necessarily a better buy than a similarly-priced lens with the more modest aperture of *f*/2. Camera manufacturers are in a highly competitive market and lenses are often constructed 'down to a price' rather than up to a level of quality, merely to make the specification seem more attractive.

Remember, also, that even the best lenses give their optimum performance when stopped down about two *f*/ numbers. Thus, there is no point in buying an *f*/1·4 lens if all your photographs are to be taken outdoors at apertures between, say, *f*/5·6 and *f*/11.

Depth of Field

The range of sharpness in a photograph depends on how much the lens is stopped down and at what focusing distance it is set.

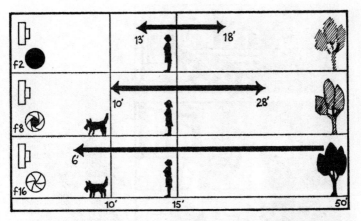

Fig. 6. Depth of field increases as the lens aperture is reduced. One should not automatically try to get everything sharp. Often sharp background detail would confuse a picture, so opening the lens wide can concentrate emphasis on the subject proper by reducing the plane of sharp focus. This is known as differential focusing, and is a useful pictorial device.

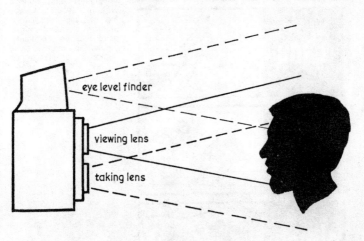

Fig. 7. Parallax error is the difference between the view of the lens and the view of a separate viewfinder, usually placed above the taking lens. In an extreme case, as when using the eye-level viewfinder of a twin-lens reflex, this can cause the upper half of a sitter's head to be cut off, unless allowance is made by leaving plenty of space above the head in the viewfinder. Parallax error does not exist in single-lens reflex cameras, and on other types provision is often made for correcting its effect.

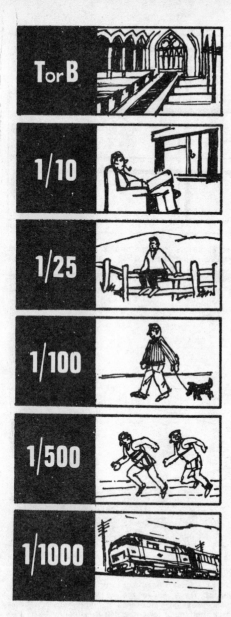

Fig. 8. Conventional tables of shutter speeds that will stop action are based upon the mathematical movement of the subject image across the film, and what is known as the 'circle of confusion' of the lens. Here is such a table. No account is taken of aesthetics — very often a subject is improved by introducing a degree of blur. Thus, using a top speed of 1/250 and 'panning' (swinging) the camera with the subject, a racing car can be photographed sharply, with a good blur on the background to improve the impression of speed.

When a lens is focused on an object, there is an area of sharp focus which extends from a distance *in front* of that object to a distance *behind* it. This zone of sharp focus is known as depth of field (sometimes confused with depth of focus, which is the amount a lens is moved backwards or forwards while focusing).

There is always a greater range of sharpness behind the object focused upon, than in front of it – an important point which should always be borne in mind. Furthermore, as the lens is focused for shorter distances from the camera, the range of sharpness which extends from in front to behind the object steadily decreases. This depth of field also decreases when the lens is opened up to larger apertures, and yet again if the camera is fitted with a lens of longer than normal focal length.

The following factors are therefore involved:

1. The distance focused on.
2. The lens aperture selected ($f/$ number).
3. The focal length of the lens.

Camera and lens manuals often contain tables giving the depth of field at various apertures with lenses of different focal length. These tables may form a useful reference for technical photo-

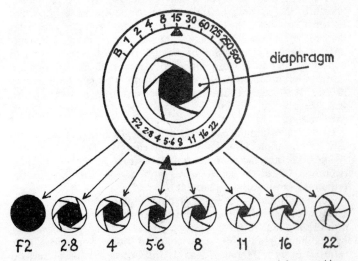

Fig. 9. There is a reciprocal sequence between shutter and lens markings. Each larger aperture allows twice as much light through, while each faster shutter speed is half that of the previous one. Thus, 1/125 at $f/8$ gives the same overall exposure as 1/250 at $f/5\cdot6$, or 1/500 at $f/4$. The lens aperture is reduced by means of a bladed diaphragm.

graphy, especially at extremely close distances, but are hardly necessary for everyday photography. A much more practical system is adopted nowadays—the lens mount itself is engraved so that when it is focused on a given distance the near and far distances it will sharply record at all apertures can be read off. This is called the depth of field scale.

Hyperfocal Distance

If a lens is focused on a distant object, the *nearest* object which is sharply recorded on the film is at the hyperfocal distance. Not only is the hyperfocal distance dependent upon the focal length and aperture of the lens, but also, equally important, on what degree of sharpness we are prepared to accept as sufficient for our needs.

If, instead of focussing on infinity, we focus on the hyperfocal distance, all objects will be sharp from *half* this distance to infinity – a useful point to remember.

The Lens

Although the 'speed' of a lens is determined by its largest aperture, this is only half the story. An even more important factor is its definition. It is little use striving for faster and faster lenses if performance is to suffer. Designing and producing large-aperture lenses costs a lot of money, so it is unreasonable to expect to find such lenses fitted to cameras of modest price.

Just what a camera will and will not do is largely governed by its lens. It is useless to fit a fast shutter to a camera with a 'slow' lens, because insufficient light might be passed during short exposures.

Lenses of maximum apertures between $f/8$ and $f/11$ are generally of a simple type known as 'meniscus'. The next group, $f/5\cdot6$–$f/3\cdot5$, are more complex in construction and give better definition. These are anastigmat lenses, as also are those in the remaining group, up to $f/2$ or $f/1\cdot4$.

To avoid internal reflections from the glass elements of which a lens is composed, all better-class lenses are 'coated'. This results in more brilliant pictures. The coated lens is usually recognizable by its bluish-mauve or straw-coloured tinge. Sometimes it is referred to as a 'bloomed' lens. It will not be out of place here for me to stress the importance of:

1. Never tampering with a lens or trying to unscrew it.
2. Never touching the glass surface with the fingers.

Optical glass is soft, and consequently marks and scratches very easily. Use a soft brush or lens tissue to clean it.

The Viewfinder

This is perhaps the most important part of the camera – it is vital to be able to see, as clearly as possible, what you are photographing.

There are two basic forms of viewfinder, direct-vision and ground glass.

Most direct-vision viewfinders consist of an optical system incorporating a 'bright line' frame. When you look through the viewfinder this 'bright line' frame appears to be projected in space, and corresponds to the angle of view of the camera lens, allowing you to frame your composition accurately.

Ground-glass viewing applies to twin-lens and single-lens reflex cameras. In the case of the twin-lens reflex, the upper lens projects an image identical (see Parallax Error, below) with that of the taking lens, via a 45° mirror, on to a ground-glass screen. One racks the lens backwards and forwards observing the image on the ground-glass screen until sharpness cannot be visually improved.

A simple ground-glass screen is never evenly illuminated. The image appears bright in the centre, dark at the edges. To facilitate both focusing and viewing, a fresnel lens is fitted to the underside of the ground-glass. This causes the illumination to be evenly distributed, at the edges as well as the centre of the screen.

A foldaway magnifier assists critical focusing.

The viewing system is somewhat different in the case of the eye-level single-lens reflex camera. Here, the focusing is achieved via the taking lens itself. The image is projected by the lens, via a 45° mirror, up to a ground-glass screen and then, via a five-sided prism (universally known as a pentaprism), to the eye.

Because one can see exactly what the lens sees, including the effect of depth of field, the single-lens eye-level reflex (usually simplified to SLR) is the most popular of modern cameras.

On some SLR's the pentaprism may be removed and the screen viewed directly through a magnifier. This method has certain advantages in technical and copying photography.

Parallax error

Whereas the single-lens reflex shows you the subject from the viewpoint of the taking lens, neither the twin-lens reflex nor the

direct vision finder can do this. The reason is that the viewfinder, or viewing lens in the case of the twin-lens reflex, is situated at a higher level than the taking lens. (See Fig. 7.)

When viewing a subject by either of these methods you are seeing it from a point an inch or so above the viewpoint of the taking lens. This difference of viewpoint is known as parallax error. It does not matter at distances of ten feet or so, but in close-ups it is often responsible for cutting off the tops of heads.

Most twin-lens reflexes and the more expensive range-finder cameras incorporate a parallax-compensating device in the viewing system. Although the two viewpoints remain different, this ensures that the same field of view is maintained, albeit from slightly differing angles.

When using a simple viewfinder close-up, the remedy is to keep the subject well below the top edge of the finder frame.

Because of its freedom from parallax error, the single-lens reflex is deservedly the most useful camera for those who do a great deal of close-up photography – portraits, flowers, copying, and so on.

It's All Happening

When you release the shutter, light enters the lens and an image is momentarily flashed on the surface of the film. The sensitive surface of the film undergoes a chemical change but at this stage if you were to open the camera and look at the film (and thus spoil it!) you would see nothing.

In order to reveal the image, the film must be processed in a developer solution, then the revealed image must be 'fixed' in a further solution. After the film has been washed and dried you have your negatives ready for printing. Film processing will be described in detail in Chapter Seventeen.

The Equipment for the Job

Most people's choice of camera is governed by price, but it is wrong to think that you will take 'better' pictures merely by paying a great deal for an instrument. Fine pictures can be made

with cameras costing very little. On the other hand, more expensive cameras have a wider scope. Let us look at the various types of camera one by one – for the kind of photography that interests you, the ideal camera may be far simpler and cheaper than you think.

Simple cameras

Few people nowadays buy the old-fashioned box camera, though a certain number of these instruments are still manufactured. Some models take 8 pictures on No. 120, 620, or 127 size films, while others produce 12 square pictures on the same film. The 8-on-a-film types usually have twin waist-level finders or a single direct-vision finder, and the more sophisticated ones are synchronised for flashlight photography.

Picture size: $3\frac{1}{4} \times 2\frac{1}{4}$ in. on 120 and 620 films, $2\frac{1}{2} \times 1\frac{5}{8}$ in. on 127 film. Square pictures are $2\frac{1}{4}$ in. on 120 and 620 films, $1\frac{5}{8}$ in. on 127 film.

Normally, these simple box cameras have a single shutter speed of 1/30 or 1/50 second, and a few have in addition a 'B' or 'T' setting for time exposures. The lens is a simple meniscus type, usually working at $f/11$, though in one or two cases an alternate stop is provided. Occasionally, such cameras have a built-in colour filter which can be slid across the lens.

The square negative has much to commend it. There is no need to decide whether to take a view horizontally or vertically, and as most of the pictures made with these cameras end up as same-size album prints, composition is not vital, anyway. Corrections can always be made when enlarging from a particular negative.

Because of the slow shutter speed and lack of focusing control, photography with simple box cameras should be limited to groups, landscapes, and other subjects of a fairly static nature.

Prices are normally in the range 25/- to 45/-.

Folding Cameras with Non-Interchangeable Lenses

These are normally compact folding cameras using 120 or 35 mm. film. Most have a front-lens shutter ranging from 1 second to 1/500 of a second. Maximum aperture of lenses varies from $f/3.5$ to $f/2$, according to price.

Such cameras are ideal for all general work, and most manufacturers supply a close-up attachment which extends the range

of focusing from 3 ft. (the usual minimum) down to 18 in. or so. This is good for close-ups of flowers, plaques, and similar subjects, but is not good for head-and-shoulder portraits, where the perspective would normally appear too violent.

Although the prices begin around the £15 mark, at about £20 refinements such as coupled rangefinders and built-in exposure meters begin to appear. In its most refined form, such as the 35 mm. Kodak Retina range, this type of camera is capable of very fine work indeed.

At the highest price, around the £50 mark, these cameras enter the price range of the cheaper 35 mm. single-lens reflex cameras, which have a wider scope.

Twin-lens Reflex Cameras

Perhaps more prizes and competitions have been won by pictures produced with this type of camera, than with any other. It has been a firm favourite of serious workers for many years, chiefly because of its simplicity of operation.

The focusing screen is an excellent aid to composition, and the method of operation (looking down into the hood) enables pictures to be made with ease from ground level.

These cameras are virtually two cameras in one; the lower taking the picture, the upper showing you just what the lower one is taking. Normally, a parallax-correcting device is incorporated, especially necessary at close distances, owing to the distance between the viewing and taking lenses.

The Rolleiflex and Rolleicord are the originals, but similarly designed twin-lens reflexes are the Yashicamat and the Autocord. These are available with or without a built-in exposure meter.

Whereas these have non-interchangeable lenses (apart from two special wide-angle and tele-Rolleis, wide-angle and tele supplementary lenses are available for the Rolleiflex – these are called Mutars, are very costly, and do not equal the performance of the prime lens) the Mamiyaflex extends the usefulness of the twin-lens design.

In the Mamiyaflex, detachable lens panels on which matched pairs of lenses are mounted, allow the photographer a choice of focal lengths from moderately wide-angle to a moderate tele-effect. Bellows extension allows close focusing without the need for supplementary close-up lenses.

As the centre of a 'system', one camera with two or three interchangeable pairs of lenses, the Mamiyaflex has advantages over

Quick-working rangefinder camera with fast f/1·8 lens is ideal for those not needing the facility of interchangeable lenses. Such cameras cost between £35—£55, according to lens and other refinements.

Instamatic camera is ideal servant for the snapshotter who doesn't want to learn 'technique'. Drop-in cartridge and foolproof action ensures a snap (nearly) every time. Enlargements are of good 'album' quality only. Such cameras cost between £3—£5.

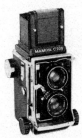

Retina S2 is typical of small cameras with lens in front shutter. Although relatively inexpensive, and seldom possessing a lens faster than f/2·8, these will produce big enlargements of high quality. Cost is between £20—£35.

Mamiya C220 is latest in line of twin-lens reflexes taking interchangeable pairs of lenses. Used by advanced amateurs and professionals both outdoors and in the studio. Basic camera with one pair of lenses will cost around £140, but with two extra lens pairs this outfit could cost £260.

This Voigtlander with front-lens shutter and f/2·8 lens is quick-loading, easy to use, and within its limitations will turn out excellent work. Such a camera will cost £15—£20, depending on extras such as built-in exposure meter, programmed shutter, and so on.

Advantage of 35 mm. single-lens reflex is its versatility. This one is connected to bellows attachment and slide copying device, allowing the photographer to make duplicates of his favourite transparencies.

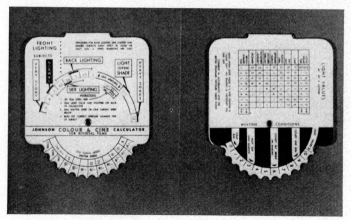

Exposure determination at a cost of a few shillings. Simple plastic calculators will give a very high standard of success, especially if used with intelligence.

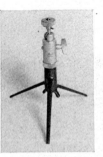

Brockway Studio meter is designed primarily to take readings by incident light, via the hemispheric receptor. Meter can also be used as reflected light meter if an auxiliary attachment is used. Price around £16.

Ikophot S is typical of modern meters designed to give best performance with reflected light readings. This one has a follow-pointer which one aligns with the meter needle, and exposures can then be read direct from the dial. Depending on quality and land of origin, such meters can cost anything from £8–£18.

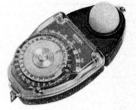

A folding table-top tripod is a useful, easily-carried accessory. For longish exposures it can be pressed against a tree or other firm object. For exposures in the region of 1/15 second it can be used to steady the camera by angling the tripod legs against the chest. Various qualities are available, costing from £3–£12.

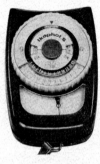

Opposite page:
Vertical camera position and use of a wideangle lens enabled the photographer to get in the whole of the tower A moderate wideangle lens is probably the most useful 'second' lens for view photography. Plus-X film, 2X yellow filter, 1/250 at *f*/8.

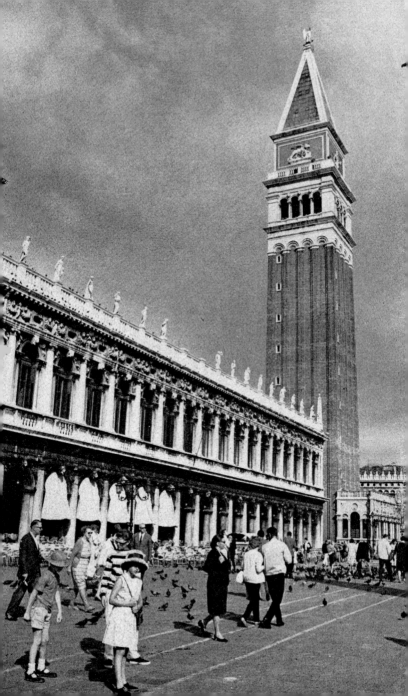

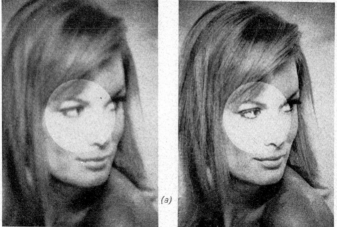

(a)

(b)

Microprism is circle of tiny wedge prisms at centre of focusing screen in single-lens reflex. When image is out of focus *(a)* that part of image within the microprism circle is broken up into a sharp pattern. At moment of correct focus *(b)* image in microprism circle 'snaps' into sharp vision.

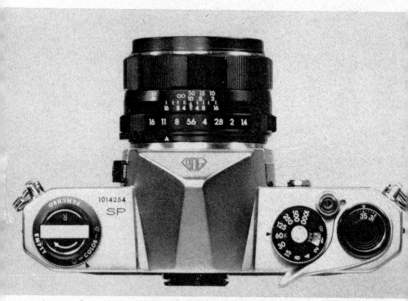

Layout of top-plate of Asahi Pentax Spotmatic camera has classic simplicity. Left to right: rewind knob with foldaway rapid-rewind crank and film reminder dial. Shutter speed knob with quick-set ASA film speeds clearly visible in window. Shutter-and-film wind lever is cranked so that operation is effected by either single long stroke or several small strokes. Self-resetting film counter dial operated by opening and closing camera back.

Modern photography is magic. Asahi Nocta device works on infra-red principle and allows photographer to 'see' and photograph his subject in the dark. Undoubtedly useful as specialist equipment, this peaceful gadget is nevertheless reminiscent of a wartime infra-red sniper's equipment, where device was connected to self-illuminated cross-hair rifle sight.

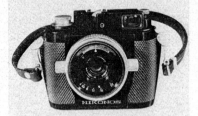

Nikonos camera is specially designed to work under water without special casing. It is also an extremely useful camera when pictures must be taken in rain and flying mud — as several sports photographers, notably those covering football matches, have discovered.

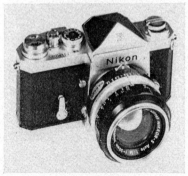

Most popular single-lens reflex with pressmen is the Nikon, on account of its ruggedness and reliability. Interchangeable lenses supplied with Nikon (called Nikkors) are evenly colour-matched — this means that transparencies made with them will all have similar degree of 'warmth' or 'coolness'.

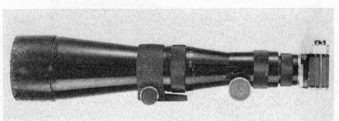

35 mm. camera attached to back of giant 1,000 mm. telephoto lens looks ridiculous, but a lens of similar magnification made for a large-format camera would need a truck to transport it.

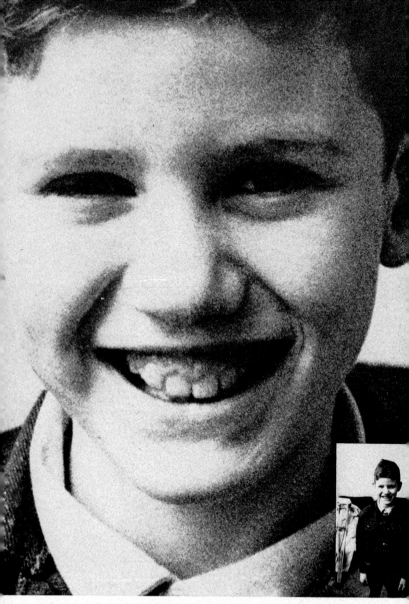

Emulsion of developed film contains thousands of tiny clusters of grains of developed silver. Coarseness of grain (more correctly called granularity) is associated with fast films and ordinary developers. Fineness of grain is associated with slower films and fine-grain development. Here, face of boy is enlarged 17X linear from negative made on fast film and granularity is obvious in the enlarged image.

Panchromatic films will darken blue of the sky only slightly and, because sky is also over-exposed, it tends to appear pale or even white on the print (left). Using a 2X yellow filter (right) darkens blue of sky and gives satisfactory contrast with white clouds.

With a silhouette picture like this it is undesirable to retain much detail in shadow areas, so meter is pointed at the sky, which requires to be correctly exposed. Ilford FP4 film, 1/125 at f/5·6.

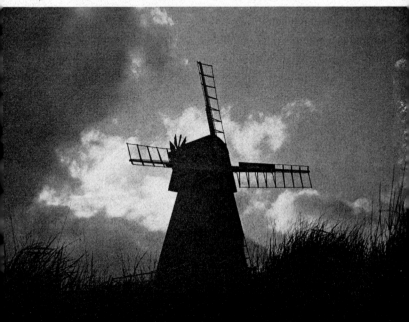

For success with snow pictures, use a yellow filter. This will darken the blue shadows and show texture and modelling. A medium-speed film is fast enough for such a bright subject, and the fine-grain is better for adequate rendering of detail.

twin-lens reflexes with non-interchangeable lenses. Used with just a pair of standard lenses, however, the latter are less cumbersome and swifter in use.

Prices range from about £60 for a Yashicamat, to £100 or more for a Rolleiflex, depending on specification. $f/3.5$ is the most usual maximum lens aperture, though $f/2.8$ lenses are available. The Mamiyaflex costs over £100 with 80 mm. $f/2.8$ lenses, while interchangeable lens pairs cost on average £50.

Single-lens 2¼ in. square Reflexes

In these instruments the lens image is reflected on to the viewing screen via a 45° mirror, which swings out of the way when an exposure is made.

In earlier forms the lens had to be stopped down manually after focusing, and the mirror stayed in the 'up' position after an exposure (thus blacking out the viewing screen) until dropped again by the action of the film-wind lever or knob.

Viewing is either downwards into a hood or, in most modern instruments, at eye-level via a pentaprism, and mirrors are now of the instant-return variety. Focusing is carried out at full aperture and, when the shutter release is pressed the sequence is: 1. The mirror flies up, blocking the entry of light through the viewing screen. 2. The lens diaphragm is stopped down to the aperture pre-selected. 3. The shutter operates. 4. The lens diaphragm opens up to maximum aperture again, and 5. The mirror drops into reflecting position again. The 'black-out' time to the eye (interruption of viewing) is as fast as a blink of the eye.

Single-lens 2¼ in. square reflex cameras have the advantage over twin-lens reflexes of the Rolleiflex variety that high-grade interchangeable lenses may be used, and there is no parallax problem.

Such cameras tend to be very expensive. Most expensive are the Swedish Hasselblad and the Rollei SL66, which have interchangeable magazines so that a variety of films may be exposed as the occasion arises. New eye-level cameras of this type, such as the Pentacon, look like scaled-up versions of 35 mm. single-lens reflexes and are considerably cheaper.

Miniature Cameras

Any size from 2¼ in. square downwards used to be called 'miniature'. This is no longer the case, and the term nowadays is used exclusively for 35 mm.

Over the years, the 35 mm. camera has become increasingly popular, for snap-shotting because of its convenience (up to 36 exposures in one loading). As mechanical precision and films have improved, a large percentage of professionals and serious amateurs have turned exclusively to 35 mm. Amateurs who had never before attempted anything other than a snapshot, have purchased a medium-priced miniature and use it exclusively for the production of colour transparencies and prints.

Projected on a screen, transparencies from cheaper miniatures may be passably sharp in the centre but lacking definition at the edges. Usually this would not spoil enjoyment of an at-home slide show, but where an enlarged print (say, 8 × 10 in.) is made from a colour negative, the lack of edge definition may be disturbing.

On the other hand, most lenses fitted to *medium-priced* miniatures are capable of resolving fine detail all over the image, when stopped down a couple of stops.

Cheaper miniatures normally have a maximum lens aperture of $f/2\cdot8$, provision for flash synchronisation, and a suspended bright line frame in the viewfinder, but few other refinements.

In the medium-priced range, apertures may reach $f/2$, and rangefinder focusing and a built-in exposure meter may be included in the specification.

Above £50–£60 the trend has long been towards the eye-level single-lens reflex, a more sophisticated instrument capable of a tremendous range of work. Interchangeable lenses of all focal lengths and apertures are available, and a vast number of accessories, such as microscope attachments and rapid-wind motors, which extend the use of the 35 mm. SLR from the laboratory to press work.

Many such cameras employ through-the-lens (TTL) metering. Sensitive cells measure the light falling on the mirror or, in some cases, the light-path itself, and an indication of correct exposure can be seen at the edge of the viewfinder. The meter is switched on and the lens diaphragm ring (or the shutter speed dial) rotated until a pointer is aligned with a pincer or other mark. The camera is then set for correct exposure. The whole operation takes but a moment, avoids the necessity for manually transferring the 'reading' of a separate exposure meter to the camera controls, and can be accomplished without removing the viewfinder from the eye.

Apart from speed of operation, two main advantages are claimed for TTL-metering systems. First, that the meter is registering only the part of the scene that appears on the viewing screen.

Second, that no exposure adjustment factors need be worked out when the camera is being used (with a bellows or extension tubes) for extreme close-up work.

Modern Features

The most important advances in camera design have been towards facility of operation. On some cheaper and middle-priced cameras there is no longer the need to insert and thread a roll of film. 'Instamatic' or 'rapid' cartridges are simply slipped into the back of the camera, an improvement appreciated mainly by the casual photographer who requires the utmost simplicity of operation.

Fully automatic exposure has given success to millions of amateurs for whom picture-making in the past was very much a hit-and-miss affair. Instead of determining the exposure with a meter and adjusting the shutter speed and $f/$ number accordingly, one simply points the camera at the subject. A light-sensitive cell, placed beside or round the lens, automatically adjusts the diaphragm (stop) to suit the shutter speed and the type of film in use. Exposures made in this way are accurate for ninety-five per cent of one's work, but under-exposure will result if a very bright light, such as a window, appears with the subject frame.

Some automatic cameras have the additional facility of 'manual over-ride'. In a lighting situation such as the one mentioned, the photographer may switch over from automatic to manual, adjusting the lens aperture or shutter speed as he wishes.

Most professionals who use cameras with built-in exposure control, prefer this to be the semi-automatic variety. Turning the lens aperture ring centres a pointer within a pincer or against a mark – if the photographer sees that a bright light within the frame is giving an inflated reading, he will turn the lens ring to give extra exposure. Conversely, if large dark areas would cause the meter to over-expose that part of the subject which he wants correctly exposed, he adjusts the aperture ring until the pointer indicates less exposure.

Most modern small cameras have a rapid-wind lever. A single stroke advances the film one frame, indicates this on an exposure counter, at the same time cocking the shutter.

Shutters have the speed marking in geometric sequence:

1 2 4 8 15 30 60 125 250 500

where 1 stands for one second and the remainder are fractions

of a second. Some older cameras have the shutter speeds arranged as follows:

1 2 5 10 25 50 100 250 500.

Intermediate settings are also possible in most models.

Other cameras feature the EVS (exposure value scale) (sometimes incorrectly called the 'light value scale') exposure system. This consists of a series of numbers representing the relationship between lens aperture and shutter speed. An interlocking ring (releasable) ensures that once set to the correct exposure figure, subsequent alteration of shutter speed *or* aperture will maintain the correct reciprocal sequence, i.e.:

$$f/11 \; 1/60 \; = \; f/8 \; 1/125 \; = \; f/5{\cdot}6 \; 1/250$$

where each larger aperture is compensated by a faster shutter speed. The LVS system is particularly useful for beginners.

Most simple shutters have a range of only three or four instantaneous settings in the order of 1/25, 1/50, 1/100, and perhaps 1/200 second. More complex shutters incorporate a delayed action device (sometimes wrongly called a self-timer), indicated by a 'V' setting of the flash synchronisation lever, or as a separate spring-loaded lever. When this is set and released, the photographer has time to place himself in the picture and after a delay of ten or twelve seconds the shutter is fired by the delayed action mechanism.

Flash synchronisation is indicated by 'X' and 'M' settings (see Chapter Fourteen) for electronic flash and expendable flashbulbs respectively, and by an 'FP' setting for use with long-peak flashbulbs on focal-plane shutters.

Advantages of the Miniature

Most people nowadays prefer to use 35 mm. cameras, partly because of their convenience, partly because they enable one to focus and expose rapidly and with accuracy, and partly because of their relatively light weight when considered as the centre of a 'system'. For example, a 35 mm. camera with four interchangeable lenses may weigh as little as five pounds; a similar outfit in a larger size could easily weigh three times as much and be many times more bulky.

Add to this the great variety of 35 mm. films that are available, and the economical running costs, especially with colour, and the reasons for the overwhelming popularity of the format is obvious. It is true that high quality results, up to exhibition

standards, are more *easily* achieved on large size cameras, but with skill the same high quality is achieved on the miniature.

Typical inexpensive miniatures are: Silette Vario, Ilford Sportsman, Konica C35. In the medium-priced group are instruments like the Voigtlander Vito, Zeiss Contina, Baldessa, Retinette, etc., while the high-price range includes the Leica, Pentax, Nikon, etc.

Camera Cases

Cameras need the protection of a case, not only from rain, but also from dust and dirt. Carrying a camera around on a strap without a case is a bad practice, as prolonged exposure to bright sunlight may affect a high-grade lens. It is also possible that concentrated rays from the sun, gathered by the lens, may get through and damage a focal-plane shutter of a non-reflex type camera.

Some professionals use a gadget bag to hold cameras and accessories, but prefer to operate the camera without the encumbrance of a case. Even if he does not carry other lenses or accessories, the amateur is advised to protect the camera with an ever-ready case which can be opened, but need not be removed, when an exposure is to be made.

Tripods

Some photographers can hold a camera steady at 1/30 second, while others find it difficult to take sharp pictures even at 1/60 second. People normally think of the latter speed as fairly fast, and therefore quite safe. Even those professionals who consistently produce *satisfactory* pictures at 1/15 second, however, know that for reliable sharpness, a speed of 1/125 or faster is to be preferred.

Camera-shake is responsible for more unsharp pictures than any other single factor, and is often the culprit where a photographer suspects the resolving power of his camera lens.

Exposures from about $\frac{1}{4}$ second to 1 second can be achieved by pressing the camera firmly against a tree or a wall, but if many time exposures are to be made, a less arbitrary positioning of the camera is made possible by use of a tripod.

Small, flimsy models folding to as small as 8 in. in length may look quite smart strapped to a gadget bag, but are of little use. The serious photographer is advised to buy a more robust model with a good pan-tilt or very large ball-and-socket head. This is especially important when using a focal-plane single-lens reflex,

as vibration is much more pronounced than with any leaf-type shutter.

A flexible cable release should be used to trip the release when the camera is on a tripod. This helps to avoid jerk at the moment of exposure.

Separate Rangefinders

For quick focusing on moving subjects, especially at close distances (i.e. children at play), the built-in coupled rangefinder or the focusing screen is indispensable. Users of cameras without these facilities often require to judge distance accurately for less exacting work, and a separate rangefinder may be found useful.

Such an instrument may be clipped on to the camera shoe, and will accurately measure distances from about 3 ft. to infinity. It should be remembered that while moderate lens apertures will give considerable depth of field at moderate distances, a lens used at say, $f/2.8$ at a distance of 4 feet leaves absolutely *no* margin for focusing error.

Lens Hood

Most serious photographers use a lens hood as protection against stray light rays entering the lens and causing internal reflections that will spoil the picture. A lens hood must be of the right size for the lens in use. Wide-angle lenses need shorter hoods, telephotos longer ones. Too long a hood will cause cut-off at the edges of the picture.

It is best to get the lens hood provided by the manufacturer for use with the particular lens, but a great many kinds are available. Some of these can be used with a filter attachment, and are known as a combination hood and filter mount.

Supplementary Lens (Portrait Attachment)

By fitting a positive supplementary lens over a non-interchangeable camera lens, the close-up range can be considerably shortened. Such supplementary lenses are measured in dioptres and are usually designated $+ 1$, $+ 2$ or $+ 3$. They can reduce the point of focus, with the prime lens set at infinity, to as close as thirteen inches.

To obtain good definition small apertures such as $f/11$ or $f/16$ must be used, but even so, accurate focusing by a tape

measure is essential – this is normally from subject to the film plane (back) of the camera. Naturally, at such close distances, the focusing scale of the prime lens will not be usable.

Although a good supplementary lens is quite satisfactory for flowers and similar subjects, for really accurate work where edge-to-edge definition is essential, users of single-lens reflexes with interchangeable lenses often prefer extension tubes. These are inserted between the lens and the camera body, affording extension without altering the optical performance of the lens. Extension tubes can be bought in sets of three, each of different length, and may be used singly or in conjunction with each other. Some types incorporate a simple mechanism which transmits the automatic diaphragm control of the lens.

For extreme close-up work, where it is necessary to fill the frame with a small insect or other tiny object, a bellows unit, preferably incorporating a sliding stage, is used in conjunction with a single-lens reflex camera, or Leica with Visoflex attachment.

CHAPTER FOUR

Films and Filters

With the exception of some special materials the films available on the market fall into three categories: slow, medium speed, and fast. To be quite accurate, films should be described as of low, medium, and high sensitivity, which better describes the reaction of a particular emulsion to the action of light.

Very simple cameras, which have only a small lens aperture, needs a fast or medium speed film – the former when the light is dull, the latter for sunny conditions.

With more advanced cameras, having large aperture lenses

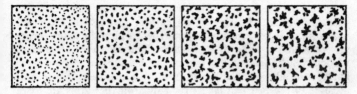

Fig. 10. The characteristic granularity of a film depends on its inherent fineness of grain and, to some extent, to the type of developer used. Left to right are greatly enlarged sections of the developed emusion of: very slow, slow, medium-speed, and fast films.

31

and variable shutters, the type of film can be chosen in accord with other factors. You see, a slow film has very fine grain, and when a big enlargement is to be made (say 12 × 15 in. from a 35 mm. negative), the grain in less obtrusive. On an enlargement of similar size, made from a fast film, the grain structure will be much more noticeable. For this reason, one of the films of medium sensitivity is generally recommended for all general subjects, with an occasional switch to fast film for subjects in very dim lighting conditions, or slow film when great enlargement and the highest degree of technical quality is required.

Orthochromatic film

In black-and-white photography the film has to translate the colours of the scene into shades of grey, and its ability to do this depends on the colour sensitivity with which the film manufacturers endow their product.

Orthochromatic film, now only used for special purposes, is not sensitive to red, and is thus unable to reproduce that colour as grey. It reproduces it, in fact, as black. If you look at ancient snapshots in a family album you will see that the ladies' lips are black, or nearly so. This was not merely because the lipsticks of those days were darker, but because orthochromatic film was used.

Orthochromatic film, still available from some makers, has one doubtful advantage – it can be developed by the light of a red safelight, so that an individual negative can be watched until development is judged to be complete.

Panchromatic film

Most photographers today have never used anything but panchromatic films, which give much more acceptable translations of colour into shades of grey. This film is sensitive to all colours, including red and orange. It does not, however, give a faithful monochromatic rendering of all colours throughout the visible spectrum. It is less sensitive to a narrow band in the green (hence, an occasional glimpse by the indirect light of a special panchromatic safelight towards the end of the development time does no harm) and, like orthochromatic film, it is over-sensitive to blue.

Some of the fast pan (short for panchromatic) films are extra-sensitive to red, and are thus especially useful for subjects in artificial light. These films are 'kind' to faces, as they minimise little reddish veins and blotches. Ilford HP4 is such a film.

Sunlight is coming over this girl's shoulder, but there is adequate illumination in shadows. This can be obtained by using fill-in flash, or, more easily, by ensuring that light from behind is reflected back into shadows by some light surface. A light-coloured towel, sheet of paper, or natural object will do.

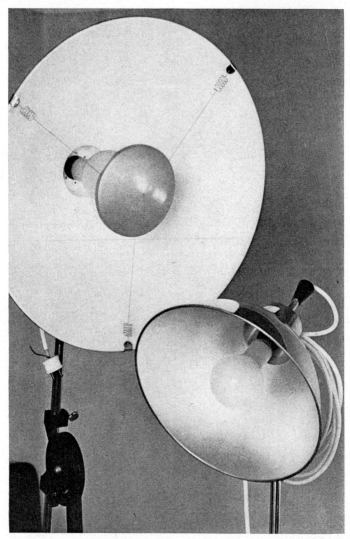

Most useful No. 1 lamp unit for home portraiture is a large shallow reflector with inverted cup over the bulb, as in the 21 in. Photax unit shown. This gives a large expanse of diffused light. One smaller and deeper reflector lamp unit can be added. This Photax 13 in. reflector (lower) has sliding rod by means of which light-beam can be 'flooded' or 'spotted'.

Diffused light from left gives excellent modelling and soft skin tone to this elegant portrait. Tone of background is carefully controlled to give emphasis to light face tones. Direct gaze is enhanced by single reflection in eyes — portraitists often 'adjust' such reflections, and eliminate double ones, by judicious retouching.

Lively expression and interesting pose give pictorial quality to what could easily have been just another snapshot. Taken on Kodak Verichrome Pan film, 1/250 at f/5·6.

Speed rating

In order to expose a film correctly, the photographer needs to know its speed rating, which is marked on the film carton and in the instruction leaflet.

Among the more commonly used are: ASA (American Standard Association); BS (British Standard); Scheiner (expressed in degrees); and DIN (Deutsche Industrie Norm). All British and American films are nowadays clearly marked in ASA, though German manufacturers still use Scheiner and DIN.

As more exposure meters, including German and Japanese ones, are calibrated in at least two systems, usually ASA and DIN, the problem of translating one to the other resolves itself. Here is a conversion table:

ASA	BS	DIN
1250	42°	32
400	37°	27
125	32°	22
64	29°	19
50	28°	18
32	26°	16
25	25°	15

Film Characteristics

For general photography medium-speed films, about 125 ASA, are to be preferred, as they give the best possible compromise between fine grain and useful film speed. They are ideal for all subjects where the highest possible shutter speeds are not essential, and with correct development are capable of considerable enlargement without obtrusive grain. Such films are usually of normal to soft contrast and will cope with a wide range of lighting conditions.

Where extreme enlargement is required, as with half-frame and sub-miniature cameras, the slow pan films are ideal, and whenever lighting conditions permit, the small-film user should take advantage of this fact. As these films are inherently contrasty, special developers of the compensating type should be used.

The high-speed films are of soft gradation, and are thus more able to cope with subjects of high contrast, and in difficult lighting conditions. Provided extreme enlargement is not necessary, they acquit themselves well in general use, having more latitude

in exposure than slower films. These films will be chosen for press, action, and 'available light' photography.

Grain

The sensitive emulsion consists of microscopic grains of silver bromide, which 'clump' together as development proceeds. On enlargement, it is the pattern of these clumps of silver which is revealed, and to which we refer as graininess.

As we have seen, the slower films are inherently fine in grain, while the faster films are relatively coarser. This, however, is not the whole story. Other important factors influencing the final grain structure evident in the print, are (A) The amount of exposure given, (B) The type of developer used, and (C) The amount of development given.

A badly-exposed and processed slow film can give a result vastly inferior to that obtained from a correctly exposed and processed fast film. This subject will be dealt with fully in Chapter Seventeen.

In general, the slower emulsions contain smaller grains of sensitive silver salts than the faster emulsions, and it follows that the developed grains will be less obtrusive. Conversely, faster emulsions gain their speed by incorporating larger grains of silver halide, which, on development, must be more obtrusive.

The *actual* grains are invisible to the naked eye – it is only their clumping or grouping, which can be seen. The quality of most modern emulsions is such that only the user of 35 mm. and smaller sizes need concern himself seriously with the question of graininess, and then only if enlargements of six diameters or more are required.

Not only knowledge, but common-sense, should be brought to an appreciation of the graininess question. Many old-timers still are influenced by the early approach to photography, which tried to imitate the effects produced by painters. The painters didn't suffer from graininess (the argument went) so it must be eliminated from photography at all costs. Unfortunately, a pre-occupation with its elimination can take precedence over the main purpose of photography, which is the production of *pictures* worth looking at, and not just a technical exercise.

Provided a negative has been correctly exposed and developed, then properly printed, the photograph will look well from a proper viewing distance. It must also be remembered that glossy paper shows the grain structure of the negative far more than one with a lustre surface, and the latter is usually chosen for private

or exhibition viewing. Where a glossy print is made for reproduction purposes, a larger print size than 8×10 in. is seldom required, and thus the grain will disappear entirely.

Halation

When a bright light source is adjacent to a shadow (such as a window in an interior, or a doorway opening on to a scene outside) the light tends to spread into the shadow area, blurring the dividing line between light and dark areas. This is caused by the light rays penetrating the film at an angle and being reflected back to the surface of the film. To minimise this, modern films incorporate an 'anti-halation' layer, usually consisting of a dye. Additionally, modern films are coated more thinly than was once the case, so the amount of light-scatter through the emulsion is minimised.

Film quality

Continual developments in the science of film making ensure that the films we buy are of a very high standard. The film is built up in layers – support, binder, emulsion and super-coating, the latter to guard against abrasions. There is also the anti-halation backing or layer.

Typical of the various groups are:

ULTRA-HIGH SPEED	Kodak Royal X Pan, Agfapan 1000.
FAST	Ilford HP4, Kodak Tri-X, Agfa Ultra.
MEDIUM	Ilford FP4, Kodak Plus-X, Agfa ISS.
SLOW	Ilford Pan F, Kodak Panatomic X, Agfa IF.
VERY SLOW	Agfa IFF, Adox KB14.

Colour filters

The way the human eye sees a scene, and the way a film emulsion 'sees' it, differ in respect of colour values. Even panchromatic film, which has been colour-balanced, cannot always translate colours into a range of greys that look acceptably 'correct' to the eye.

Panchromatic film is affected by blue, violet and ultra-violet to a greater degree than it is by green, yellow and red. Whereas the human eye sees plenty of contrast between a blue sky and white clouds, the unaided film tends to reproduce these as a pale grey,

or even white. This state of affairs is easily remedied by fitting a colour filter in front of the lens.

The filter allows rays of its own colour to pass through, while absorbing or subduing rays of the complementary colour. Its strength of effect depends not only on its particular colour, but also on the *depth* of that colour and the characteristics of the film with which it is used. Since it absorbs some of the light reaching the film, it is necessary to increase the exposure time to compensate for this. The amount of increase is usually called the 'filter factor', or to be more accurate, its multiplying factor.

A 2X factor means that exposures must be doubled when using that filter, a 3X factor calls for treble the exposure, and so on. In practice, the lens can be opened up one stop when a 2X filter is used, or the exposure time doubled. Thus, if the exposure without the filter were 1/125 at $f/11$, one could use either 1/125 at $f/8$, or 1/60 at $f/11$, with the filter.

With a 3X filter it is necessary to interpolate between the marked stop numbers or shutters speeds. Thus, with the exposure stated above, one could set the lens aperture between $f/8$ and $f/5.6$, or (if the shutter mechanism allows of this) the shutter could be set between 1/60 and 1/30 second. On lens shutters, intermediate settings are possible in infinite variety, with two normal exceptions, i.e. not between 1/10 and 1/25, or between 1/250 and 1/500 second. Neither is it possible to make midway settings between T, B, and the 1 second settings. Precise details are usually included with the instruction booklet for a particular make of camera.

Whether to open the lens wider or slow down the shutter speed? The choice is easily made by considering the situation. Should the subject be in action it is best to maintain the higher shutter speed and open up the lens! On the other hand, with a static subject such as a view, where depth of field is important, one would decide to stop down the lens and increase the exposure time accordingly.

Many beginners buy too many filters, either through love of ownership or because they believe that they cannot get the best results unless they are constantly employing different filters. In fact, for general black-and-white photography, a 2X yellow filter is quite sufficient. This will give a fair degree of correction in daylight, and darken blue skies satisfactorily.

Consider a landscape on a sunny day. If the camera is loaded with slow film, the exposure without a filter may well be 1/125 at $f/5.6$. If the photographer wanted to use an 8X red filter, which has the effect of darkening the blue sky almost to black, he would

Filter	Factor	Lightens	Darkens	Use
Yellow	1½×	Yellow and Green. slightly	Blue slightly	Sports subjects. Short exposures. Improved colour.
Deep Yellow	2×	Yellow and Green Red slightly	Blue	Landscapes. Clouds. Distance. Flowers.
Yellow-Green	2×	Yellow and Green	Blue. Red slightly	Landscapes. Woods. Clouds. General scenes.
Green	3×	Green	Blue and red	General. Clouds. Woods.
Orange	4–5×	Yellow, Orange and Red	Blue and Green	Haze penetration. Distance. Strong sky effects.
Red	6–8×	Red	Blue and Green	Dramatic skies. Pseudo-night effects.
Blue	1½×	Blue-Violet	Red and Green	Portraiture in artificial light.
U.V.	Nil	Eliminates Ultra-violet		Seascapes. High altitudes above 6,000 feet.

Always remember that filters lighten objects of their own colour, and darken those of complementary colour.

have to open up three full stops (f/2 at 1/125 second) or reduce the shutter speed settings (f/5·6 at 1/15 second). At f/2 there would be practically no depth of field and the lens, in any case, would not be giving its best optical performance. At 1/15 second, on the other hand, he could not hold the camera still and a tripod would be needed.

The answer, of course, is either not to use such a slow film, *or* carry a tripod, *or* use a filter with a smaller factor.

Filters cannot be home-made from coloured cellophane, however clear and uncreased this may appear to the eye, since, apart from its unknown colour value, such material will have a definite adverse effect on the definition of the lens. Gelatin photographic filters can be purchased and cut to size. If handled carefully and properly mounted to avoid stress, these are very satisfactory and will last some time. Optical flats of glass, dyed in the mass and accurately ground, are less easily damaged, though more expensive.

Unless the reader is going to undertake much specialised work calling for the constant use of filters, he is advised to buy one optically-worked glass filter of the most useful kind (2X yellow). If he wishes to experiment with other colours, he could first buy these in gelatin form then add glass filters when he felt sure that these would be useful additions to his kit.

Typical factors for pan film and the functional effect are set out in the filter table above.

CHAPTER FIVE

Correct Exposure

The quality of your finished photographs, however well printed, depends on the quality of your negative, which, in turn, depends on correct exposure and correct development. Thanks to the latitude and speed of modern films, the casual snapshotter who merely presses the button and hopes for the best, gets a fair percentage of printable negatives. How much better the results could be, and how much smaller the percentage of failures, if some kind of exposure calculator or meter were used.

The term 'correct exposure' should not be considered as being a highly technical computation of absolute mathematical accuracy; in practice it falls within certain limits of tolerance, rather than on one vital point. No negative is a failure because it receives half a stop less, or a stop more, exposure than would have been theoretically correct. If this were not the case, photography would be difficult indeed, and its enthusiasts very few.

However, although there is no such thing as 'exact exposure', there is definitely a *minimum* one, i.e. that just records important shadow detail.

Governing factors

Exposure is determined by four factors: (1) The amount of light reflected by the subject; (2) the speed of the film; (3) the size of the lens aperture; (4) shutter speed.

As the last three are under our control, and can be varied at will to suit the subject, let us consider the means and methods of assessing the strength of light being reflected from the subject.

Exposure tables

The inexpensive snapshot camera, with a fixed-aperture lens and one-speed shutter cannot be used in conjunction with any exposure table or calculator. The only control the photographer can apply with such an instrument is choice of film – medium speed film in fair weather, fast film in foul. All other types of camera can be used with some method of exposure determination, and should. Even the simplest tabulated guide is better than guesswork, and those given in the leaflet accompanying the film will give surprisingly accurate results in all but the most difficult lighting situations. Photographers of long experience sometimes rely on their own judgment, and are successful; sometimes they aren't. But even *they* would not tackle colour photography without a meter.

A simple exposure table, such as the one shown overleaf, will keep you within the limits of the film's latitude, during the period March to September, from about 8 a.m. to 5 p.m., with medium speed films of 100 ASA–125 ASA. Earlier or later in the day, use larger apertures.

Pocket calculators and visual meters

A simple plastic calculator, on the rotating disc principle, costs only a few shillings, takes up no room in the pocket or gadget bag, and will give fairly accurate exposure information to suit any combination of film, filter, subject, and condition of light. Visual extinction meters, costing a little more, provide the same information by means of a density step-wedge.

These visual meters, also known as extinction meters, have fallen in popularity and are now seldom seen except on the second-hand shelves of camera stores. The reason for this is that many cheap photo-electric meters are now available, costing only fractionally more than the best of the old extinction meters, and are generally more accurate.

An extinction meter is held in front of the eye and a series of

EXPOSURE GUIDE

Group	Subject	Shutter speed	Lens aperture
A Very bright subjects	Snow scenes, beach, distant landscapes without any dark-shadowed foregrounds	1/125 1/250	f/16 f/11
B Bright subjects	Medium-close scenes on beach, open water, normal scenes in bright sunshine	1/125 1/250	f/11 f/8
C Average subjects	Street and garden scenes, groups, general subjects not in shade, average country scenes, buildings	1/125 1/250	f/8 f/5·6
D In shade	Street and garden scenes, groups, portraits, etc., in open shade (i.e. not in dark shadow)	1/60 1/125	f/5·6
E Deeper shade	Under archways, trees, etc., average shady lanes, woodland (not dense thickets)	1/60 1/125	f/4

For hazy sunshine, give double the exposure in each group. (Open lens to next aperture or halve speed).

On cloudy days, give four times the exposure in each group. (Open lens 2 more stops, and/or decrease speed).

Fast films of 200 ASA need only *half* the exposure times given in the table.

Slower films of 50 ASA need *double* the exposure times.

numbers varying from light to dark is seen. After a second or so, for the eye to accommodate itself, the least visible number is chosen and referred to a built-in calculator, from which the exposure is assessed. A fault with this system is that the eye will accommodate itself with the passage of seconds to darker and darker numbers, eventually causing under-exposure.

Photo-electric meters

The most accurate instruments for measuring light, these fall into two classes, those operated by a selenium cell, and those incorporating a CdS (cadmium sulphide) cell in conjunction with a mercury battery.

The selenium meter consists of a microammeter connected to a light-sensitive photo-electric cell. When light falls on the cell, a minute electric current is generated, actuating the pointer of the microammeter, which thus indicates the intensity of the light. A built-in scale is then used in conjunction with this figure to give the correct lens apertures and shutter speeds. No batteries are needed with such meters, the best of which are virtually ever-lasting.

Good examples are the Weston, Sekonic, Bewi, Sixtus and Sixtomat.

A CdS meter works differently.

Each type of meter has its advantages and disadvantages. The selenium type has a colour response very similar to that of the human eye, whereas CdS meters are relatively insensitive to blue. Although the more expensive CdS meters incorporate a filter to overcome this, cheaper meters do not – a common fault which causes under-exposure in yellowish artificial light or outdoors in the evening.

In moderate-to-bright lighting the selenium-type meter is unbeatable, but CdS meters are far more sensitive and are therefore to be preferred when much work in very dim lighting is undertaken. CdS meters require a new battery about once a year, and towards the end of the battery life the exposure readings tend suddenly to become erratic – annoying if one undertakes a vital job but has forgotten to replace an exhausted battery.

Among the best of CdS meters are the Lunasix, Sixtar, Metrastar, and Leicameter MR.

There are also special photo-electric meters for determining the *colour temperature* of light in connection with very precise applications of colour photography. They are used to indicate the colour of the correcting filter (not to be confused with colour

filters for black-and-white work) required to produce the best colour rendering with a given type of colour film in the prevailing lighting conditions.

Using a meter

Photo-electric meters are usually calibrated to give an *average* reading of the light reflected from a scene. As there are many occasions when only part of the scene is important, and this part differs in illumination from the general view, it will be seen that a reading of the general view may be misleading. In such cases, the meter is taken closer to that part of the view for which accurate exposure is required.

By way of example, supposing you wish to photograph a person standing against a sky background or a white-washed wall. Simply pointing the meter at the scene from a distance would give a reading for the sky or wall, whereas the darker flesh-tones and clothes of the person may need at least double the exposure indicated. The solution is to hold the meter quite close to the person since this is presumably the important part of your picture.

If you want to preserve details in both the person and the sky or wall, then two readings should be taken (one close up, another from a distance) and an exposure given midway between the two. Later, at the enlarging stage, a little correction can be applied either to the person or to the background. How to do this will be explained in Chapter Eighteen.

When making a general reading of a landscape, point the meter slightly downwards, so that only about one-third sky is included in the meter's angle of acceptance. This will prevent an inflated reading, causing under-exposure in the all-important foreground.

With back-lit subjects, take the meter in very close so that only the illumination of the shadow side is being measured. Even then an extra half a stop is usually advisable. Of course, if a silhouette effect is required, ignore the shadow side and expose for the brighter background.

The Grey Card Technique

The light reflected from different parts of a subject will very in intensity in relation to the tone of the various reflecting surfaces, and whether or not these are shadows. Reflected light meters, such as we have been discussing, are calibrated to 'integrate' these varying degrees of reflectance. The method is successful in all cases where the subject contains no extremes of lighting contrast,

but can be misleading when a bright light (in which we do not wish to retain detail) such as a window or light-bulb comes within the picture space.

In such cases a grey card can be used. The Kodak Neutral Test Card has a white side and a grey side, the former reflecting 90% of the light that falls on it, the latter only 18%, or one-fifth of the white side. We speak of 90% and 18% reflectance.

The grey side, in fact, reflects the same amount of light as a theoretical 'average' subject.

These Kodak Neutral Test Cards are 8×10 in., a size that has been found most practical. In use, the card is held so that it reflects the light falling on the subject towards the meter, which is held close enough to the card not to be influenced by extraneous light, but not so close as to cast its own shadow on the card's surface. In effect, we are blending all the tones of the subject into an 'average' grey which the meter is able to read with accuracy.

When using a selenium meter in dim light, the grey side of the card may not reflect sufficient light to activate the meter needle sufficiently. In such cases, the white side of the card is used, and the exposure multiplied by five.

Incident light method

Some reflected light meters have a supplementary incident light attachment, while other meters are designed specifically for incident light readings, and are known as incident light meters. In either case, a white translucent cone, dome, or disc, is placed over the cell, which is then pointed *at the camera*, from the subject position. It thus measures the (incident) light falling on the subject, not that which is reflected from it.

This reading is always accurate for skin tones or other 'average' subjects, and is invariably used by professionals for both colour and black-and-white work.

Two points must be borne in mind. Firstly, an incident light reading will not compensate for a subject which is very dark or very light in colour. In such cases, the photographer should allow half a stop more or less than the indicated exposure. Secondly, incident light readings are often misleading when photographing distant views. This is because there will be appreciably more haze covering the distant view than exists between the light-source (the sun) and the meter. This haze is composed of tiny particles of moisture suspended in the air. A good rule is to take incident light readings for all subjects up to the middle distance, and reflected light readings of distant landscapes.

Practical working

In applying your exposure calculator or meter reading, you are faced with a choice of several combinations. For example:

1/30	1/60	1/125	1/250	1/500	1/1000
at	at	at	at	at	at
f/16	f/11	f/8	f/5·6	f/4	f/2·8

will all give the same amount of exposure, but which to choose? For fast-moving subjects, choose the higher shutter speeds and the larger apertures. Where great depth of field (zone of sharpness) is important, choose the smaller apertures and the slower speeds. At slower speeds, however, remember to hold the camera very steady and squeeze, don't jab, the shutter release.

Judging correct exposure

Whether a negative is correctly exposed or not, depends entirely on the kind of picture you want to make from it. In any school of photography, the student learns to produce a negative that contains a full range of tones, with detail visible (and printable) in the shadow and highlight areas. This is the best way to learn the craft of photography, but it must always be remembered that the final criterion is not an arbitrary 'full range of tones', but the artistic effect you have pre-visualised and want to reproduce in the print.

If, for example, you see a black sheet of paper, with just the cheeks, nose and chin of a person as splashes of white, illuminated from above it, obviously it is nonsense to go for a full range of tones. In such a case, you would merely give sufficient exposure for the few highlights to reach good density on the negative. The background should be entirely lacking in detail, as only a black is required on the print.

Nevertheless, a good small-film negative which conforms with the technical 'ideal', should have a full gradation of tones, with highlights unclogged and shadow areas containing some detail. It should be such that when pressed into contact with a sheet of newspaper, the type should be just visible through the densest parts.

In an under-exposed negative the shadow areas will be empty, and the whole negative look wishy-washy and thin. Chemical intensification can help in cases of moderately under-exposed negatives, but no process can reveal detail where it is not already present.

Over-exposed negatives are very dense and lack detail in the

highlights (i.e. the densest parts). Shadow areas are fogged and the whole negative will show coarse grain. Chemical reduction with Farmer's Reducer will help when it is imperative to print from a grossly over-exposed negative, but the grain will remain coarse and the overall effect will be inferior to that obtained from a correctly exposed negative.

Composition

A subject or picture that pleases one person will not necessarily please another. Ask twenty people what is their idea of a good picture, and you will get twenty different answers. Beauty, is indeed, in the eye of the beholder. What, then, is Pictorial Composition, can it be taught, and has it any use?

Broadly speaking, a good composition is one in which the photographer has arranged his subject matter in a satisfactory way. I do not say in a *pleasing* way, because it may not be the aim of the photographer merely to please. He may wish to excite, to shock, to amuse, or to give tranquillity to the viewer. Composition is one of the aids he can call upon to achieve his effect.

Although composition is both complex and flexible, there are certain principles which guide the novice in pictorialism as opposed to casual snapshotting.

First, aim at *simplicity*. Don't try to get too much into the

Fig. 11. Strong compositional points of picture are at E G F H, and any object placed on one of them is in a strong position. Avoid main horizontal or vertical lines (skylines, buildings, etc.) cutting frame exactly in half. Better to use lines AA, BB, CC, DD. Good composition is a matter of balance, large against small, dark against light, etc., rather than symmetry.

picture, or you literally will not see the wood for the trees. When you look at a scene, your eye flits from one detail to another, helping your *mind* to build up an impression of the whole. But the eye can be selective, too. It can zoom in on a pretty girl sitting on a gate across the road, and entirely overlook the dumped wreck of a car just a yard or so away. Not so the camera lens – it will faithfully record everything within its field of view; the dumped car, the hedges, the scraps of paper in the roadway and the telegraph poles spoiling the horizon. And there, some-where in the middle of it all, is that pretty girl sitting on a gate!

So try to have just one point of interest and let everything else be subordinated to it. Get in close! Fill the frame with just that part of the subject that matters, which helps to eliminate distract-ing surroundings that do nothing for the composition.

Hold it!

Unless you are about to photograph a fleeting moment – the sun going behind a cloud or a horse trotting through the bushes – in which case you won't have time to think much about com-position – always *stop and think* before using your camera. Ask yourself two basic questions. What attracted you? What were you just going to photograph? Good composition can only begin after you have first decided on the purpose of your work.

When shooting in black-and-white, don't be misled by colour. Half-close your eyes and study the scene. Delicate pinks and greens have good colour contrast, but in black-and-white they are approximately the same shades of grey. Half-closing the eyes helps to eliminate half-tones, enabling you to see the broad masses of light and dark areas. Do they make up well together, balancing each other? A small light area balancing a large dark one, or an expanse of light tone balanced by a small dark one. Or, in the case of equal masses, does each cancel out the effective-ness of the other? What we are after is *balance*, not *symmetry*.

Then look beyond your subject into the background. Are there any telegraph poles, wires, or advertisement hoardings to spoil the effect? An artist can merely leave them out. You can do this by changing your viewpoint, or perhaps choosing a higher or lower angle from which to take your picture.

Viewpoint

To change your viewpoint a little, left or right, farther or closer, can change the whole aspect and balance of the picture. Remem-

ber, we are after balance, not symmetry. A cow in a field may be exactly the same size as a small farm wagon. Go closer to the cow and you diminish the size of the wagon, which now forms a useful background object. Go closer to the wagon and you place the emphasis on this, with the cow now taking a balancing role in the background.

Shoot them as you first see them, and each will occupy equal *weight* in the composition, vying with each other for the eye of the viewer.

Never place the main subject dead centre in the picture space, but a little to one side and towards the bottom or top edge, according to the subject.

Low viewpoints help minimise distracting horizon lines and increase the subject's importance by raising it out of its surroundings. High viewpoints also help to eliminate distracting horizon objects.

Look into the viewfinder. Now that you have got your subject to one side, and high or low in the picture space, what do you see in the opposite corner? There should be something there to balance the offset placing of the main object, and that something must be subservient to the main object. Such balancing achieves unity. In portraiture, a hand can be positioned to balance the placing of the sitter's face. A useful trick is to turn a picture upside down. If no part looks over-large or irritating, all is well.

Leading lines

In any picture, the eye automatically follows the leading lines. These are not lines in the literal sense – they may be just shadows or patches of sunlight. It is their continuity, contrast and direction values which count. If these lines lead the eye *out* of the picture space instead of into it, the result is unsatisfactory; indeed, their direction can decide the whole mood of a picture.

Horizontal lines suggest stillness and peace; verticals suggest effort and thrust; diagonals suggest activity. Curved lines are usually more interesting than straight ones. It is not essential that such lines should be unbroken outlines. They may be full of light and change but their general direction should be apparent.

Of course, obvious lines are those of hedges, lanes and streams. These should not simply traverse the picture from right to left; the eye will simply follow from one side to the other, then right out of the picture. Let such lines recede diagonally from fore-

ground to background, which has the added advantage of creating an illusion of depth.

Whenever two leading lines meet or intersect, you have one of the strong points of the composition. These strong points should fall in satisfying positions, as shown in the 'thirds' of the diagram. One good strong point is enough for any picture. Too many will destroy unity by causing the eye to flit from one to the other.

The Outer Edge

Don't let the outer limits of the frame cut off an important part of the picture in the drive for simplicity. A foreground tree needs its base; a person's feet should not end at the ankles. This does not mean that in portraiture, for example, you must always show all of a person's head and shoulders. It isn't just a matter of physical correctness, but rather that the picture must not leave a feeling of incompleteness in the mind.

Constructional Devices

Although a picture cannot be made to a strict recipe, certain time-proven constructional devices can be brought to bear when exploring the possibilities of a subject. Very few people vizualise the same subject in quite the same way, and it is this individualism which adds zest and variety to pictorialism.

The triangular shape is one of the most common forms of contruction. Head-and-shoulders portraits naturally assume this figure; quite often groups and natural forms do, too. Others readily fit circles or repeat themselves in rhythmical fashion.

A popular device is the foreground 'frame', the picture being taken through an arch, doorway, or window in shadow. This dark frontal area is quickly passed over by the eye, and goes on into the scene beyond, so that a feeling of depth is created. The eye is always more attracted by light than by darkness, and this fact can be exploited simply by keeping any dark shape or shadow in the foreground. Such a shape also serves to give stability to the rest of the picture by acting as a good solid base.

Alternatively, a foreground object may be closely approached to increase its scale and importance in relation to the distant view, again helping to suggest depth. Lighting must always be such as to give marked tonal contrast and preserve the illusion.

Photographing against the light (known as back-lighting or *contre-jour*) is another way of suggesting depth. The sun or light

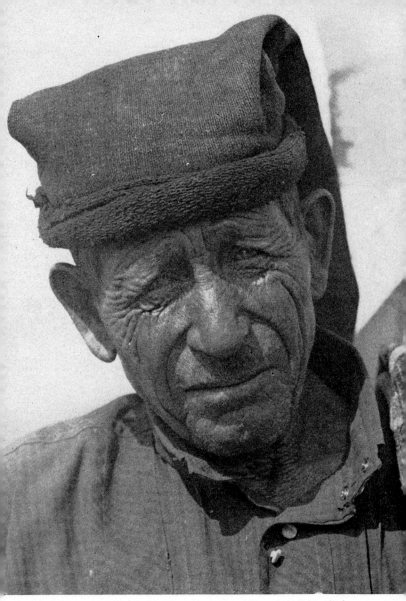

Few photographers could resist the character and lines in this man's face. Overhead but diffused sun gives strong modelling but plenty of detail in the shadows. For best effect, fill the frame with the head-and-shoulders only. Take another picture from farther away if you want to record details of dress. A green filter used with pan film will preserve sunburnt skin tones while darkening sky. This is a black-and-white print made from a Kodacolor negative.

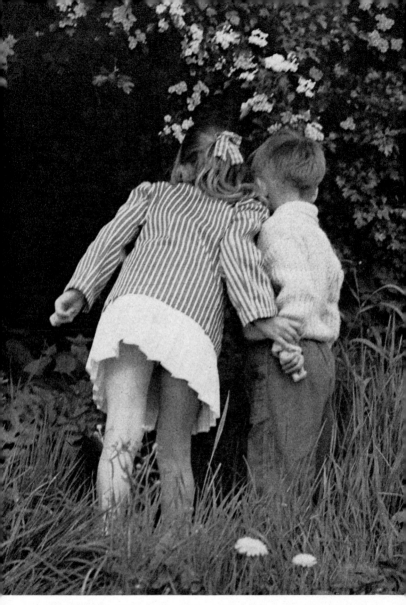

Don't go down in the woods today — unless you have your camera ready to capture such delightful scenes as this. A picture taken on a Rolleiflex camera, using Ilford HP4 film. 1/125 at *f*/8.

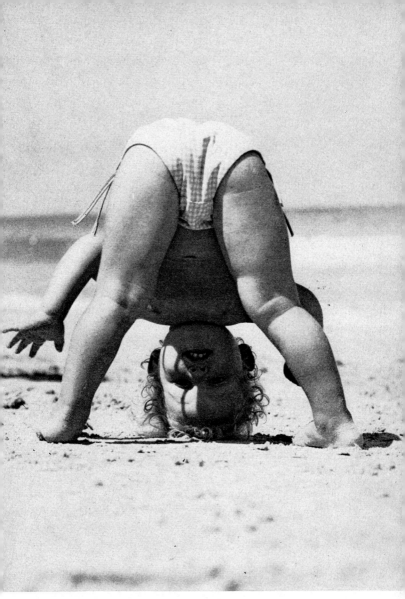

A soft negative is required to ensure adequate detail in shadow and highlight areas. In this case, film was exposed fully and development curtailed 10%, which has the effect of lessening the contrast.

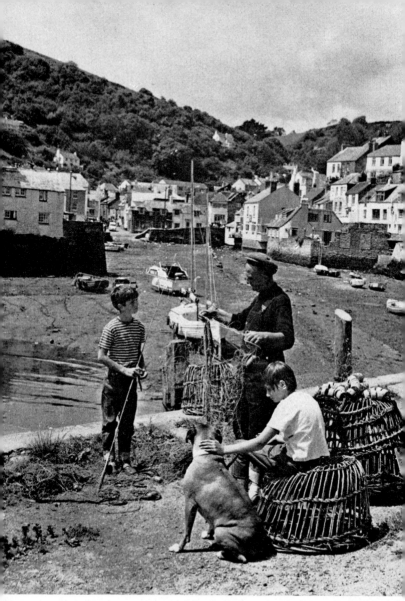

Not quite the boyhood of Raleigh, but fairly close to it. A sunny holiday scene that could easily fail because there is so much detail that the eye hardly comes to rest. This is saved by careful grouping of the figures, however. Black-and-white print from a Kodacolor negative.

source is *behind* the subject, giving it a halo of light all round its edges, thereby outlining it from the background, which is in shadow. Since the side of the object facing the camera is likewise in shadow, this treatment is especially useful when it is desired to suppress unwanted detail, the accent being on shape and mass.

Differential Focusing

By using a large lens aperture and utilizing the shallow depth of field it produces to keep only the main point of interest sharply defined, the chief object is accentuated and others sub-jugated by being softened in outline. This treatment, termed differential focusing, has its pitfalls. Too much out-of-focus fore-ground may be irritating and unnatural. Accuracy in focusing is essential, but the rather close approach required sometimes be-comes impossible in practice.

In favourable circumstances, psuedo-stereoscopic depth results. The effect is particularly pronounced in back-lighting conditions.

Differential focusing is inevitable with long-focus lenses be-cause of their lessened depth of field. They also appear to 'bring up' the background in a way which is most helpful in open land-scapes.

<div align="center">

CHAPTER SEVEN

Portraiture Outdoors and Indoors

</div>

It might be said that there are three forms of portraiture. First (in the looser sense) are the familiar full-length and head-and-shoulders family snapshots in the garden and in the park – un-doubtedly the most popular and most widely-practised of the three. Next, the more serious type of portraiture which sets out to capture a good facial likeness of the person, head-and-shoulders only, either by means of lighting equipment or careful choice of position outdoors. Lastly, and most difficult of all, 'true' por-traiture, depicting character.

Starting Simply

Let's begin with those simple little snapshots in the garden. You have no doubt already discovered that your camera, with its lens of normal focal-length, presents certain difficulties.

(a) If it is of *fixed-focus*, you cannot approach your subject closer than about 6 to 8 ft.; thus the face is far too small on the negative for a head-and-shoulders study without considerable enlargement. And when an enlargement *is* made, definition falls off and grain makes the result coarse and unacceptable.

(b) If you can focus the lens as closely as 3 ft., and so get a larger image of the face, the picture doesn't always seem 'quite right'. It may be sharp, and the person may have a pleasing expression, yet somehow, there is something odd about it.

Dealing with *(a)* first, it must be pointed out that this is a case of trying to make the camera do something for which it was never designed. If you deliberately go closer, say 3 ft., to take your picture, it will look nice and sharp in the viewfinder but will be hopelessly blurred and out-of-focus on the negative.

By fitting a supplementary portrait attachment on your lens (if your particular camera will allow of this), you will be able to photograph at closer distances. The actual distance is determined by the supplementary lens in question, and must be accurately measured at the time of taking. Some attachments are intended for close-ups of small objects, and have to be used at distances that are too close for portraiture.

Alternatively, you must content yourself with full-length and three-quarter length pictures and let it go at that. You will find, however, that much of the following advice on lighting, backgrounds, etc., will still be of great help, and there is no reason why your photographs should not please your subjects and yourself also.

The case of *(b)* is rather different. A close approach with a lens of normal (or short) focal length produces a subtle form of distortion, especially if the person has prominent features. Allied to this is the fact that people always look more plump in a photograph than they are in real life. Fashion models have to be quite slim and fairly tall for this very reason.

How To Do It

It is generally accepted that for good 'drawing' and modelling, the camera distance should be at least 7 to 8 ft. With the modern anastigmat lens, as fitted in most focusing cameras, the degree of enlargement this involves to secure a facial study of reasonable size is still a practical proposition. Using the fine-grain film and suitable developer, you can still take your pictures at this distance and enlarge only the head-and-shoulders portion if you

wish, even with a lens of normal focal length. Don't expect too much from 35 mm. negatives, however, as these involve great enlargement. A compromise solution to the problem is perhaps better: stick to working distances of about 4 to 5 ft. Any distortion which then arises is not likely to be unduly noticeable.

The camera viewfinder is designed for far- and medium-distance working, so when you approach your subject more closely it may include a little more than you will get on the film. Remember therefore to allow a fair margin around the subject to allow for this. Also, don't forget the bogey of parallax; always allow for this (see 'parallax error', Chapter Two). More expensive cameras incorporate a parallax compensating device in the viewfinder or viewing screen. As you focus on a very close subject this device causes you to tilt the camera upwards slightly, so that heads and so on are not cut off.

If your camera allows you to fit a long-focus lens, you have the perfect solution, because this gives a bigger image. A special viewfinder covering the field of the long-focus lens and incorporating parallax adjustment must be fitted, since the normal finder shows much more than is covered by this lens. On the popular single-lens reflex the problem of parallax does not arise, as the proper field of view of any lens is automatically seen in the viewing screen. Focusing must be accurately carried out, the depth of field (i.e. zone of sharpness) being shallow with lenses of this type. It will also mean using faster shutter speeds for all hand-held exposures in order to minimize the risk of camera-shake. For speeds slower than 1/125 second it is wiser to use a tripod, even if you can confidently release the shutter at 1/60 second with a lens of shorter focal length. Slow, or medium-speed panchromatic film, because of its reduced sensitivity to red, is preferable to the faster varieties.

Backgrounds

The question of background is most important, and in the average garden, most difficult to solve. It needs to be as plain as possible, so that it in no way distracts attention from the subject. A thick, uniformly trimmed privet hedge, if high enough, and well out-of-focus might serve, unless it is your intention to produce a blossom or flowered setting for a girl.

Close weatherboard fencing, in shadow, can also make a passable background. An old dodge is to stand your subject at an

open doorway, the room behind having been darkened by drawing the curtains across the window. It doesn't take long to prepare, and if properly done, you have an even, dark-toned background for a head-and-shoulders picture. None of the doorway need show in the finished enlargement unless you wish.

An open window (the subject inside the room, leaning out towards your camera) provides a natural-looking setting. In this case quite a bit of the window, held open by your model, can be included with advantage. Sash-type windows are unsuitable. Or you might like to use a bedroom window; this will mean a long-focus lens and possibly a step-ladder as well! Why go to all this trouble, did you say? Simply because the lower viewpoint gives a refreshingly *different* 'home portrait', breaking away from convention without being too 'stunty' or forced.

A plain cloth or blanket hung on the clothes-line and fastened or weighted at the bottom to prevent folds or wrinkles will sometimes make a useful background. Your subject should be 4 or 5 ft. in front of it, in order to prevent any shadow appearing on the background, and to keep the cloth out of focus. A white sheet should be used only for high-key portraiture (i.e. one in which dark tones are absent, light and medium tones predominating). Brick walls are not suitable backgrounds, but if there is one conveniently low, your model could probably sit comfortably on top and a low camera viewpoint with a 2X or 3X green filter will give a sky background. Such treatment demands care, however, for the below-the-chin viewpoint can be most unflattering, particularly at close distances.

Never be tempted to use an orange filter. You'll get your deep-toned sky all right, but you'll also get an anaemic-looking subject, pale and wan, devoid of colour in cheeks and lips! Yellow filters, if sufficiently deep, exhibit, the same tendencies to a lesser degree. When there is no blue sky, a filter is unnecessary. Clouds, unless unobtrusive and even, can spoil things by getting mixed up with the subject's hair and outline. A clear blue sky is often better for this reason. Look out for poles and aerials, etc., in the line of vision.

Hilltops, downlands, flat roofs, may provide vantage points for uninterrupted sky backgrounds which with full-length studies can be very effective. Outdoor, informal attire must be worn for these essentially open-air pictures. The treatment is most suitable for gay holiday portraits; the inclusion of an animal such as a dog (or a light parasol or sun hat for the ladies), can sometimes add to the attraction without creating divided interest.

Sky backgrounds are not recommended on dull, sunless days,

as they are then rather too light in tone, which no amount of filtering can remedy.

Many beginners make a practice of photographing their friends standing in front of famous buildings, statues, etc. If this is simply to prove that they really had visited these places, well and good, but unfortunately this is seldom the reason. Usually the photographer chooses settings like this because he firmly believes that a good picture will result, but nothing could be further from the truth! Bits of masonry invariably get mixed up with uncle's ears, and long shadow-shapes bite into grandma's hat – two separate subjects, a group and a building, each spoiling things for the other.

Never do this. Always make up your mind in advance just what it is you want: a picture of uncle, or one of the statue! In portraiture, the person is the subject first and last, and *everything else* must be at least sufficiently subordinated so that there is never any doubt in the matter.

Of course, if you are sufficiently enthusiastic you can always find a vantage point a few hundred yards away. Then you will be able to take your family group portrait, with the building or statue nicely located in the background.

Lighting (Outdoors)

Bright sunshine is *not* the best lighting for outdoor portraits. It produces hard shadows and causes people to frown and screw up their faces. On such a day it is better to seek the shadow of a building; trees are only suitable if their foliage is really dense, otherwise they are inclined to give a dappled effect on the face, because the sunshine is filtered through the leaf spaces.

A sunless day, although giving flat lighting, can be quite acceptable if the film is slow or medium-slow panchromatic. The trick is to give just a fraction *less* than normal exposure and just a fraction *more* development if you want brighter prints, but normally the prevailing softness is not a handicap.

The ideal outdoor lighting is hazy sunlight; the sun is then naturally diffused, giving good modelling without hard shadows.

In summer, between the hours of 11 a.m. and 3 p.m., the sun is too much overhead for outdoor photography to be successful pictorially. Early morning or late afternoon is much better.

A stock-in-trade of many professionals is to photograph a model in the shade with the brightly-lit scene as a background. Expose for the model, so that the background scene is over-

exposed. The background will then appear much lighter on the print, and the model will stand out boldly against it.

Direction of Light

We have seen how the *quality* of light can influence the result; no less important is the *direction*, or angle at which it falls on the face. This means that you must take particular care how you place your subject in relation to it. Basically, 45° lighting is considered good and a simple way to check for this in full-face portraiture is to get the person positioned so that the shadow from the nose falls slantingly towards one corner of the mouth.

Earlier or later in the day the sun will not give 45° lighting in *height*, but this can be an advantage in the case of prominent features, for by turning the head so that it faces the sun more, the low-angle rays falling on your subject will lessen the shadow-areas, making for a kinder result.

Back-lighting, and oblique back-lighting (i.e. with the sunlight coming from an angle *behind* the subject) can be most effective. The background must be in shadow for this, and an efficient lens hood is essential because the camera will be turned towards the sun. If you haven't a hood, or have any doubts about the rays striking the lens, get a friend to hold a piece of card – or folded newspaper will do – so that it casts a shadow on the camera. It needs to be held well away, however, or it might cut off some of the picture.

Back-lighting produces a halo of light round the head and shoulders of the subject. It also throws the face in shadow, so some form of reflector should be used to direct light on to it. If you are in a garden (as opposed to a public park) you can easily use a clothes-horse or screen with a white sheet or table-cloth on it. Alternatively, when the subject's hands are not included in the picture, he or she could hold a newspaper about waist-level at the appropriate angle. If someone else can do this for them, so much the better.

Side-lighting or cross-lighting as it is sometimes called, is suitable for profile and three-quarter face positions. Shadow is cast from the nose across the side of the face, where it joins cheek-bone shadow. It is useful for males; the background must again be in shadow, or at least dark in tone.

The importance of a reflector, particularly with outdoor portraiture, is not always realised. Always remember that the brighter the light, the deeper the shadow, and with it, the greater the need to lighten those shadows, unless you are aiming for deliberate

shadow effect. The other exception, of course, is when frontal and near-frontal lighting is required.

Posing and Expression

The worst possible position your subject can take up is that when the shoulders are square-on to the camera. Even when it is to be a full-face study, always have shoulders turned so that one is nearer than the other, the person then turning the head to look into the lens or any other direction indicated. There must be no evidence of posing or tenseness in the photograph, and the job cannot be done in five minutes. Half the battle is in getting, and keeping, the subject at ease; if you want a smile, your conversation should create one, not command it.

Reading a book, lighting a cigarette, knitting – whatever is a normal occupation for the subject, will help to induce a natural attitude and expression. A gate can prove useful as something to grasp, possibly lean over, with or without hands on chin, a log or stile to sit on (or, in the case of a man, to put a foot on, in comfortable easy stance). The bank of a river or pool, etc., is suitable, always provided that you remember that it is the *person* you are out to photograph, not the setting. Regard the setting as an adjunct to the picture – a very necessary one – don't include too much of it or it will compete for interest with the figure. In the garden, a swing can be a good setting for a girl, but not for an elderly woman or man. Garden furniture will not look out of place, a kitchen chair will. A stool is better – there is no likelihood of any back-rest protruding from the sitter's spine in an ugly manner.

Full-length studies are easier to produce this way, for one avoids the long narrow picture so characteristic of the lone, standing figure. Don't let your sitter slump, though. And watch those hands! When they are in front of a camera, many people don't know where to put them, which is another reason why it is best to give them something to do or hold.

Let the hands rest gracefully and naturally in the lap; loosely folded harms can be tricky, tightly folded ones disastrous for the shoulders and the figure – generally speaking, it is only in male portraiture that this sort of pose is successful. Short sleeves can be a problem, too, because of the expanse of bare arm they reveal. Fussy accessories may draw too much attention to themselves. Dark clothing normally needs a light- or medium-toned background and vice versa.

If the subject wears spectacles, take care that they do not reflect

the light and so obscure the eyes. A slight turn of the head, this way and then that, a slight forward or backward tilt, will generally eliminate the trouble.

Indoors by Daylight

Provided that certain precautions are observed, and a fast film is used, excellent portraits can be taken indoors without the aid of artificial lighting.

First it must be realised, that whereas outdoors the light comes from the sky, and there is also plenty all round the subject, indoors *there is little or no top-light*. It all comes from a window or windows, i.e. side-lighting only. Once this fundamental condition is grasped, the task is easier. The trick is to regard the window as a 'sun' and work accordingly.

Light which comes from a small source, in this case the window, is always more concentrated. This means that contrasts of light and shadow are also greater in consequence. So it is an advantage to take your photographs in a room with two windows, or one large bay – not so much because the increased amount of light allows of shorter exposures, but because heavy shadows are reduced and the light softened.

Fine net or mesh curtaining across a window acts as a diffuser and is thus helpful in softening the light, particularly in direct sunlight; the sitter must not be placed so that it casts a patterning on the face, however. Away from the window, more into the room, the light gets progressively softer. This advantage is unfortunately nullified by the fact that: (1) it is considerably weaker; and (2) the lower part of the subject then gets more light than the head and shoulders, i.e. lighting is uneven.

The size of the room also affects the issue. If it is a large one, the side walls will be farther from the window, receiving less light, and so, in turn, reflecting less. Similarly, a dark-toned wall reflects less than a light one. Summing-up, therefore, a small room with light walls, one large bay window or two smaller ones, is the best proposition for indoor portraiture by daylight alone.

The Reflector

If you try to work without some form of reflector, you are likely to get unpleasantly heavy shadows. A table-cloth or sheet on a screen, or even an opened newspaper, set at an angle to throw light into those shadows, is always worth the bit of extra

trouble it involves. Watch the effect of it on your sitter's face, and place it accordingly. Normally it will be best opposite the window and at a slight angle to it. But don't have it too near the face or it will destroy modelling.

If you can conveniently use a mirror in place of the white reflector, you will find it almost as good as another window – if not better, in that you can manipulate and move it about at will. It needs to be fairly sizeable – a hand-mirror is too small except to reflect 'catch-lights' in the eyes. You can use a mirror in conjunction with the white reflector if you wish, but its reflected light is stronger and more directional, giving more strongly defined shadow patches. In effect, you are now working with double lighting, so watch those shadow shapes carefully.

Sometimes it is a help to spread a white sheet on the floor, and put the model's chair on it. Naturally, it should not appear in the picture, so it cannot be used for full-length portraits.

Avoid direct sunlight if you can, since, in the absence of any worthwhile top-light, it is virtually a spotlight, to say nothing of the shadows from the window-frame that it casts. Sometimes an upstairs room will prove lighter and brighter, and there is often less bric-a-brac cluttering up the background. As with outdoor portraiture, the plainer the background, the better, unless you are after a 'homely' setting.

Plain, light walls make ideal backgrounds. Alternatively, a plain cloth or blanket may be pinned to the picture rail and stretched so that it does not show any folds or creases.

Placing

Don't place your sitter centrally in the window. Near to one side, with the camera also sideways-on, and opposite, is better. The diagrams (page 155) indicate various positions in relation to window and camera.

If you include any of the window itself in your picture, the negative will be very contrasty and 'blocked up' in that area, requiring careful 'dodging' (see page 168) when enlarging from it, to give these dense parts additional exposure. With the subject sitting *facing* the window, and camera in front or near one side of the window, it may not be necessary to use a reflector. The dead-frontal lighting can be flat and uninteresting. Never be tempted to reverse this arrangement, so that the subject's back is towards the window and the camera poining out. A silhouette is likely to result if you do.

Don't let your model sit at right angles to the window; you

will cut the face in half, giving flat highlights on one side and deep shadow on the other, unless there is a second window opposite or at an angle sufficient to lighten these shadows.

Once you have found a good position for your sitter in relation to the window(s), try the effect of changing the camera viewpoint, moving in an arc from the front to the side of the subject. Note the changes in modelling that this presents. As you move towards the centre of the room, more of the shadowed side of your model's face is shown. By raising or lowering the camera also, certain features can be subdued or emphasised.

For example, a bald man would not thank you for putting your camera at a high level and so including quite an expanse of the top of his head. A girl with a fleshy chin would be unkindly depicted from a low viewpoint. A prominent nose should never be photographed in profile. Prominent ears can be most disconcerting in a full-face portrait of a man. For normal portraiture, the camera ought to be level with the eyes. A long-focus lens is best for head-and-shoulders. It is up to you to analyse your sitter's features bit by bit, deciding on what constitutes the weaknesses and what the chief attractions. By your ability (or otherwise!) to play down the one and accentuate the other, your success in portraiture will be judged.

Just moving the camera is not enough. Your sitter must be prepared to move the head and shoulders slowly in any direction you indicate; a tilt here, a turn there, can make all the difference. Watch out for arms and legs which project towards the camera, for they may be distorted and exaggerated at close distances. Remember, too, that almost invariably one side of a face will photograph better than the other. This 'better side' you must be at pains to discover. Prolonged posing can be a tiresome business for the sitter, and in time this may become evident in the expression. Natural posing is an art which is more difficult for some people than others.

When taking a three-quarter view of a face, always focus on the nearest eye.

Exposure

Unless you have a large aperture lens on your camera, even with fast film the exposures will be relatively long if you venture far from the window. In any case, the camera should be on a tripod, or placed on some solid support, such as a table. Use the lens hood, and a flexible cable release, too.

With a photo-electric meter, the exposure problem is quickly

settled by taking a reading on the model's face. On a bright day it might be possible to work at 1/30 second at $f/3.5$ with the fastest film, speeding this to 1/60 second if very near the window. It is seldom an advantage to use a very small stop – the increased depth of field it gives will make the background details just as sharp as the face, and this is not wanted. If your camera is fitted with a 'slow' lens, i.e. maximum aperture $f/8$–$f/11$, the background cannot be thrown out of focus, and the all-over sharpness must be accepted unless you resort to a supplementary portrait attachment, with its attendant danger of too close an approach to the face. Exposure at such apertures is likely to be in the region of 1 to 4 seconds. It is always advisable to err on the side of over-exposure because of the rather contrasty lighting conditions.

Adding One Lamp

Mixing daylight and artificial light is quite a practicable business in monochrome photography, but must *never* be done when using colour film. Switching on the room lighting is no good – you need a 'photoflood' lamp. This looks like an ordinary household pearl bulb, and can be plugged into a lamp-holder and run directly off the mains in just the same way. There the similarity ends, because it is especially designed to give approx. 500 watts light output while consuming only 275 watts of electricity. Being over-run like this, it has a life of about 2 hours only; but since it is inexpensive, and many photographs can be taken during its working life, it is an excellent aid for all forms of indoor photography. Edison screw fittings are also available, with a more powerful bulb. These will not fit the household 'bayonet' lamp-holder unless a suitable adapter is obtained. The lamps are made for all standard mains voltages.

Photoflood bulbs are perfectly safe to use, for they incorporate a safety fuse. Three of them can be run off the household circuit together. They get extremely hot to the touch, and for this reason should never be fitted into fabric or parchment lamp-shades. Photographic lighting stands, adjustable in height and angle, and with metal reflectors, are a sound investment if you intend to do much indoor photography.

To light your subjects properly, a boomlight (or top light) is required, and if you are prepared to go to the extra expense, a proper spotlight (for those 'glamour' shots) is a refinement for which you will find many uses in other branches of photography, i.e. still-life, table-top, etc. A spotlight gives a sharply defined

controllable beam instead of the general spread of light produced by a photoflood lamp. You can make a diffuser by stretching a piece of muslin on a wire hoop or frame to clip an inch or two in front of a lamp (a spring clothes-peg will do) if you wish, or you can buy one ready-made. Its function is to soften and spread the light.

When using one photoflood lamp and daylight, regard the window as your main light, and the bulb as the 'fill-in' to relieve the shadows. Try moving the lamp while your sitter keeps in one position and study the change in modelling it produces. If you put it close, it will compete with the main light and flatten contrasts too much. Experiment with it towards the back of the sitter, from a point somewhat above the head. Note how the oblique back-lighting enhances the hair, then lower it slightly and watch it 'rim-light' the side of the head.

More can be learnt from an hour's manoeuvring with one or two lamps than be acquired from any textbook. There is nothing like *seeing* these things for yourself. Fix the diffuser on a lamp and see the difference it makes! Draw the curtains, or wait till night-fall and juggle with the lights all over again. It is the best way to learn what to expect when lamps are arranged in certain positions and at varying heights and distances.

Have a perfectly plain wall background whenever possible, and clear sufficient space all round your working area to allow freedom of movement for sitter, camera, lights – and yourself. You can't do good work in cramped quarters. The sitter needs to be some 3 to 4 ft. away from the background.

Artificial Light Only

Adding lamps just for the sake of it is not the way to tackle portraiture by artificial light. All you can be sure about is that it will shorten the exposure needed. There must be some basic plan, some logical scheme behind each arrangement.

Start with one lamp only. Make this the 'key' or main light, to give more or less the general effect aimed at – and you must have some idea of this before you commence. A safe set-up is somewhat higher than the sitter's head, for 45° lighting, diffused if you wish. Now you have to deal with the shadows. This is where your second lamp comes in. Adjust it, at a greater distance, similarly diffused if desired, to lighten those shadows *without eliminating them*.

Achieving perfectly balanced lighting is most difficult. The intensity of light varies with the square of the distance, so if you

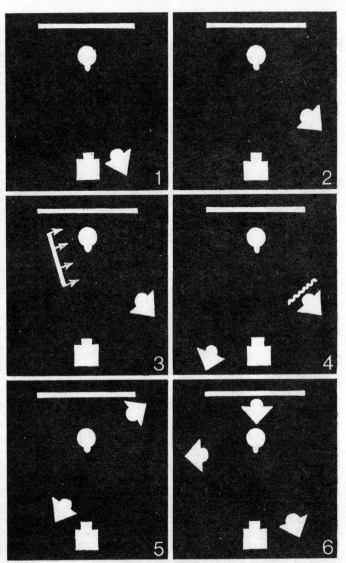

Fig. 12. 1. One lamp only close to camera gives flat lighting and lack of modelling. 2. Moving lamp to one side gives better modelling. 3. Adding reflector lightens heavy shadows. 4. With two lamps, one can be used with a diffuser, to provide modelling with soft-edge shadows; second lamp is placed near camera farther away, to act as fill-in. 5. Dramatic light is provided by putting one lamp close and three-quarter rear to give hard light across shoulder; second lamp placed frontal and slightly high. 6. One lamp provides strong modelling sidelight, another provides frontal fill-in. A third lamp placed behind the figure provides a bright spot on the background, and helps to 'separate' the sitter.

move a lamp from 3 to 6 ft. away, the amount of light falling on the subject is not *half* what it was, but only *one-quarter*. With two or more lamps, it is possible to use the slower panchromatic films, thus getting finer grain and a truer colour rendering.

Adding a third lamp gives scope for back-lighting effects from above the head; or, placed on the floor behind the model, it can give graduated lighting to the background. *Always* make sure that it does not shine into the lens. This may mean screening it in some way. The professional uses a 'barn door' on his spotlights for this purpose.

EXPOSURE GUIDE FOR 2 NO. 1 PHOTOFLOOD LAMPS IN REFLECTORS, USED IN SMALL ROOM, LIGHT WALLS; AND WITH 200–250 BS/ASA PANCHROMATIC FILM IN CAMERA

Aperture	Distance of Lamps from Subject		
	3 ft.	6 ft.	9 ft.
f/11	1/30	1/8	1/4
f/8	1/60	1/15	1/8
f/5·6	1/125	1/30	1/15
f/4	1/250	1/60	1/30
f/2·8	1/500	1/125	1/60

For one lamp only (in reflector), double the above exposure times.

Glamour Photographs

Except in specific cases, such as character studies, a portrait is expected to flatter the subject. If it doesn't, it may be a masterpiece of lighting, expression and pose to the photographer, but it will be a 'bad photograph' so far as the sitter is concerned.

The extent to which retouching should be carried depends on: (1) the size of the negative (with 35 mm. only the actual enlargement can be worked on); and (2) the subject – whether male or female, young or old. Portraits of children need no retouching other than routine spotting as a rule; it is only when faces start to collect wrinkles, crow's feet and blemishes that any extensive handwork becomes necessary.

For portraits of women, a diffusion disc is sometimes used. This

fits over the lens like a filter, and consists of optical glass on which are several raised concentric circular ribs. These produce slight refraction of the light passing through the lens and create a soft image surrounding the normal one on the negative, softly spreading the light into the shadow areas. An out-of-focus image is *not* the same thing – with that, nothing is sharp; whereas soft focus is actually two-images-in-one, i.e. a soft image overlying a sharp one.

But not only does the diffusion disc soften facial blemishes and lines, it also imparts a pleasant, sunny halo to the hair, contrasts are decreased, and a suggestion of mystery is conveyed. Let me hasten to add that diffusion is not the touchstone to successful glamour portraits. Indiscriminately used, it can be monotonous and irritating; it doesn't suit all subjects or all forms of lighting.

A shaded or spot-lighted background, toplight on the hair, backlighting, or (at the other extreme) flat frontal lighting – all have been used for glamour pictures. Make-up plays a big part in many instances. Max Factor 'Panstick' and powder or similar preparations will cover freckles and produce that smooth finish. Lips may need reshaping (preferably with a brush), rouge, lining and mascara finishing the process. Max Factor Erace will hide blotches and crow's feet, and add a highlight to cheek or chin.

Holiday Photography

Even people who normally have little interest in photography usually 'have a go' with a camera at holiday time. The trouble is that this seasonal spate of gay snapshotting often does not come up to the expectations of the snapshotter. All sorts of unexpected things happen. Surely that tiny speck on the skyline is not that big liner we photographed? What's this strange splash of light blotting out most of Dad in the deck-chair? Why is this one a blank?

Yes – we've all done it in the past, but surely that's no reason why we should continue to do it in the future? Those holiday shots can still be *pictures* instead of a surprising miscellany of frequently unrecognisable shapes and blurs.

Check everything before you set off. Make sure the camera is working properly. If it has been stored away for some time, see

that there is no dust inside it, look for signs of rust, sticking bellows and any other troubles.

Let a good repairman check it over if all is not well; don't tamper with it yourself.

If possible, expose a film in the camera as a final check. You will find that these precautionary measures are wise ones. Don't send the camera with your luggage in advance; it is far better to carry it with you. Similarly, look after it while you're away; protect it from sand particles. Never leave it lying around on the beach. A useful dodge, if you haven't an ever-ready case, is to pop it in to one of those transparent polythene bags which are sold for keeping food fresh. It will not protect it from accidental knocks, however, and a proper case is a good investment.

From the Beginning

Carrying the camera has other advantages, too. It is always ready for likely subjects *en route*. Unless you have made up your mind to take your usual sort of photographs, why not start at the railway station? Presumably you won't be alone, so get your companion(s) to go towards the open carriage door, either in or outside the compartment – not a stiffly posed 'this is me' attitude, but something in keeping with the occasion. Someone can be handing in luggage from several bags on the platform, or poking head-and-shoulders through the window, buying a newspaper, confectionery, etc., from a platform attendant. If such actions (and shutter speeds of 1/60 second will suffice if the moment is carefully chosen) can be caught unawares, without posing, so much the better.

Keep an eye on your fellow-travellers, particularly the youngsters. It's almost certain that one at least will want to go and gaze with awe at that huge engine. The idea is not new, but a tiny child taken from platform-level, looking with respectful wonder at the engine-driver provides wonderful opportunities for the alert cameraman. A low viewpoint will make the engine look even larger. Watch the general hustle and bustle. Your holiday has begun, so why not record the start? If you're unlucky enough to have a dull or wet day, lens apertures of $f/2.8$ may be necessary, even with the fastest film, which in any case is advisable. If you want unselfconscious expressions and natural attitudes, keep your camera out of sight until the last moment.

During the journey itself, a miniature with a fast lens may be able to take pictures in the compartment if you wish; larger cameras, with less depth of field and lenses of smaller apertures,

A high viewpoint has ensured that not only all the faces and figures, but the sweep of beach and the headland behind, all help to fill the frame. A happy holiday group taken on Plus-X film with a 2X yellow filter, 1/250 at f/8.

What's wrong with this? Did we need *quite* so much surround — in sea and sky. A closer approach, or enlarging the figures more to eliminate some of the surround, would have given far more emphasis to the figures. Panatomic-X film, 1/250 at f/8.

The figure adds the final compositional touch. Verichrome Pan film, 1/250 at f/5·6 with green filter.

Child occupies relatively small part of picture space — but this helps to show small 'scale' of subject.

A black and white print from a Kodachrome transparency. The subject looked glorious in colour. Some subjects appeal simply because of their line and form, and colour adds nothing to them.

A yellow filter darkened the sky and gave contrast to the lighter blooms. Note how cross-light from sun helps modelling. Plus-X film, 1/60 at f/8, 2× yellow filter.

are unsuitable. Because of the train movement you will need shutter speeds of 1/60 second or faster. Do not lean against the carriage door or window while operating; vibration will be transmitted to the camera.

Most effective shots are sometimes possible by waiting until the train is approaching a curve. A window shot from the inner edge of the curve can be made to include engine and front section of the train as well as the surrounding countryside. Focusing can be tricky if you want the engine sharp, and you must compromise between size of lens stop and relative shutter speed in order to get a fair depth of field; 1/250 second at $f/5·6$ will usually produce acceptable results with good lighting and fast film. Setting the focus for hyperfocal distance (see page 20) is the safest plan.

A word of warning: *don't* lean out of the window if there is another track alongside. If you *must* lean out – and it is still risky, do so on the 'blind' or embankment side.

Photographing the view on either side demands the fastest possible shutter speeds, even for objects at infinity, as the direction of motion is dead across the line of vision. Better results are likely from more oblique viewpoints, i.e. towards the direction of travel or opposite to it. There is no time for careful composition, and you will be lucky if your negative is really sharp.

On the Beach

It is always much lighter on the coast (and near large stretches of water) than it is inland. If you have a photo-electric meter you may be tempted to disbelieve the high readings it gives. On a sunny day it may indicate as little as 1/500 second at $f/11$, or 1/125 second at $f/8$ on a very dull one. Accept the readings it gives you!

With a fixed aperture camera be very careful; you may well find yourself consistently over-exposing with fast film, since the shutter cannot be speeded up from its normal functioning. Almost without exception, therefore, it will pay you to load up with the slower type of film (Panatomic X, Ilford Pan F, Agfa Isopan F, or similar); their finer grain will allow of bigger enlargements, too. Whatever your camera, the fastest films are not likely to be wanted on the seafront during the hours of daylight at least; keep them for evening and night-time exposures of illuminations, etc.

If you've tried to manage without a lens hood so far, you're going to need one now! Almost as much light is reflected from

sea and sand as comes from the sky itself, and it is because a stray beam or reflection strikes the lens that you get those mysterious flares of light which somehow managed to blot out that shot of Dad in the deck-chair. Use the lens hood on a dull day, too; it always helps.

By all means get your usual 'family on the beach' pictures – but this time with a difference. Don't have them lounging back and smiling straight into the lens. They're bound to be facing seawards, and that means screwed-up eyes and strained expressions, especially if they've only just removed their sun-glasses. If conditions permit (direction of sunshine, too), get them sideways-on to the sea, almost with their backs towards it, thus giving an ocean and sky background instead of sea walls and probably lots of other people also. Use a 2X or 3X yellow, yellow-green, or green filter to get tone into the blue sky.

Get them to do something natural! If they are sitting, have them eating or drinking, or reading (if the light is not too bright), or drying themselves briskly after a bathe. But one of the party should be kneeling or stooping; you must not have everyone in similar attitudes nor all heads level. Better still, get them playing games on the sand, beach-ball, leap-frog, building sand-castles for the children.

Best of all, keep your camera handy and catch them unawares. There is plenty of light for fast shutter speeds, and their actions will be natural. Often a breakwater will make an excellent 'prop'. Your subjects can lean back against it, or stand or sit on top for an easy all-sky background from a low camera viewpoint. The same low viewpoint can capture children's heads enquiringly peering over the top of the breakwater, or a very wet dog eager for the ball. With side-lighting, preferably not too high in the sky, all these make interesting picture material.

Look Around You

Don't concentrate on your own family all the time. There are endless opportunities for pictures. Watch the children, particularly the toddlers; they'll be so engrossed in their activities that the chances are they won't notice you or your camera. Get as close as you can, open your lens aperture to $f/4\cdot5$ or more in order to throw the background out of focus, with correspondingly fast shutter speed. Focus accurately on your selected child or group. If the light is very bright, a filter may be needed if your fastest shutter speed is 1/500. Low viewpoints are usually best.

Ice-cream cornets, animals, toys never fail to capture a child's

interest; the rest is up to you. If it doesn't happen – make it! Go find a crab and introduce it to your young model. Proud parents will be only too pleased to receive a picture from you later on, and if they themselves have a camera, they're not likely to object anyway. The tiny tots, in uncertain-fitting swimsuits, toddling towards the sea, make good studies from the rear; it isn't always easy to keep others out of the picture, though.

This candid snapshotting is much easier with a long-focus lens. You can work at greater distances and are less likely to be observed. Don't stick slavishly to conventional subjects or conventional viewpoints. The pier will often give you a high vantage-point for studies of people on the beach immediately below; this can be very effective in early morning or late evening, when the shadows are long and interesting. In fact, your pictures will always benefit from such lighting conditions; it cannot be stressed too much that overhead lighting is unsuitable.

There are always other attractions at seaside resorts, all worth investigating from the photographer's point of view. Never neglect the Punch and Judy show. The young audience is perennially gripped by the exploits of these puppets, and they show their emotions so clearly. A sunless day is generally best – there is less squinting and shading of eyes and lighting contrasts are more manageable.

If a youngster lifts the enclosing canvas to peer underneath, be quick with that camera. If it doesn't occur to him to do so, a quiet suggestion may do the trick. Remember that the *back view* of a child or person can sometimes be more expressive than a frontal one. Always be on the look-out for against-the-light (back-lighting) pictures; the most mundane objects are transformed to things of beauty in this manner.

The side-shows, automatic machines, beach donkeys, should not be overlooked, either. And there are always bathing belles. Harsh, bright lighting is best avoided for them too, and if you pose them on the rocks, don't take all day about it – it isn't fair to expect endless happy smiles when sharp stone is making its presence felt. An upraised beach ball, a wave of greeting against the skyline of sand dunes are time-tested poses. You must still consider your models as you would for portraiture, and take care to pick an angle which will make the most of her good points and subdue physical shortcomings, if any.

Low viewpoints add height to a person, but if taken too near, may produce heavy modelling of lower limbs. A wide-angle lens so used will give distortion approaching the grotesque if a close viewpoint is used.

If you wade into the sea to get pictures, or have the camera with you on a boat trip, beware of spray! Except when actually using the camera, keep it in its ever-ready case, and with a lens cap in place as an extra precaution. Sea water can be disastrous for photographic equipment. Never let any dry on if you do get it splashed; wipe the lens gently with the corner of a soft hand-kerchief or lens tissue dipped in fresh water, then dry.

Other Subjects

Seascapes, coastline studies and scenery in general can make fine pictures if you are patient and watchful – disappointing if you are not. Avoid the half-way horizon, which invariably divides your picture in two. Whether you keep the skyline about a third from the bottom of your picture or a third from the top margin depends largely upon circumstances. If the sky portion is more interesting, then let it take up the bigger area. If sea and fore-ground are the attraction, include less of the sky. It's got to be one or the other, and if you just can't make up your mind about it, then do the obvious thing and make two exposures. This may not be good photography, but you can sort it out when it comes to printing, and at least you won't be thinking about 'the one that got away'.

Cliffs and rugged coasts are difficult to deal with. Unless you are in a boat or a small, sharply curving bay, the result is often a one-sided picture with nothing to balance the land masses. Shadow contrast is also a problem in many cases because of the bright lighting conditions. A square-on viewpoint with cliffs running right across from side to side in regular depth is seldom satisfactory.

A calm sea is never so pictorially interesting as one that is wind-lashed. Waves dashing against the rocks make wonderful studies and difficult subjects, with great risk of wet equipment if you're to do the job properly. A carefully chosen corner, with rocky edge and foreground, will make a better study than that vast coastline of rollers. Several foam-topped waves, with one dashing into spray on a rock previously sighted in a good position in the viewfinder and a stormy sky background, are the ingredients of many successful photographs. Luck plays its part. You may hit on a good viewpoint only to find that small waves have taken over and that you've just missed a beauty on the rock you'd pre-viously focused on!

It's all in the game, and adds to the thrill and satisfaction of success when it comes. A companion can be of great assistance

by warning you of the approach of a big wave, giving you a running commentary, as it were, of impending possibilities, while you concentrate on the camera ready to fire. This may sound a childishly crude technique, but you'll find it thoroughly practical and reliable. Early morning or evening light is best.

Low viewpoints increase the apparent height of the wave; back-lighting will give sparkle and light. Shutter speeds may vary between 1/125 second and 1/250 second. Faster than this (unless you're *very* close) will tend to 'freeze' the movement too much. To record any blue in the sky you'll need a filter; don't use one in back-light conditions. Waves breaking over promenades, etc., are in the same category; both demand respect and care if you don't want your camera drenched. Very often the lighthouse is sufficiently approachable to make another interesting subject. As these are invariably light in colour, a good blue sky (yellow filter) is essential.

Water, Reflections

Don't overlook the unending possibilities of still, calm water, of the little pools and rivulets left by the outgoing tide. They are always effective against-the-light studies, with or without a small child. Children who are scared of the sea and waves will play and paddle quite happily in these sea puddles, and you can safely leave them to their own devices and concentrate on the camera.

Close-ups of the seaweed, shells, old anchors and so forth are usually worth investigating, as also are the time-worn stumps and timbers that once were breakwaters. You are likely to be disappointed with any attempts at photographing objects *under* water. Even if you succeed in getting a clear, sharp result, you'll find that you'll always have to explain that it is a picture of something under water, chiefly because the camera has usually to be almost directly overhead.

Don't be fooled by colourful objects. Analyse their shapes, textures and relative dispositions in the prevailing light and setting before you make any exposures with monochrome films; it is so easy to be deceived. Study the patterned ripple shapes moulded in the glistening sand, the imprint of feet. Get into the habit of assessing the pictorial possibilities of even the most commonplace things; low-angle lighting, long shadows, sparkling settings, unusual angles – there's literally no limit.

Reflections of newly painted boats are always attractive. If the water is completely calm, the surface should be disturbed by

throwing a pebble into it. The ripples will break the mirror-like repetition and will also help to suggest water better. *Where* you throw it is important; it must never be in the centre of the intended composition or too near the foreground. In fact, it is a good plan to get a companion to throw in one or two pebbles at different places, while you study the effect in your viewfinder. This will also reveal if the exposure has to be made immediately after the ripples commence, or later when they have reached certain limits.

Ships and Boats

Always try to get reasonably close viewpoints. A big ship will appear small and unimportant otherwise; and a small vessel, if at all distant, may well be insignificant and unrecognisable. The lens is not so accommodating as the human eye in the matter of distance and relationship.

Three-quarters-on or frontal view is preferable to photographing squarely from the side. If you go aboard, subjects will abound. You may be tempted to use a wide-angle lens, but this will give you exaggerated foregrounds and rapidly dwindling perspective.

Smaller craft are easier to depict in their entirety. Several may be included in one picture provided balance is maintained and each does not vie with the other for predominance. End-on viewpoints may not be satisfactory unless the lighting is effective or the scene has unusual features. Sailing vessels are better subjects when they are heeling over, thus indicating movement, than when they are perfectly upright. Tilting the camera to attain this will only result in making the sea go up-hill. The picture will look unnatural and will fool nobody. Speed-boats at rest are no longer speed-boats. They need to be caught tearing their way through the sea, and from a fairly close viewpoint. Minimum shutter speed for this is around 1/250 second, panning (swinging) the camera with the subject.

Fishing boats offer plenty of likely subjects, including the popular one of the nets being mended. Patterns and shadow-patterns from hanging nets are always interesting, often serving to make a logical foreground.

The catch is always worth photographing, and also things like lobster-pots and coils of rope. Keep an eye on the fishermen themselves. There is character in their weather-beaten faces. Don't forget, too, the anglers on the pier, and the small boys watching them with envy.

Seagulls

It isn't essential to have a long-focus lens for photographing gulls, either singly or *en masse*, but it certainly is a great help. Although many of them become quite tame, swooping down and taking food from visitors' outstretched hands, it requires nice timing and a fast shutter to capture that moment; 1/250–1/1000 second is advised. You may get the action perfectly, yet not secure a real picture. It will no doubt be *interesting*, but unless the bird's outstretched wings, the angle of the hand, and the lighting all combine harmoniously, you're not likely to want to frame the result! It is, however, an excellent test of co-ordination of eye and shutter-finger, so try your skill!

Against a blue sky use an orange filter if you have one, or else a 3X yellow or 3X green; this shows up the gulls' wings better than a paler filter would. Set the lens aperture at $f/8$–$f/11$ and the focus at 25 ft., and objects from about 12 ft. onwards will be sharp. Now you can lie in wait for the gulls continuously cruising and gliding overhead in their quest for food. A shutter speed as slow as 1/125 second can sometimes be used when they're gliding; wing movements require 1/500 second or faster.

For gulls close at hand on the water or land, a filter is not needed unless any sky is included. Stalk them patiently, focus accurately (no sudden movements, which may startle the bird) and having due regard to lighting and background, get as close as you can. If you can successfully isolate one or perhaps two from their fellows, so much the better.

Later in the Day

Towards evening, and at night, your daytime subjects take on a different guise. A boat, lighthouse, rocky promontory, etc., silhouetted against the setting sun can be most attractive, provided that you avoid central placing. And when the lights come on, your camera can still be active (see Chapter Thirteen, Pictures at Night).

The Country Holiday

Those who favour a country holiday will have as much, if not more, to photograph. The countryside is ever-changing, and subjects for the camera are limitless. Much of the subject-matter is dealt with in Chapter Nine, Pictorial Photography (trees, villages, landscapes, etc.).

The quiet lanes and fields inspire a leisurely approach to

picture-making, and this is a good thing. Much can be learnt about lighting, viewpoint and composition, the effect of each upon the other. Few farmers have any objection to people entering their fields provided no gates are left open, allowing cattle to stray, and no damage such as walking across a field of crops, is done.

Seasonal activities, such as ploughing, harvesting, threshing, are always worth photographing. A fairly near viewpoint is often best. A close-up of corn against a sky background can be most effective. The country market will give you countless subjects, both human and animal. Local industry is another source of pictures worth investigating; it may be horticulture, pottery, basket-making, weaving, all adding to the enjoyment of your holiday and range of pictures. Should any of the local characters pose for you, don't forget to send them a print.

Thatched and whitewashed cottages in suitable settings are always attractive subjects. Try to take them at a time when the angle of the sun is just glancing on the sides, giving long shadows and picking out the rough texture of the walls. Inclusion of a suitable figure may be advisable to add life and human interest to the dwelling. Look out for those telegraph poles, wires, cables and aerials!

The church will doubtless figure in many of your pictures. Avoid getting too close and tilting to include the spire or tower. If the church lies in a valley, try a high viewpoint which shows it with the surrounding cottages nestling all round. Don't get too far away, though, or you'll lose the fine detail. If it's on a hill, then make the most of this if you can do so without having a long stretch of uninteresting foreground. Look for any unusual features it may have, both inside and out, not forgetting things like lych-gates, gargoyles and ancient carvings.

There are more pictures to be had of the village green and its duck pond, old inns and their signs, and perhaps the oldest inhabitant himself.

<div align="center">CHAPTER NINE</div>

Pictorial Photography

Because lighting can make or mar a portrait, weather conditions, which control lighting, are all-important in outdoor pictorial photography. Such conditions being entirely beyond our control,

great patience is necessary. The photographer must be prepared to suffer setbacks and disappointments. Not a very encouraging start for the would-be pictorialist, perhaps, but it is better to know and recognise the snags than to discover them the hard way!

Practically without exception, it is wiser not to take photographs during the months of June, July, and August, between the hours of 11 a.m. and 3 p.m. This is because the sun is then so much overhead that it casts short shadows which largely destroy roundness and modelling.

The exceptions are:

(1) When you want to photograph in the shade
(2) on a sunless day; or
(3) when it is raining.

Landscapes

Light makes the picture and determines its mood and atmosphere. Your subject may be full of material attractions and interesting shapes, yet if the lighting is of the wrong kind or at the wrong angle, your picture will never look as you hoped it would. Particularly is this so with landscapes.

Strangely enough, that exciting panorama which you see from a hill-top, that open view you so admire, is the most difficult of all landscape photography. There is so much to it, so many points of interest to draw the eye. You must have sunshine for such a subject, but not a completely cloudless sky unless the sun is very low.

Two additional lenses make the 35 mm. user a complete pictorialist – the 3·5 cm. wide-angle, and one of moderately long focal length between 8·5 cm. and 13·5 cm. The former allows you to get in close, filling the foreground with a tree, the village pump, or some other interesting object, which will set the scene, as it were, for the scene behind it. The latter lens allows you to select a part of the more distant view, which is often more effective than the whole.

This is one of the bugbears – too many little puffy clouds or too many forceful banks of cumulus tend to become rival attractions instead of harmonizing with the scene. The ideal is moderate cloud, showing a sun patch in an interesting part of the composition. If you include a distant church spire, hill, river bend, farm-house, etc., spotlighted in an undulating setting or wooded background, you have good pictorial material.

Under certain favourable conditions, usually showery weather, the slanting sunbeams themselves, breaking through a dark cloud,

make a fine study. Avoid over-exposure here or you'll lose the delicate tones. An orange filter can help to lessen the effect of the haze and also increase contrasts.

If you wish to take a panoramic view, a tripod and a panoramic head are essential. It must be set up so that the camera is *absolutely level*, otherwise the horizons will not join up. By rotating the camera on this head and taking several pictures, each slightly overlapping the other, up to a full 360° panorama can be covered. The marginal overlap is cut off the prints, which can then be joined together to form one long scene.

Sunshine from *behind* the camera is not suitable for the landscape as such, but frequently it will be ideal for cloudscapes with a narrow strip of horizon showing at the base of the print. Use a fairly deep filter (3X green or yellow, or even the 4–6X orange) and preferably an upright format.

Selecting

We have seen that the part is often better than the whole, so unless you deliberately set out to produce a panorama, examine that open view most carefully before you decide. What lies before you is largely patterning. You *must* find a main point of interest. A field of mustard or grain in stooks will often present good tonal contrast to neighbouring pastureland or tilled earth. Woodland copse, or more simply, a not too-distant tree might also make a natural focal-point for the eye.

Remember not to get that horizon half-way up your viewfinder, and now study the foreground. You do not want a vast expanse of more or less even tone, neither do you want the parallel lines of a hedge, pathway, fence or river running right across it. Try to find some feature, or even a shadow patch, to balance the distant scene. If there is none, then either include more sky, or get closer to your chosen area, in doing which you may, of course, lower your viewpoint anyway.

Unless you have some foreground object, the feeling of distance will be lost. Sometimes it is a good plan to have a companion standing in an appropriate position, looking out towards the scene – never at the camera This also helps to give scale and size comparison to hill-sides, boulders, trees, etc. Paradoxically, the positioning and attitude of the person needs careful planning so as not to look planned or posed.

There is always argument as to whether a figure should be included in a purely pictorial landscape or not. Some people hold that the human element tends to steal too much attention to it-

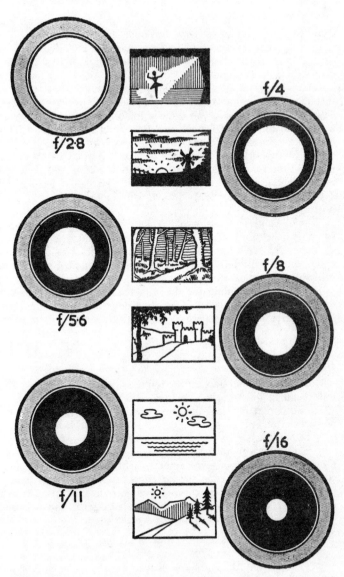

Fig. 13. Different apertures are suitable for different subjects. In bright light, such as over the sea or in distant open landscapes, very small apertures are sufficient. In the woods, where shadows abound, larger apertures are required. For theatrical work, or hand-held night pictures, very large apertures will be needed. If you never intend to work in very dim light, there is little point in buying a very wide aperture, expensive lens.

self, while others contend that the scene looks more natural, less deserted. Both points of view obviously have some truth. The important thing, however, is that if a person *is* included, then he or she must be in character with the setting. Country clothing goes with country scenes.

If there isn't a good sky, see if you can sight your view through a 'frame' of leaves and branches of a foreground tree. This will serve to cover up quite a lot of sky and also provide a step into the picture for the eye. Beware of having a few bitty leaf sprays cutting into the top and sides without any visible means of support. Try to include at least a portion of the trunk if it isn't too massive. A 2X green or yellow filter is deep enough in these circumstances, or don't use a filter at all if hardly any sky shows through the leafy frame, which must be in focus and not fuzzy.

Frontal lighting is unsuitable because strong tones are needed for this foreground frame; side-lighting is much better. The shutter speed for a hand-held camera should not be slower than 1/60 second – preferably 1/125 second to minimize shake and probable leaf movement by breezes.

Take a meter reading for the distant scene, then give half a stop more exposure to avoid empty black shadows in the tree. Don't increase it too much or you'll lose contrast in the main view.

Getting Closer

Now let's see what happens with more intimate landscapes: the little bend in the lane, the stream, waterfall and woodland.

Provided that physical features such as fences and hedges do not prevent it, it is easier to experiment with your viewpoint, getting round the subject and approaching closer. Analyse it all very carefully with the camera viewfinder and decide not only distance and angle but also camera height. If you can't get close enough to your subject, a similar effect can be produced by enlarging only the centre portion of your negative, or using a lens of longer focal length. For this to be successful, the negative must be needle-sharp, which in turn depends upon:

(a) no camera-shake at the time of taking;
(b) a lens capable of first-class definition;
(c) fine-grain film and developer.

Eye-level is not necessarily always the most effective. An uninteresting foreground can be reduced in length by a low view-

point, and perhaps slightly tilting the camera upwards. Nearby objects appear to gain in height and relative importance by this treatment.

Don't tilt too much if you're near a building or it will appear to be falling backwards in your photograph. This problem always arises with church towers and spires. Even if you are able to fit a wide-angle lens, a slight tilt often seems unavoidable. Should you, then, want that spire, get closer and give a decidedly pronounced tilt, with the spire placed somewhat diagonally.

The result is more acceptable in such cases, giving an illusion of height. Never tilt against a bald sky, so remember to use a filter. Unless you want merely a silhouette against a dramatic sky or sunset, don't attempt it against the light (back-lighting).

A stream or river is seldom interesting if it has a straight, unbroken course. Its setting must also be attractive. Try to photograph *along* rather than *across* the stream. Always choose a low viewpoint for waterfalls, so giving them height, and get sparkle in the water if you can.

A shutter speed that is too fast may 'freeze' the water and tend to kill the suggestion of movement. But if you use a shutter speed of 1/125 second or 1/60 second you will get slight blurring which better suggests it. Slower than this will defeat its own purpose by smoothing out the water to an unpleasant blur.

Often the waterfall picture turns out to be a dismal failure as a picture. This is not really surprising when you come to analyse the facts: much of the appeal of the original lies in its leafy, rocky setting, which in sunshine presents countless areas of fussy detail, spotty highlights and rugged, empty shadow shapes. Without the sun, it all appears dull and dead and the gay ripples just moving water. It is because we are attracted by the colour, the sound and the movement that most of us feel impelled to photograph a waterfall; it seems that that glancing sparkle cannot fail to make a picture – but it can!

Beware of reflections on placid lakes! Their mirror-like qualities may greatly appeal at the time, but too often they produce two pictures in one, with the reflections competing with the setting, providing a classic example of divided interest.

Trees and Woodland

A single tree, perhaps balanced by a more distant group, can make a splendid picture against a suitably filtered sky, but if this same tree has others behind it, you are likely to get a tangled background. In such cases the problem, therefore, is to isolate

the tree. Sometimes hedges, fences, etc., make this impossible. When this happens, it is better not to try to make the best of it but to look for another viewpoint.

An interesting shape and good lighting are the other main essentials. Remember, a tree is fundamentally a round object, and its rotundity can only be successfully portrayed if there is sunshine to give modelling. But sunshine does more than this. Falling at an angle, it picks out and reveals the texture in a satisfying manner. Overhead, dead frontal or back-lighting can never do this, but in the case of woodland pictures, back-lighting and oblique back-lighting can produce the loveliest effects which are often far preferable. After all, who wants to see every little leaf, every little twig shown in biting realism?

The *kind* of tree will largely determine its shape. For instance, Lombardy poplars and lofty pines create a feeling of dignity, whereas oak and elm make for solidarity and ruggedness, silver birch and willow for daintiness, and so on. As a rule, it is best not to include too many *kinds* of tree in one composition, if only because of the varied shapes they display.

Too close an approach may not only cause the top to be cut off in the picture, it will present a focusing problem with those lower limbs which thrust out directly towards the lens. Unless these foremost branches are rendered sharply, as well as the main trunk, the result is sometimes irritating.

Oddly enough, the densest wood does not provide the best woodland pictures. This is because the single 'eye' of the camera cannot see round the individual trunks and sense a pathway through – the whole appears to be an impenetrable thicket, a tangled mass. Thus it is better to photograph in the outer edges and clearings where branches and foliage are more sparse. Don't load your camera with a slow film because it has to cope with very strong contrasts of light and shade, and slow film itself has contrasty tendencies. Kodak Tri-X or Ilford HP4 films are very suitable; develop in a fine-grain developer if you wish to make fairly big enlargements.

Watch out for the shafts of sunlight which cut through the wood, to pick out and spotlight some particular specimen, for very often these produce an appealing picture. Don't take the scene just as you first see it. It may well be that from another viewpoint it will be far more pleasing, and in a short time those beams will have moved on to another tree, perhaps of a more attractive shape. There is no need to use a filter on the lens; if anything, be generous with the exposure and so avoid dark shadows devoid of detail. If you use a tripod, and the exposure

is anything slower than 1/60 second, you'll have to pick the moment when there is no leaf movement caused by wind.

Beech, chestnut, lime – in fact, almost any tree with fairly large leaves – will make attractive close-up and semi-close-up studies. The interlacing patterns of the leaves against a blue sky, or against the light with a shadowed background and the sun shining through each leaf, produces a delightful effect. Spring or autumn is the time for this. Choose your spray carefully, so that the leading-lines formed by the branches and twigs fit into the picture shape in harmonious arrangement.

All-over sharpness is essential with these pattern-pictures, so a small aperture is required. Use a filter to hold back the blue of the sky, but work without one for back-lighting conditions. Exposure for the latter is best determined by holding the meter only an inch or two away from the leaves. If you do this from the front, i.e. the sunny side, you must give 2–3 times the exposure it indicates to allow for the loss of light through the leaves; should these be large enough, or close together, then the reading can be made from the back, i.e. the taking side, no increase being necessary.

Note carefully how the gaps in the leaf groups are spread in your composition; these are the lightest parts of the picture and as such will invariably attract the eye. Too many may therefore be irritating, particularly if small and bitty; for this reason small-leafed trees are unsuitable for pattern-pictures.

Skies and Sunsets

Always be on the look-out for sky effects. At certain times of the year, particularly after stormy or showery weather, cloud formations can be strikingly beautiful. Don't be misled by colour – we are dealing now with monochrome photography, and its shapes, masses and their disposition which count. Strong winds will feather and break up banks, or trail long strands across the sky. If no likely-looking subject is at hand to go with a notable sky, try to get near some water – a pond will do. By taking an exposure reading for the sky alone and working to that you will very much under-expose the foreground, giving a psuedo evening effect, with the otherwise dark foreground broken by reflected light in the water.

You may be able to include a church spire, or suitable tree, perhaps the upturned shafts of an old farm-cart (from a low, close viewpoint) or even a towering pylon. Almost anything, in fact, can, with a little skill and imagination, be turned to good

account in such conditions. The secret is not to have *too* much unrelieved hard black silhouette dominating the picture. On occasions, a human figure or figures in the foreground will serve, but animals are seldom suitable.

If you prefer to keep some detail in the ground masses, then take your exposure reading for this, and put a 2X or 3X filter on your lens, but do *not* increase the basic exposure to allow for it. You then get a fine, bold rendition of the sky, with your ground scene somewhat under-exposed.

A sunset is much the same proposition, requiring similar treatment and setting. It is better to wait until the sun is partly obscured by cloud – if you try pointing your camera straight into those rays you're asking for trouble. You'll get flare on the negative, even if you have a coated lens. Don't forget that lens hood, either!

With lenses of modest aperture it may be necessary to use a tripod or some nearby support such as a fence or wall. If you can't actually rest the camera conveniently on top, try pressing it firmly against it while you expose.

Simply photographing a sky or sunset by itself, no matter how lovely, is not likely to produce a very satisfying picture. Somehow it never looks really *right* without some association with the earth (or water) beneath it. Exceptions, of course, are birds or planes in flight, but here the sky is not devoid of contrasting subject-matter.

Some photographers make a point of collecting negatives of good skies which they combine with other negatives of scenes which need such a sky, by careful double-printing during enlargement. Considerable experience and skill are needed for this, however, if the result is to look natural.

Towns, Villages, Buildings

Lighting and viewpoint are the key to successful pictorial studies of these. A classical example, which most readers must have seen, is the 'across the roof-tops' study, where nothing but gaunt, angular chimney-stacks and cowls jostle with each other against a bleak sky. It isn't just merely the *material* which makes the picture. Whoever would have thought an ugly, bent cowl could qualify for inclusion? Repetition, distribution, arrangement, lighting – all play their part. By all means, therefore, photograph the beauty spots, the quaint and the picturesque, but don't overlook the less obvious subjects.

Old masonry, timber and cobbled streets are best portrayed when sunlight strikes them at an acute angle, picking out every

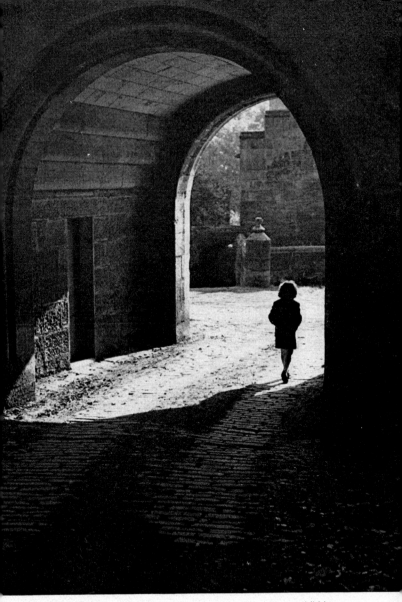

Careful balancing of light and dark tones makes this strong, exhibition-type picture. Exposure should be for the highlight areas through arch.

A picture which depends on the strong diagonal pattern of the nets, the placing of the fisherman and the bollard, and the hazy perspective of the distant mountains. Taken on a 6×6 cm camera, using Ilford FP4 film and a deep yellow filter. 1/125 at *f*/11.

Should you expose for the brilliant white façade, or the shadow areas? Certainly not for the white façade, in which there is no detail anyway. Take one reading of façade, another of shaded walk beneath the arches, and set exposure midway between the two.

Such idyllic country scenes are photographic treasures, and deserve careful composition and exposure. This was taken on Plus-X film and even at big enlargement every tiny detail is recorded. The picture owes as much to modelling afforded by cross-light from the sun as to choice of viewpoint.

The Cruise-ship *Oronsay* berthed at Venice, is given greater interest by the careful placing below the ornamental bridge. Pressmen call this 'establishing location'. A wideangle lens on a Leica, with Plus-X film and a 2X yellow filter did the trick. 1/250 at *f*/6·3.

little undulation in bold relief, and emphasising surface texture. Doorways, arches, etc., often look well in back-lighting or near back-lighting, but usually need a figure to give scale and life to the scene. We are among habitations now, remember, and we don't want the place to look like a deserted village.

If often pays to wait a while, keeping an eye on passers-by, until someone walks naturally into the spot where you want a figure, or stands and chats to a neighbour. The more unobtrusive you make your equipment, the more likely you are to get a natural result. Children, in particular, readily spot a camera, and it is difficult to stop them staring straight at it.

Watch the shadows. Where they fall, their size and shape, can greatly influence the scene. Sometimes they are more interesting than the object or building which casts them. Early morning and late afternoon are the times for long shadows. If your camera has interchangeable lenses, you will find a wide-angle lens a great boon in restricted localities.

Look back from time to time as you walk along – very often the best subjects are not those you are approaching, but the ones you've passed.

Unless your camera takes square pictures, it is sometimes difficult to decide whether the scene fits an upright or horizontal shape best, and how much should be left out. If you are doubtful – and the subject merits it – make two exposures, one upright and one horizontal; perhaps even a third from a nearer or more distant viewpoint.

Don't get into the habit of doing this as a matter of course (it is all too easy with the 35 mm. camera) as the practice dulls the ability to 'see' a picture and encourages indecision. You are not likely to need a filter unless the sky is included. *Never* forget the lens hood.

If the lighting is not right for some particular scene, put your camera back in its case; estimate the time of day which should be more suitable, and try again later.

Just to Remind You

Whenever convenient, carry a tripod – the sturdier the better. I have always carried a solid tripod in the back of the car. It is needed seldom, but when the occasion arises I am certainly glad it is there.

Don't be afraid of trying unconventional viewpoints.

Forget colour – concentrate on tones, masses, shapes and *arrangement*.

The closer you get to your subject, the more accurately you must aim your camera and study the effect in the viewfinder or screen.

Avoid frontal and overhead lighting.

Don't imagine that exhibition pictures are secured only by the man with expensive, flashy equipment. Brilliant results are obtainable with quite modest apparatus, as long as one works within its tolerances.

CHAPTER TEN

General Subjects

The perfect camera does not exist. Certain subjects are best dealt with by certain types of camera, but most cameras are well able to make a fair job of quite a wide range, provided their limitations and shortcomings are recognised. You know *your* camera, and no doubt have a pretty good idea of its scope, but it is not a bad thing to see how it behaves with unusual or unfamiliar subjects now and again. Sometimes it may not succeed, and you must ask yourself whether you are at fault or the camera. In any event – success or failure – you will have learnt something and prevented your photography from getting in a rut; furthermore, there's every chance that you will be surprised at what your camera *can* do.

Only one stipulation must be made: the lens must be capable of fair definition. Definition is not to be confused with its light-passing capabilities, or the fact that the lens is a 'fast' one of large aperture. If definition breaks down before any reasonable degree of enlargement is reached, you must content yourself with well-lit, simple subjects and only a moderate degree of enlargement.

Architecture

This is a subject in which sharpness and detail are absolutely essential. It is *not* recommended for inexpensive equipment. A firm, steady tripod, lens hood and flexible cable release are indispensable. The best type of camera for this work is one with a ground-glass focusing screen, the facility for taking lenses of different focal lengths, and a rising front and swing movement.

These refinements allow tall buildings to be photographed without converging verticals, and facilitate working in confined spaces where distortion could arise.

Miniatures with wide-angle lenses offer fair scope. The important thing is to resist the temptation to tilt the camera unless seeking what we might call an 'archipictorial' effect. A small spirit-level is a great help here. If at any time a slight tilt is necessary to include some important detail, it can be compensated for during enlarging by tilting the masking board until the converging lines become parallel once more, then stopping the enlarging lens well down.

Generally, it is advisable to stop the camera lens well down to get maximum depth of field and marginal sharpness.

Don't take buildings from square-on viewpoints, or in dull flat lighting. Sunshine at 60°–30° to the line of vision is excellent; frontal lighting kills texture and modelling; extreme side-lighting may exaggerate detail by over-long shadows from relatively small prominences. Back-lighting (contre-jour) is out of the question.

Exposure should be such that detail is visible in all but the deepest shadows. If you 'expose for the shadows', it is likely that texture rendering will become blocked up in the lightest parts and that additional exposure will be needed during enlarging. A 2X or 3X yellow or green filter will record clouds in the sky background, while for dramatic contrasts for white and light-toned buildings, an orange filter is very effective. Try a few angle-shots of the taller structures by deliberately tilting so that they fall diagonally in your picture area. Remember that many buildings are darker in tone after rain.

Interiors

Exposures for interiors may vary from 1 second to 1 minute or more, with lens stops of $f/11$–$f/16$. Anyone who happens to walk across the line of vision during long exposures will not be recorded on the film.

In photographing cathedrals and churches (sometimes it is necessary to obtain permission for photographing inside), avoid central placing of the aisle, doorways and columns; choose bright days.

Why not photograph the rooms in your home? Carefully taken, they have a strong appeal, and make an excellent series for your album. I have taken such a series for several of my friends, binding the whole into book form. For the covers I used a shot of the house from the garden gate, and inside we proceed logically by

way of the hall, lounge, living-room, etc., until every room is included. Next comes the garden, and finally, forming the back cover, a picture of the back of the house. In postcard size and larger, such albums are highly prized by the owner of the house.

Try not to move any of the furniture – and don't add to it – you need the room to look as natural and homely as possible. Show more of the floor than of the ceiling, and avoid furniture appearing in the immediate foreground or it will look far too large in relation to the rest of the room. Corner viewpoints are often best, and at least two different pictures should be made of each room.

Drawing a curtain, switching on a light, may help to even-up the lighting, and an open door might add to the interest. Watch out for reflections from pictures and mirrors. Tilting them slightly by pushing a wad of paper behind them, will often eliminate the trouble. Direct sunshine will produce unmanageable contrasts; this problem also arises in rooms with only one window, the corners then being too much in the shadow. A white cloth reflector will sometimes help, but it needs to be double-bed sheet size. A strategically placed photoflood lamp, well out of the picture and directed on the ceiling, will do the job better. On bright days, do not include windows; the source of light should come from the side or behind the camera, not in front of it.

Gardens and Flowers

Only white and light-coloured flowers will make attractive garden pictures when photographed in black-and-white. Those of darker colouring or rich bright hues become a tone of grey which in many instances is indistinguishable from the surrounding foliage. To do justice to such subjects, colour film is needed.

In monochrome, panchromatic film of medium speed should be used, and lighting, viewpoint and setting all carefully chosen. Hazy sunlight is ideal, preferably from the side, or oblique backlighting. Sunless days and harsh or overhead lighting are best avoided. A reflector can be useful.

Massed blooms photograph better than straggling clumps or narrow borders. The problem is to isolate the selected portion so as to show it off to advantage. Things like trellis-work, canes, ornaments or even other flowers appearing in the background can spoil the result. Sometimes, unwanted plants can be tied back out of sight, or a lower viewpoint might abscure them. Don't try to show *all* the garden in one picture.

A light yellow filter (or a deeper one if the sky is included) may often be used with advantage. Shutter speeds should not be slower than 1/25 second in case of movement by wind; 1/125 second is usually needed. Corner viewpoints are often best; never photograph a border square-on; get to one side and have it running diagonally across the picture.

There must be foreground interest, and foreground clusters must *always* be sharply in focus. Unless you want a pattern picture, do not photograph from directly above; keep the camera more at their level. The inclusion of a sundial, fountain or garden ornament can be effective if it is not rendered too small in relation to the rest of the scene. Tall flowers such as hollyhocks, and tree blossom look well against a blue sky; use a 3X yellow or even an orange filter for this sort of subject. Photographing from a bedroom window will give you a *plan*, not a *picture*, of your garden.

Close-ups

A supplementary lens or extension tube is needed for close-ups of small groups and individual blooms. Since this decreases the depth of field, the lens has to be well stopped down; then comes the problem of movement caused by the breeze during the longer exposure it necessitates. A plain piece of card, darker or lighter than the flowers to be photographed, can be positioned behind them by means of canes, and curved in such a manner as to serve the double purpose of background and wind-shield. Serious workers sometimes use a sheet of stout clear celluloid, which will shield the plant without shading it.

Low viewpoints are best, and the exposure made during a lull in the breeze. Focusing must be accurate, flat lighting avoided, as shadows are needed to create form and texture. A few large blooms look better than a lot of small ones. Make sure that all dead flowers, unwanted sprays, etc., are first removed. Butterflies or bees can be photographed, if the lighting allows of 1/60 second exposure, without opening up the lens aperture beyond, say, $f/8$. Alternatively, the fastest film can be used. Open flowers of the daisy species are most suitable as a base for the bee – and your picture.

Extension tubes can be fitted to cameras with interchangeable lenses, extending the lens so that it is possible to photograph an object from a matter of inches away, thus producing a large image on the negative. Some of the professional bellows type cameras allow the lens to be pulled forward to double or triple

extension for the same purpose. An exposure increase is necessary, dependent upon the amount of extension.

Indoors, the flower vase will need harmonious, *plain* backgrounds, not fancy wallpaper or flowered curtains. Here, your blooms can be arranged and rearranged to best advantage. A window-ledge or seat will often make an attractive setting, but a white reflector will be needed to lighten the shadows. Don't clutter up the foreground with ornaments.

Photographing Children

It is sometimes necessary to pose children for pictures indoors by ordinary lighting on account of the rather long exposures involved, but posing should never be resorted to when photographing them outdoors. Photography should become part of a game in which you will probably have to join, the camera – to all intents and purposes – taking second place. Children are never still.

Babies and toddlers are easiest dealt with, in that their movement can be restricted by a play-pen or high-chair; and, of course they can be photographed in their pram or cradle. Unfortunately, the white clothing in which they are normally dressed produces very high contrasts in bright sunshine, therefore hazy sunlight or even bright daylight is to be preferred for such shots. Alternatively, the fastest film should be used, because the emulsion is better able to cope with these contrasts. Don't let the sun shine into their eyes, and unless they are lying down, keep the camera down to their level.

If you choose a place under a shady tree, beware of patchy flecks of sunlight coming through the leaves and mottling both face and clothing. Try the old dodge of focusing on some particular spot on the lawn, marking it with a twig, and letting the child crawl or walk towards you, releasing the shutter when the twig is reached.

Always focus for the child's face, and use a fairly high shutter speed, around 1/250 second.

Children love make-believe, dressing-up, climbing trees and fences. A little encouragement will readily set them off. Give a small boy an old gramophone record and a hammer, a girl a powder-compact and lipstick, then stand by for interesting pictures! Don't forget their pets; children and animals always make good studies, but if the pets don't want to play, don't make them. Try again some other time.

Action Photographs

In photographing moving objects, speed of movement is not the only factor to be taken into account; it is the *image* moving across the film with which we are mainly concerned. It moves far more rapidly when the object is travelling directly *across* the line of vision than it does if the object is travelling directly *towards* the lens at the same speed. The effect is also more pronounced with near objects than when the movement is at a distance.

Thus a faster shutter speed is required for a given movement at, say 10 ft., than 80 ft.; and a person walking across the line of vision at 8 ft. needs a faster shutter speed than one running towards you at 200 ft. Movement in directions between these extremes, i.e. oblique movements, require shutter speeds of intermediate values. The following table gives the shutter speeds for people and things photographed from three basic directions.

SHUTTER SPEEDS FOR ACTION SUBJECTS

Subject	Distance	Directly across	Oblique movement	Towards or away
Pedestrians	25 ft.	1/100th–1/150th	1/100th	1/60th
Running figures	25 ft.	1/500th	1/300th	1/200th
Vehicles (10 miles per hour)	25 ft.	1/500th	1/300th	1/150th
Vehicles (20 m.p.h.)	25 ft.	Use fastest speed available	1/500th	1/300th
Divers	25 ft.	1/500th	—	—
Trains (50 m.p.h.)	50 ft.	1/1,000th	1/300th	1/100th

Sporting events, races, jumping, etc.: use highest speed available. All these shutter speeds may be *halved* when taking distance is *doubled*, and *pro rata* for greater distances.

By panning, i.e. moving the camera in the same direction as the moving object so that its position in the viewfinder remains constant, and releasing the shutter while the camera is actually moving, it is possible to reduce image movement considerably.

In this way fast cars, trains, etc., can be photographed success-fully at relatively slow shutter speeds such as 1/250 second. Naturally, the background is blurred, but this frequently helps to convey the feeling of speed. Trains are best taken from a three-quarters-on viewpoint, but the suggestion of speed and motion will be lacking unless there is a hint of blurring.

Similarly, a certain amount of blur is often acceptable in the arms and feet of athletes and footballers. Sometimes, if action is frozen too well, the subject looks too static.

In sports photography, a long-focus lens is a great help in bring-ing the subject nearer. At the peak of upward movement in jumping there is always a momentary pause before the down-ward movement; with a little practice this moment of arrested motion can be captured, at 1/250 second, though 1/500 is safer. Time spent in last-minute focusing may lose the action alto-gether. It is best, therefore, to adopt zone-focusing methods, i.e. pre-setting the lens so that depth of field ensures sharp focus over the chosen area – in this case that in which the action is taking place.

While fast film has obvious advantages for this type of subject, there are often times when an enlargement of only a small part of the negative is needed. So, except in poor light, it may be pre-ferable to work with medium-speed film and benefit from finer grain.

Candid Photography

For candid photography – the informal snapshot technique of catching people unawares – composition and lighting are sub-ordinated to capturing some fleeting moment, attitude, expression, action, or a combination of circumstances. The result is often a slice of life, and it may, indeed, portray genuine drama. It can also be cruel in its realism and unflattering viewpoints.

The essence of success lies in speed and sureness; the ability to aim the camera without a moment's indecision, and to know in-stinctively when and where to aim. Fumbling with lens adjust-ments, distance calculations and so forth are out of the question. Here the miniature scores every time; it is small and unobtrusive, has great depth of field and large aperture lenses.

By setting focusing distance and lens aperture in advance, it becomes a de luxe version of the fixed-focus camera, and there is no longer any need to do more than aim and fire it. The rapid lever wind really comes into its own in this type of photography, there is no risk of forgetting to wind on, or blank frames, and

Kentish oast houses carefully composed beneath a flying pattern of blossoms and branches. However good your camera your own choice of viewpoint is of paramount importance.

Was this intrepid photographer *inside* the cage, or risking his neck by getting his lens between the bars? Often, you can make close-mesh wire netting 'disappear' by pressing the lens against it. The netting will then be so far out of focus that it will not record on the film. Note how much more modelling is given by side lighting, than when the sun is directly in front. Taken on a 35 mm. single-lens reflex with 9 cm. lens. Ilford FP4, 1/250 at f/3·5.

A cat may look like a jungle beast when photographed close-up in the middle of a yawn. To render such fine detail of individual hairs a good enlarger and enlarging lens is required as well as a good camera technique. This was enlarged on a Durst enlarger.

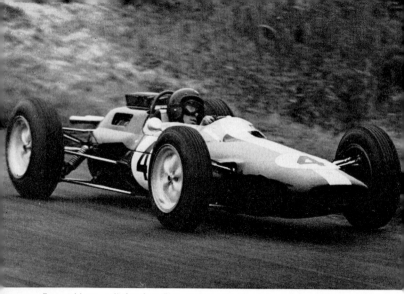

Fast subjects call for fast film, and a smooth swing of the camera (called panning) to keep the subject central in the viewfinder. HP4 film in a miniature camera. 1/500 second at f/4·5. Note how panning of the camera has rendered car sharply, but blurred background to aid impression of speed.

Long focal length lenses are used to take such sports pictures from a safe distance. Usually, a point on the track is pre-focused, and the shutter tripped as the riders reach the spot. HP4 film, 1/500 at f/5·6.

The camera was rested on a firm support and a short time exposure (2 seconds) used to obtain this fine night shot of a berthed ship. Taken on medium-speed film. With fast film, such a subject could be taken hand-held at a large aperture, but quality would not match up to this.

Superb quality, with every tone of sea, proud ship and tossed spray clearly visible. A larger negative size is to be preferred if the utmost in quality is to be obtained. HP4 film.

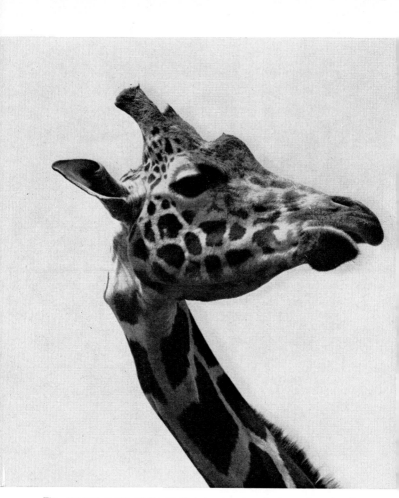

The opposed angles of the giraffe's head and neck give a dynamic effect to the composition here. A good lens hood will help cut down flare from the bright sky, which could soften the outline of the subject. Exposure must be adequate for the giraffe, this exposure is best judged by incident light or a reflected light reading from the palm of one's hand, rather than just pointing the meter up at the sky. Plus-X film, 1/250 at f/5·6.

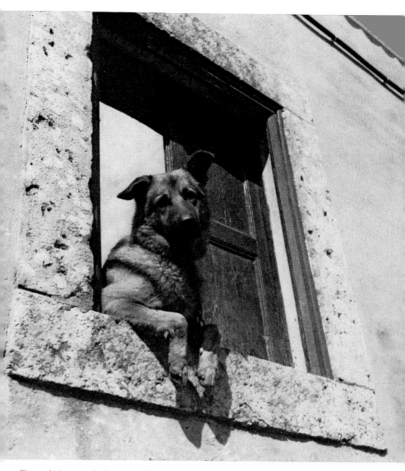

The window and the upward angle make this dog portrait far more eye-catching than if the dog were simply photographed at ground level. Verichrome Pan film. 1/60 at *f*/8.

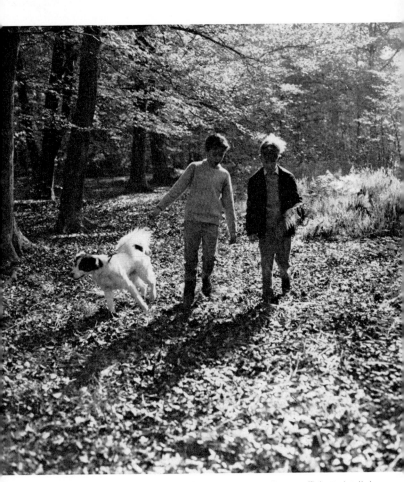

Full exposure is needed if shadow areas are to have sufficient detail in a woodland scene like this. A green filter, though not essential, will help lighten foliage where this is desirable. A black-and-white print from a Kodacolor negative.

sequence pictures can be taken in rapid succession if desired. It is excellent practice to try shooting from the hip, or from the chest if the camera is suspended from a neck-strap. After a few tries, especially if a wide-angle lens is used, you will be surprised how often you can frame your subject accurately in this way.

When you see your subject, approach to the pre-set distance, stop, and take immediately.

The shutter speed is, of course, governed by the calculated exposure, and whenever practicable, speeds not slower than 1/250 second should be used. Choice of subject can hardly be premeditated – it is simply a question of having your camera ready for instant use: in the street, bus, train, market – anywhere frequented by people; the stage is set, the rest is up to you.

If you come across likely subjects while you are unprepared, turn your back on them while you make the necessary adjustments. When you are all set, turn round and get as close as you can, keeping the camera out of sight until the last moment.

Below is a table showing suitable settings for zone-focusing at useful working distances.

ZONE-FOCUSING TABLES

Lens	Camera	$f/4$ sharp zone	$f/5\cdot6$ sharp zone
SET AT 20 FEET DISTANCE			
3·5 cm. (1⅜ in.)	Miniature (35 mm.)	12–60 ft.	11–100 ft.
5 cm. (2 in.)	Miniature (35 mm.)	14–40 ft.	12–60 ft.
7·5 cm. (3 in.)	2¼ × 2¼ in.	15–30 ft.	14–40 ft.
10·5 cm. (4⅛ in.)	3¼ × 2¼ in.	16–27 ft.	15–30 ft.
SET AT 15 FEET DISTANCE			
3·5 cm. (1⅜ in.)	Miniature (35 mm.)	10–30 ft.	9–45 ft.
5 cm. (2 in.)	Miniature (35 mm.)	11–24 ft.	10–30 ft.
7·5 cm. (3 in.)	2¼ × 2¼ in.	12–20 ft.	11–24 ft.
10·5 cm. (4⅛ in.)	3¼ × 2¼ in.	13–18 ft.	12–20 ft.

The Unusual

Closely allied to candid photography is the quest for the unusual and unexpected. Don't be content always to picture the

normal subject in the normal way. This does not mean that you should completely disregard all the accepted canons of composition, but now and again a 'different' subject may come your way, one demanding unusual treatment in taking-angle and lighting, and you'll want to know how to deal with it. *Contre-jour* and oblique angle lighting can play strange tricks with simple everyday objects, producing long shadows of bizarre pattern.

Unusual foreground framing offers interesting possibilities Striking pictures have been made by photographing a cricket match through a player's legs, a ship through a lifebelt, a power-station through the shell of a half-completed boiler. Spiral staircases have been photographed from ground- or near ceiling-level, with the lens looking straight up or down. A small lens aperture is needed ($f/8$–$f/11$) in order to keep both the foreground and distance in focus. The very high viewpoint, the very low viewpoint, the deliberately tilted camera, the diffusion disc - all are worth exploiting from time to time; but not in a mechanical kind of way. Imagination must be given rein.

Industrial Photography

As with architectural subjects, industrial and technical photographs often need verticals to be kept parallel, and for this reason the field camera, with all rise, fall and swing movements is the best choice. A good miniature or 6×6 cm. reflex can produce many striking results if these subjects are treated photo-journalistically rather than technically, but the simple fixed-focus type is quite unsuitable. A lens capable of first-class definition is essential, and unless the work is to be undertaken out of doors, reliable lighting equipment is also needed, together with a sturdy tripod. Generally speaking, the larger the negative, the sharper your results are likely to be. To this end, it is better to use slow fine-grain films rather than those of the faster variety unless high contrasts and some action are present.

The subject range is vast: from a single nut and bolt to perhaps a whole factory or plant. Frequently it involves including people at their particular job, sometimes in actions which cannot be slowed down or halted. If action is to be caught, you must have plenty of light to allow of sufficiently fast shutter speeds being used. Exposure time must always be carefully calculated for detail even in the shadow area, especially where machinery is concerned. The lamps must therefore be arranged so that no deep shadows are thrown. Whenever possible, stop the lens well down, to give sufficient depth of field.

Most professionals use twin-flash for pictures of men and machines. One flash on or near the camera to give full detail overall, another, stronger flash (or one of equal power close to the subject) high and to one side, to provide dramatic highlighting.

For small compact parts, a spotlight can be most useful. In photographing cloth, wood, glass, etc., lighting must come from an angle to indicate texture and 'feel' of the substance. Colour rendering and contrast can be controlled by judicious use of filters, bearing in mind that they lighten objects of their own colour and darken those of complementary colouring.

Outdoors, industrial photography calls for technique similar to that for architectural subjects, the only real difference being that subject movement may be encountered.

Copying

With a supplementary lens (see Chapter Three), extension tube, portrait attachment or long-focus lens, your camera will copy documents, drawings, paintings and photographs. The essentials are flat, even lighting; dead squareness between camera and object; accurate focusing; knowing the precise area covered by the supplementary lens at the working distance; and a tripod.

Fairly small documents can be evenly illuminated by two lamps (ordinary domestic ones will do) – one on either side, at 45° to the centre and shielded from the lens. Larger subjects may require four, one at each corner. It may be convenient to place the document on the floor, adjusting the camera directly over it by means of a ball-and-socket head on the tripod. Alternatively, it could be pinned or fastened by sticky tape to a door or wall. A shaded spot outdoors, or a dull day, will often allow you to dispense with artificial lighting.

The single-lens reflex is the ideal camera for copying and, indeed, all forms of close-up photography, as there is no parallax error to account for.

There are special films made for copying, but slow general-purpose films such as Ilford Pan F and Kodak Pan-X are quite satisfactory for all black-and-white and coloured originals. When copying coloured originals, the appropriate filter will darken or lighten certain colours, or add contrast where two adjacent colours (say, pink and green) might otherwise be identical shades of grey when reproduced in monochrome (see Filter Table, page 37). Minimum exposure and increased development are given to produce good contrast in the negative.

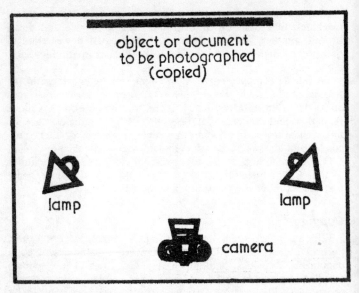

object or document
to be photographed
(copied)

lamp

lamp

camera

Fig. 14. When copying flat objects, even lighting should be provided at 45°
to each side of camera. This will provide even illumination and prevent
reflections from glossy surface of some subjects reaching camera.

Picture glasses cause reflections and should be removed where-
ever possible.

Groups of People

Formal group photographs, such as are taken at social gather-
ings, sports meetings, weddings, etc., are not good subjects for
35 mm. cameras if more than a dozen people are included. Every
person in the group expects the result to be an individual portrait
study, pin-sharp and full of delicate detail, but the degree of
enlargement required from the tiny negative inevitably results in
a measure of softness of definition. It cannot compare with a
print from a *larger negative* of the same group. At all normal
viewing distances, where it is not subject to such detailed scrutiny,
the precision miniature will acquit itself very well.

A fairly high viewpoint is better than a low one when a large
group is involved, and a lens stop of $f/5·6$–$f/8$ or smaller is
advised. With a large camera and its smaller depth of field, $f/11$
is a safe maximum aperture.

Grouping to avoid the formal line-up is a tricky business.

Chairs and tables will be needed, and the members of the group should not be looking into the camera, but rather chatting among themselves, some standing, some sitting, pouring coffee and so forth. The problem gets progressively more difficult as the number increases, a wide-angle lens often becoming necessary.

Several exposures should be made, because someone is almost certain to make a sudden movement to adjust his tie or draw a neighbour's attention. If the group includes children, work quickly; they very soon get impatient and fidgety.

Mountains and Hills

Miniature cameras have obvious advantages for the hill-climber and mountaineer, but with the normal short-focus lens, massive distant peaks will look far too small. A long-focus lens is therefore most useful for this kind of photography, although when bold foreground masses are included to give scale and recession to the scene, the normal lens is frequently helpful.

At high altitudes, the exposures required for open scenes are of very short duration, and there is a great temptation to disbelieve the meter-readings, and so over-expose. This is fatal to distant detail. There is also a danger of over-filtering; a light yellow filter is all that is generally needed up to altitudes of about 5,000 ft. Above this, to prevent slight loss of definition due to the ultra-violet light prevailing at high altitudes, a UV (ultra-violet) filter should be used. No exposure increase is needed for this, and it will also darken the sky as much as a 2X yellow filter at lower altitudes.

If you wish to include foreground figures in your picture, make sure they are suitably attired, and *not* looking towards the camera.

<div align="center">

CHAPTER ELEVEN

Photographing Animals

</div>

The animal study is a popular subject with most camera owners, for it can be beautiful, interesting, appealing, amusing or even downright funny. Further, there is never any fear of the subject becoming camera-conscious and behaving unnaturally, as can happen with humans; and seldom is an animal clumsy or awk-

ward. So, given the right conditions and technique, the percentage so successful pictures is very high indeed.

Failures are generally the fault of the human element. The cameraman must be alert, nimble, extremely patient, and – perhaps the most important – must *understand* animals.

The term 'understand' may seem vague and somewhat pointless to some, but all true animal-lovers will know that animals are quick to sense when someone really likes them, and react accordingly. I have taken thousands of animal pictures – and I still find animals absorbing subjects.

Let's begin with the family pets.

Kittens

A kitten is perhaps one of the best models in the animal world, its natural curiosity, air of helpless surprise and lovable antics providing endless opportunities for pictures. Its movements, at this stage, are not so quick that ultra-fast shutter speeds are needed to catch them, and it is much easier to handle than a fully grown cat.

Nevertheless, since all animals are unpredictable in their movements, it is always advisable to use the fastest film, breaking this rule only when enlargements of many diameters are required. But medium-speed films, if lighting conditions allow, will always give better quality.

A sleeping kitten is the easiest prey, but in the finished photograph tends to look like a shapeless ball of fur. A kitten's eyes are its most appealing feature, so the rule here is get in as close as possible.

Best results are usually obtainable with flash (preferably electronic) or other bright lighting, allowing short exposures to render fur detail and whiskers sharply. A long-focus lens enables you to fill the frame without approaching too close, but if you have only a 'normal' lens, you will have to fit a close-up lens and shoot from a lesser distance.

Once again, it must be stressed that the nearer you get, the more accurate must be the focusing, because the near and far limits of sharpness (depth of field) diminish very considerably. Consequently it is best to stop down the lens as much as possible. To do this without risking under-exposure you need plenty of light.

Also, parallax error, caused through the viewfinder or focusing screen being set higher than your taking lens, is considerably increased at these very close distances, and it is all too easy to

lop off the top of the animal's head. To prevent this, sight it so that the head is much lower down in the finder's picture-area.

As with all close-up photography, the single-lens reflex is the ideal instrument.

Take pains to ensure that your negative is needle-sharp and nicely exposed. Any slight focusing error, any camera shake, will completely spoil the fur texture and prevent adequate enlargement.

Get Outdoors

The logical place to get your pictures is in the garden. If the kitten is sleeping on a cushion in a chair, it isn't difficult to lift the chair slowly and steadily outside. Don't try to handle everything by yourself; a friend can make things much easier, from assisting with the chair to arresting the kitten's attention at a given moment. If it isn't practicable to move the chair, place another chair in readiness and carry out cushion and kitten. A little forethought is necessary. If it has just had a meal or saucer of milk, it is likely to be too sleepy to bother about being transported outdoors, but you won't get it to wake up and become interested in pieces of string dangled in front, and you must therefore content yourself with 'sleeping kitten' pictures only.

On the other hand, if you're *very* careful, it is possible to move it after it has been sleeping for some time. Then you stand an excellent chance of getting a whole range of studies as it awakens, stretches itself, yawns and starts playing with that length of string held by your assistant. Tell your helper in advance what you plan to do, and where you want him or her to stand, so as to be out of the picture; this leaves you to concentrate on the camera and the actual taking. A sudden movement, an unusual noise, will usually cause the animal to look in the direction you wish; but this trick may work only once!

Please don't tie on bows of ribbon; no kitten *enjoys* it.

Background

The background is most important. In this case it will be the cushion. Never photograph a dark animal against a dark background and vice versa. Similarly, it is folly to place a delightfully marked tabby on a highly patterned cushion. This does not mean that you'll get the best results by having a black kitten on a pure white cloth; choose any plain colour of a lightish hue

which will register as a fairly light grey when photographed in black-and-white. Conversely, any dark (unpatterned) colours will serve for sandy, white or similar kittens.

An all-black animal, be it cat or dog, is notoriously difficult to photograph successfully. The lighting must be at such an angle that it catches the sheen of the coat, and a full stop more exposure than indicated by the meter will do no harm.

A second cushion or drape (a plain towel will do) will be required to cover the back of the chair, otherwise when the kitten sits up, his head will get mixed up with that chair-back; it is a good idea to cover the sides, too.

Don't place the chair so that shadows from trellis-work, fencing or tree-branches, fall across it; and remember not to have the sun right in the kitten's face, but well to one side. Failure to do this will throw your own shadow on to the kitten and give you the frontal lighting, anyway. Use a tripod if you wish; you can still work at fast shutter speeds and you won't have to think about camera-shake or sighting.

Get your assistant to hold a white cloth or newspaper so that it reflects light back into the shadow areas, just as in portraiture.

In order that the kitten shall really *look* small and helpless, try to include some object with it for size-contrast. A cotton reel is ideal, and shopping baskets, boxes, boots, etc., have served for this purpose time and time again. Such objects also arouse the animal's curiosity.

Remember that movement *close* to the camera needs faster shutter speeds to stop it than does the same movement at a greater distance. Focus accurately on the eyes and work quickly, *always keeping the camera down to the kitten's level*.

Setting the Stage

The cushion-and-chair has its limitations, however, since movement is restricted, and you can't clutter up the chair with boxes and baskets. A very practical plan, and one which is equally suitable for photographing fully grown cats, dogs, rabbits, etc., is to put an old table in the garden. It is worth while going to some pains to devise a background by tacking strips of wood, goalpost fashion, at the rear, and stretching a plain cloth on it. Alternatively, brown paper will do. The main thing is to avoid folds or creases. Make sure this set-up stands firmly.

Now you have a most useful 'stage' which can easily be moved around to make the most of the lighting, and it's surprising how quickly an animal gets used to the idea. One or two tricks can

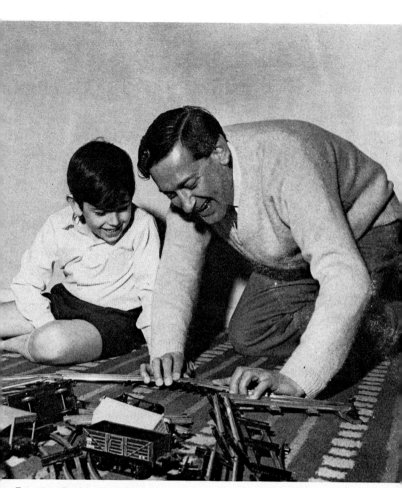

Two photoflood bulbs, strategically placed, enable shots like this to be made at exposures of 1/30–1/60 at f/2·8 if fast film is used.

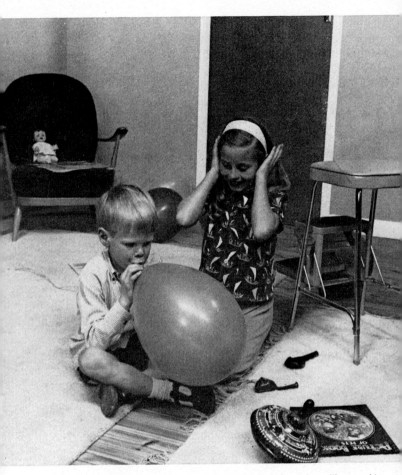

'Bouncing' the light of a flashbulb or electronic flash from the ceiling provides general diffused light which is unobtrusive but allows fast exposures. This picture and the next were taken by this method. It is necessary to have sufficient flashlead to remove the flash from the camera — a 3 ft. extension

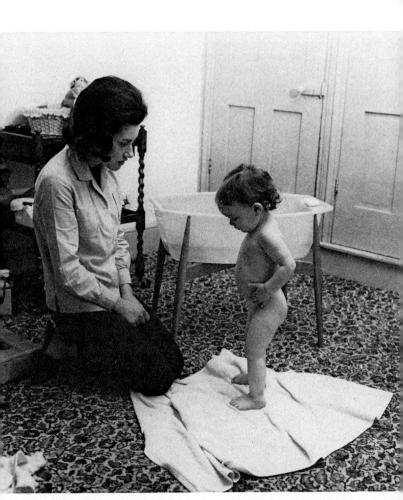

lead can be bought at any photo dealer. Generally, fast film should be used, and in average rooms the lens should be opened about two stops more than would be required for direct flash at 12 ft. (regardless of the actual distance). Both pictures taken on Kodak Tri-X film.

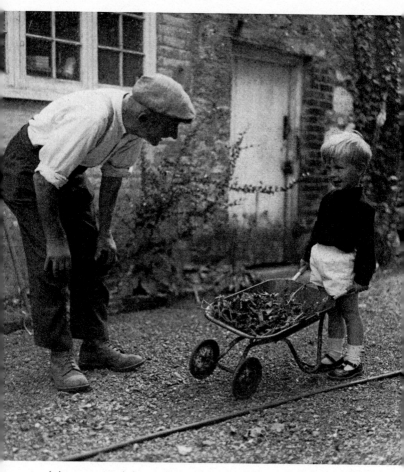

A large aperture helps to throw the background out of focus and give better relief to the subject proper. Slow and medium speed films are better in this respect, as fast film so often necessitates stopping the lens right down. Panatomic-X film, 1/60 at *f*/3·5.

be tried out on the table. A morsel of fish or meat can be popped inside a box – the animal will do the rest. For real fast-moving fun with a dog, try nailing a bone to the table-top! Produce some new toy at the psychological moment and be ready with a fast shutter.

Two or more kittens together can be a real handful. As fast as one is persuaded to face a certain direction, the others promptly spoil the group. Infinite patience is required, plus a great deal of luck. Should they decide to play, shutter speeds of 1/500 second with fast camera technique and lots of light will give you all the action-photography you'll want for that day!

Cats

A fully grown cat can be difficult at times. It has a will of its own, and if it has made up its mind not to co-operate, you'll have to give up and try another day. You cannot *make* a cat do anything; if it's in a condescending mood, it will probably allow you to cajole it into posing. Study its habits. If it sits on the fence or wall in a certain place, you may be able to get a picture there with a well-filtered sky background. You will need a very low viewpoint for the camera to avoid including neighbouring buildings and things like radio and TV aerials.

A sleepy cat will stand for quite a bit of fussing around, but not too much moving about. All cats, young or old, love sunshine, except in hot weather – a predilection that the photographer can readily turn to advantage. But if puss insists on sitting in some particular spot in the garden, in preference to your table-top, then you'll just have to accept the fact and make the best of it.

A long-focus lens or portrait attachment is still a great help, but beware of a too-close approach or you may get distortion, particularly if the animal is end-on to the camera. Keep an eye on that tail; you don't want it sticking out of the picture or thrusting towards the lens. Try the old trick of giving the cat a saucer of milk, then photographing it washing itself immediately afterwards.

If the cat is posing beautifully in good light, in a spot of its own choosing, the long focal length lens can be a great help. Used at wide open aperture the extremely shallow depth of field will throw right out of focus any fussy or disturbing details in the background. Make the most of the animal's good points, and don't be afraid of trying back-lighting with a white cloth or card reflector to throw light into the shadows. Don't use a mirror

for this – it is tantamount to turning the sunlight directly into the cat's eyes, causing them to narrow into slits or close altogether.

Indoors

With the fastest film, pictures by daylight indoors are possible even if your camera has a maximum lens aperture of only $f/4.5$. The chances are that your cat or kitten will sit in a patch of sunshine, if not on the window-ledge itself. Shadows from curtaining and window frames can be a snag, but their effect can be lessened by judicious use of the white reflector or a photoflood lamp.

Never mix daylight and artificial light in this way when you are using colour film.

If you photograph the animals so that the window forms the background, contrasts will probably be so harsh that you will end up with a silhouette. You can do it the other way round, of course, if you wish, and take your camera outside and get puss peeping through the curtains.

The strip of sunshine which falls on your carpet (preferably unpatterned) is a much better proposition. It becomes a spotlight which will pick out the cat from the room. The camera needs to be at floor-level, or practically so, for the best effect. Remove any chairs, etc., which appear in the background, and watch out for patches of reflected light from highly polished furniture.

On dull days indoors, try two or more photofloods, and treat your sitter as you would a human subject whose portrait you are taking. Also, when you are using these lamps, don't let that flex dangle about too much; this will invite playful tugs.

You *may* be able to photograph *slow* action indoors if you have a miniature camera with a lens of large aperture, but electronic flash is much better for the job. Flashbulbs very often frighten animals, especially if used at close range, but the faster electronic light often seems to go quite unnoticed by the animal.

Dogs

All that has been said about lighting, background and general taking conditions for cats is equally applicable and desirable for dog studies. Things should be a little easier though, because a dog can usually be relied upon to obey commands, and an urgent cry of 'look' or 'cats' will bring an alert stance at the appropriate time; but constant repetition of such injunctions will

quickly fail in its effect, so it is advisable to set focus, aperture, and shutter beforehand.

The important thing is not to excite the animal, as may well happen if he is surrounded by people. One helper, preferably his master, is all that is needed. It is often easier to photograph a sitting dog than a standing one. Again, beware the too-close approach. Long-nosed dogs are difficult subjects at close quarters: focusing on the eyes may mean that the nostrils are just outside the depth of field and so will not be sharply rendered. If the dog has a well-shaped head, the answer is often to take a profile shot.

I make no excuse for reiterating that the camera must be at the animal's level; this is where a reflex usually scores. Head-and-shoulders pictures can be more effective than those showing *all* the dog. The long-focus lens is practically a necessity here. As a rule, full-face is not so attractive as three-quarter face or profile.

There is no need to restrict your photography to the confines of your garden; get him romping in the park (1/500 second or faster), jumping, or sitting on a tree-stump. Keep out of long grass unless you want a picture of him peering over the top. You'll be lucky indeed if you ever succeed in getting a good shot of two dogs romping; this is a most difficult subject.

The table overleaf shows the minimum (slowest) shutter speeds required to stop movements of animals.

Puppies

These are sure tests of the cameraman's efficiency, as they are seldom in one place for more than a few seconds. Only fast shutter speeds are likely to cope with their eager restlessness, and accurate focusing is out of question unless they are tired and sleepy. It's a good idea to learn to estimate distances by eye alone, and move backwards and forwards (if you can!) with them to avoid constant focusing adjustment.

If they are young enough, you might be able to contain them in a basket or box, with heads and paws over the edge. Alternatively, someone could hold one in the air, at arm's length, thus giving you a sky background. This is very useful with white animals; use a 3X yellow or even an orange filter for darkening the blue sky. You'll have to work rapidly, or your pup will become a wriggling, nipping mass – to the discomfort of your helper.

Unless you use flash, you won't be able to photograph puppies indoors once they're on the move. Fortunately, all young animals rest and sleep a lot, and that's the time to get them. A couple of

MINIMUM SHUTTER SPEEDS FOR STOPPING MOVEMENT

Action	Far away (over 50 ft.)	Medium-distance (15–35 ft.)	Near (5–10 ft.)
FAST Jumping, running, at play, etc.	1/125–1/250 second	1/250–1/500 second	1/500–1/1000 second
MEDIUM Walking, turning, etc.	1/60–1/250 second	1/125–1/250 second	1/250–1/500 second
SLOW Begging, slow movements, etc.	1/30–1/125 second	1/60–1/250 second	1/125–1/250 second

The slower speeds quoted are for movements directly towards or away from the camera, and the faster ones for movement across the line of vision. Always use the fastest shutter speed you can, and pan (swing) the camera with the running animal if he is occupying one-third or more of the frame.

photofloods or a sun-drenched window setting might give you a passable shot or two if you get them immediately after they wake and before full activity has commenced. But why make a difficult subject more difficult?

Other Animals, Birds, etc.

Pets such as rabbits, guinea-pigs, hamsters, etc., can be photographed by the 'table in the garden' technique or, with adequate care, on the ground, but you may sometimes find it difficult to get the camera down low enough. Sunshine is essential in most cases to prevent the animals' colouring merging into their surroundings. A sky background is unnatural for such creatures.

Wild birds demand infinite patience of the photographer. A

bird-bath and half a coconut, if close enough to a window, can provide all-the-year-round opportunities for photographing several species from the comfort of an indoor vantage point. Obviously, birds can seldom be photographed against the sky; electronic flash, indoors, is the most successful medium.

A parrot on its garden perch is an exception – a camera held low can do the trick. The domestic hen can generally be pictured in a corner of the garden (not among the flowers!) thus enabling you to dodge wire-netting and scrappy bric-à-brac of the fowl run.

Swans are highly popular subjects. They are large enough to be photographed by a lens of normal focal length, and are relatively slow-moving. Side or oblique back-lighting is best. Exposure and development must be accurate or the delicate tones and feather detail will be missing from your print. A shutter speed of 1/60–1/125 second will probably be fast enough.

Newly born cygnets are delightful, but beware the wrath of the parent birds! Ducks and drakes with their young are more amenable; they are also faster-moving.

Animals such as horses, cows, etc., will appear to have large heads and bodies tapering away in a most unnatural manner if you photograph them from too close a viewpoint. Sideways or three-quarters on will help to prevent this, and a head-and-shoulders study of them is generally more effective. Young foals and lambs are generally such elusive quarry that they become action subjects, requiring shutter speeds of at least 1/250 second. Don't try to walk straight up to them; 'inch' your way, if needs be, stopping whenever the animal appears disturbed – and have your camera ready for instant action. Piglets also require stalking, and a fast shutter speed. To cope with such work seriously, a long focal length lens is a must.

At the Zoo

Zoos are the photographer's hunting-ground *par excellence*. Except for indoors sections such as marine, reptile, etc., where $f/2$ and even $f/1·4$ lenses would be needed in many instances, any camera can get a good bag on a bright day.

The biggest snags are the poor backgrounds. Near back-lighting will do much to subdue them by keeping them in shadow while the creature is picked out by the sun's rays. Hot sunshine does not appeal to some animals, and if such as these are on your list, you'll have to pick your day.

Wire-netting is not difficult to deal with at apertures of $f/5·6$

or wider, providing you can get your lens close enough; it is then so much out of focus that it just does not appear on the negative at all. At distances of 4 in. or more it will form a fuzzy blur, and with the lens hood actually touching it, the wire-netting will disappear altogether. Chain-mesh and iron bars are formidable obstacles unless the lens can be poked in between them. Unless you have a long-focus lens, it is best to concentrate on the larger animals. Open enclosures offer the most scope. And there are always some animals so tame that it is difficult to keep them far enough away from the lens!

All the Year Round

There are subjects for your camera all the year round. Whether you are in town or country, in fair weather or foul, there is no excuse for putting the camera away in drawer or cupboard, to be forgotten until next holiday-time. Present-day films and lenses are fast enough for the majority of lighting conditions which are likely to be encountered.

This chapter suggests subjects for each season, and the ways and means of photographing them. So often a photographic jaunt is put off because no particular ideas of what to look for, what to take, are in mind at the outset. Sometimes subjects stare us in the face without our realising it. This is the case with every-one at some time or other – I know it is with me. The trouble is that our sense of perception is not consistent.

But setting out with one particular subject or theme in mind should not blind you to others *en route*. A fixed idea is one thing, a search for pictures another.

Spring

At this time of the year nature is so prolific and lighting so varied and interesting, that the active cameraman often wishes that he could be in two or three different places at once. Spring is upon us before we fully realise it, and outdoor subjects change and grow with such rapidity that it just doesn't do to put off photographing anything till the last moment. That last moment is often too late; a few showers, an extra burst of sunshine, and

the face of the countryside has changed. And not only country scenes. The play of slanting sunshine on streets and roof-tops will change in its directional spot-lighting in a very short time, and some particular effect that you may have noted to 'take in the near future' can easily be missed – and that means a twelve months' wait until it recurs.

It is primarily the season of colour, and unless you are fortunate enough to possess two cameras, it is often difficult to decide in which medium to work, monochrome or colour film. The British landscape is often said to be the most varied in the world, and it would therefore be futile to give any exhaustive list of subjects.

What to Look For

Where there are trees, the opening buds may be photographed if you have a long-focus lens. A lens of normal focal length records them in too great a number and of too small a size. Blue sky background is perhaps best, with a 3X yellow or green filter to contrast the young leaves against it. Blossoms need similar treatment as a rule, except that if they are large (such as horse-chestnut, flowering cherry, etc.) or taken *en masse*, the normal lens can be used.

The technique is applicable to so many varieties that it can be summed up as follows:

1. Small detail and general close-ups against sky: long-focus lens and filter.
2. Ditto at eye- or ground-level: long-focus lens, extension tube *or* supplementary lens, with or without filter.

A lens hood is always necessary. Use a small lens-stop with shutter speed around 1/60 second or faster. Slow films give brighter contrasts and sharper detail than the fast varieties.

3. General landscape views including blossom, etc.: normal lens and filter. Keep plenty of blossom in foreground.

'Natural' spring subjects are snowdrops, newly born lambs, chicks, crocuses, daffodils and blossom generally. Fledglings in their nests (long-focus or supplementary lens needed), delicate young beech leaves, feathery willow, sowing activities in the fields – all make splendid studies. First butterflies appear about March or April. Cow parsley and hawthorn invade the lanes and hedgerows in May. The spring scene needs sunshine. Without it, it is apt to lose its effect in a photograph. Woodland

flowers such as anemones, primroses, garlic, are bitty and patchy when taken as a whole, select a good group instead. Bluebells *must* be photographed in colour, preferably in an open or semi-open glade. The early blackthorn is a doubtful proposition unless very profuse; hawthorn (may) is much better. Catkins need close-ups.

In towns, there is no less variety of picture material. Thin, low-angle sunshine and sudden showers combine to produce essays in back-lighting and marked side-lighting. People venture forth in gayer clothing, more alertness in their step. Your camera can find hosts of lively human interest subjects. Look out for festive occasions.

Weather

The pictorialist must be acutely weather conscious, because his outdoor pictures stand or fall on his appreciation of weather lore. March and April can produce some wonderful skies, but the strong winds will often make faster shutter speeds necessary. Nothing slower than 1/125 second is advisable, with 1/500 second on a very gusty day unless your subjects are unaffected by wind movement.

The month of May often brings with it thunderstorms, so be prepared for dramatic lighting effects, stormy scenes, and rather harsh morning light. It is also the time when cattle go out to grass, sheep are sheared, and moving machines and tractors are busy on the farms – subjects well within the scope of the average camera.

Summer

During the summer months, the camera is best kept in its case between the hours of 11 a.m. and 3 p.m. because the sun is then too much overhead, giving short, vertical shadows which destroy modelling. The countryside is less fresh and attractive, the foliage has thickened, and heat haze begins to lessen visibility for distant views.

Nevertheless, there are wild rose, elder, rose-bay, willow herb, poppy, campion, mallow, meadow-sweet, scabious and daisies to be photographed, to name but a few. Then there are farm activities: harvesting, haymaking, etc.

In towns, outdoor activities are in full swing. There are sports subjects in every park and recreation ground – cricket, tennis and athletic meetings; lots of pictures to take in your own garden,

including the one of the quiet snooze in the deck-chair; picnics, outings, hiking and cycling tours – the range is boundless. The local swimming pool is a good source of pictures and, incidentally, a training ground for getting speed and action shots. High diving calls for shutter speeds of 1/500 second or faster, according to the distance from the camera. Poised in readiness against a well-filtered sky, the divers make almost as attractive a picture, and your shutter speed then need only be 1/60 second. Don't concentrate on adults all the while – there's lots of fun going on among the younger element at the shallow end.

Watch out for wonderful sunsets in September, and, especially in low-lying districts, ground mists which give an eerie atmosphere to the landscape. Rainbows photograph very well on colour film (slightly under-expose), but are seldom successful on black-and-white.

Many other summer subjects are dealt with in detail in Chapters Eight and Ten.

Autumn

Some regard autumn as the season of dying things and the herald of winter. Others revel in its beauty, its russet hues and leafy carpets. From the photographer's point of view it is all too short. The soft, low-angle sunshine and wealth of subject-matter make it a joy for the pictorialist both in town and country.

The pastel shades can only be truly conveyed by colour film, but leafy lanes make splendid monochrome subjects. Use medium speed or slow pan film, and an orange filter. This combination helps to preserve the effect of the golden leaves by rendering them very light in tone, at the same time darkening the blue of the sky and shadowed trunks. Back-lighting and oblique back-lighting lighten the leaves even more; it is particularly suitable for large-leafed trees such as horse-chestnuts, sycamore and lime, and a close-up with a long-focus or supplementary lens is well worth while.

The half-denuded branches of the beech, elm and hornbeam depicted against the sky make attractive pattern-pictures – and don't forget a few shots of the fallen leaves themselves. One or two large leaves in slanting light on the pavement can be more expressive of autumn than a whole carpet of them. The smoke from burning leaves in park-lands has often been turned to good account as it catches the slanting rays of the sun.

On the farms the ploughs are busy, and if you can still find a horse-team at work, and suitable lighting, you should get some

Fig. 15. Position of light source in relation to subject not only controls the modelling, but the aesthetic effect, too. Frontal light is flat and uninteresting, three-quarter light gives better modelling, near-back light adds a touch of drama, while back light provides the impact of a full silhouette.

splendid pictures, but nowadays tractors usually provide the motive power. Keep an eye on those birds that follow the plough. A long-focus lens and a good sky might yield an excellent study of rooks, seagulls or starlings wheeling and fluttering. Use the fastest shutter speed you can for this.

Mist in the woods, lanes, and streets is a wonderful help to the pictorialist. By veiling detail it gives added significance to shapes and masses, besides lending a marked feeling of distance and receding planes. Its effect can be further enhanced, if you wish, by using a diffusion disc on the lens. This spreads it into the shadow tones even more.

Conversely, if mist is present when you are striving to photograph a *distant view*, an orange or red filter will help matters, but not if the mist is at all dense.

Close-ups

Subjects for close-ups abound in autumn: spiders' webs, thick with dew or morning frost, fruits such as acorns, conkers, fir and cedar cones, sycamore keys, berries of all kinds, and of course cultivated flowers in the garden.

The fungi species reach their full beauty in September, and the variety of their shapes and their colouring is truly astonishing. Found in fields and woodlands, their colourings range from velvety subtle tints to vivid gaudy hues. When projected on the screen in colour, they can be strikingly beautiful.

A long-focus lens, supplementary lens or extension tube, used with the camera on a tripod, brings all these subjects within your grasp. If you have never experienced the satisfaction to be derived from taking a good close-up, you are missing one of the most interesting facets of photography, particularly where colour is concerned.

Winter

Indoor pictures are dealt with in the next chapter, and further subjects suitable for winter are described in Chapter Fifteen. Portraits indoors, with photoflood or flash, are of course all-the-year-round subjects (Chapter Seven).

Outdoors, the dull and dreary days are not likely to present you with much in the way of pictures, but rain, fog, sleet and snow, and the days when the pale sunshine struggles through, all present opportunities. In busy streets, fog suppresses detail so efficiently that picture-making resolves itself into a process of

arranging shapes and masses in your camera viewfinder. The complex business of composition is, in fact, simplified because of this.

Choose viewpoints which have figures, substantial shapes or dark tones in the foreground to help emphasise the receding planes. Street lamps, shop windows and vehicle lights later in the day are most effective. In the country, bare trees and winding lanes trail off into space very quickly, and foreground interest is most essential. Thin rays of sunshine breaking through fog produce subtle lighting effects. Use no filters, and always check to make sure that condensation does not form on your lens in cold weather.

Photographs of people scurrying along with umbrellas suggest rain more effectively than shots of empty wet streets. Keep puddles in the foreground if you can, and never let your camera get wet; have a companion hold an umbrella over it while you concentrate on the picture.

Hoar frost drapes everything with a delicate veil, which in close-up and semi-close-up is most attractive. Spiders' webs, twigs, leaves, railings, fences – almost anything holds pictorial possibilities when powdered with frost. The appearance of the sun will add sparkle and modelling, but also make fast working necessary, for it will quickly melt the graceful covering that is your reason for taking the picture. Use a long-focus or supplementary lens, medium-speed or slow pan film, and a tripod.

Snow needs sunshine to reveal its true nature. The shadows it creates in the snow have a bluish tinge, so to record these properly, a yellow filter should be used. Over-exposure is fatal, destroying all those subtle nuances of light and shade which give snow its brittle sparkle. Over-development must be avoided for the same reason. Side-lighting, oblique and back-lighting are suitable. Simple subjects like cart tracks, footprints, tree stumps, boughs, etc., are best, because of the near viewpoint they demand, with its opportunity for the lens to portray texture.

Large expanses of snow-covered landscapes are not recommended camera-subjects – they are apt to appear as just so much white paper on the print. Don't forget that a lens hood is essential; there is almost as much light thrown back from the snow as from the sky. Children making snowmen, snowballing and skating are also best photographed at near distances. Snow blown against trees and fences often yields attractive pictures. Icicles need close-ups and bright sunshine for their successful portrayal.

If you try to photograph falling snowflakes, you are likely to

be disappointed with the result. They won't look like those you see in paintings on Christmas cards, but blurred streaks – if they show at all. Nevertheless, should you wish to have a shot at them, 1/250 second or faster will usually catch them.

Pictures at Night

Thanks to the speed and latitude of modern film emulsions, even the most modest and simple camera is capable of taking pictures at night. Obviously, its scope is much more limited than that of the miniatures with their fast lenses, but almost any stationary scene or subject merely needs a tripod and a time-exposure. Only when there is movement, and lighting is inadequate, does recourse to flash or photoflood lighting become advisable (if then, with ultra-fast film).

When neither of these two lighting aids is available nor permissible (as in the circus and theatre) only the fast lens can produce adequately exposed negatives.

Such films as Ilford HP4 and Kodak Tri-X will give double the normal speed, and can be 'pushed' even further, if processed in a maximum energy developer such as Microphen (Ilford) or Promicrol (May & Baker). These developers give remarkably fine grain and shadow detail and give a very sharp image if the 'dilution technique' is employed. Instructions for this treatment are enclosed with the developers.

This increased film speed makes up for the shortcomings of the lens of only moderate aperture. In a brightly-lit circus ring, for example, exposures of 1/125 second to 1/250 second at $f/3 \cdot 5$ will be adequate.

Even faster films are available, such as Kodak Royal X and Agfapan 1000. The gain from maximum energy development, however, is usually less with these films than with those previously mentioned, grain in more evident, and overall quality is not so good. .

Street Scenes

Shopping centres and main streets of large towns are usually bright enough to provide a complete range of interesting night

pictures. Exposures will naturally vary a great deal, according to the amount of light, its distance from the surrounding buildings, and to a certain extent, on its nature (i.e. tungsten, diffused, fluorescent etc.) and colour. For practical purposes, however, the main consideration is the amount, and in this respect a well-lighted scene may require as little as 1/60 second at $f/2\cdot8$, and certainly rarely more than four times this exposure. It is the general illumination that counts, not individual lights.

What exposure you give depends on how much shadow detail you wish to record. 1/60 second at $f/3\cdot5$ with fast film will adequately reproduce street lighting and brightly-lit shop windows, but very little will be seen of passers-by, other than those directly before the windows. Under the brightly-lit overhangs of cinemas, however, the same exposure is sufficient for people.

Exposure meters are an unreliable guide to exposures in the streets at night, owing to the many bright points of light and the large shadow areas. Ordinary reflected light readings tend to indicate exposures too long for illuminations, and too short for full shadow detail. Experience is the final arbiter of exposure choice, but the Night-time Exposure Guide will ensure a fair degree of success. If, for a start, you take three shots of everything, giving the indicated exposure, then one stop more and one stop less, you can be sure of getting printable results.

Floodlighting

Floodlit buildings, memorials, etc., need exposures in the region of $\frac{1}{4}$ to 1/30 second at $f/2\cdot8$. In many cases, a wide-angle lens may be necessary to avoid tilting the camera. This means extra care in dodging the street lights which may shine into the lens. Whenever possible, keep them out of the picture altogether, so as to give full emphasis to the building.

The square-on viewpoint is seldom best, but too much to one side may prevent full exploitation of the delicate gradations created by the spreading light. A shadowed statue or tree in the foreground will help to give depth and realism, and if there is a river or lake in the foreground, the effect can be very attractive. The ripples will smooth themselves out of existence during the exposure, however.

Coloured floodlighting does not have the actinic value of the white, but it is only when it borders on dark orange to red that considerable increase in exposure becomes necessary.

Fairgrounds

The fun of the fair really begins at night, when all the attractions are brightly lit. Fast film and an aperture of $f/2.8$ will enable you to shoot close in to the sideshows at 1/60 second, though the fall-off in illumination will be rapid within a few feet. Dodgems and other under-cover activities are brightly enough lit to allow exposures in the region of 1/60 second at $f/1.8$ or $f/2$. Don't worry about movement and shallow depth of field. Such subjects are all the better for a little blue, which better portrays the feeling of the activity.

If you are enthusiastic enough to carry a tripod, have a go at the ferris wheel. Frame the picture so that the ferris wheel occupies all the background, but keep one or two of the tents or sideshows in the foreground for atmosphere. Stop down to $f/8$ and give $\frac{1}{2}$ second exposure at a moment when the wheel is not moving.

The same exposure will create interesting patterns while the wheel and roundabouts are in motion.

Fairgrounds are a rich source of studies in human expression. Candid shots of people registering curiosity, amusement and excitement are all there for the taking. If you feel too embarrassed to aim your camera directly at people, work from behind a companion, aiming the camera over his shoulder when you are ready to shoot.

Fireworks

Photographing firework displays is within the scope of the simplest of cameras. A tripod or firm support is all that is required. The dark sky does not affect the film, so, providing that there are no other lights in the vicinity (fires or lighted buildings, passing vehicles) the lens may remain open for several fireworks in succession. Recording one firework alone is effective only if it produces a complex, well-spread pattern of lights. A set-piece, of course, offers no difficulties.

The procedure is this: set lens aperture at $f/8$ to $f/11$, and shutter at 'Time' or 'B'. Open the shutter when the first firework goes off, and then close it. Repeat this with the next firework, without moving the camera in any way or winding on the film. Three or four fireworks on one negative will then make an interesting picture. If your shutter and film-wind are inter-locked, so that you cannot repeatedly open and close the shutter without winding on the film, try this: Open the shutter on 'Time'. After

each firework has registered on the film hold the lens cap (a dark hat will do) over the lens until the next firework goes off. Finally, after several bursts, close the shutter.

Moonlight

For pictures by moonlight, a very long exposure time is needed. Although on a bright moonlit night you may be deceived into thinking that a minute or two would be ample, this is not the case. For example: at $f/5.6$ and with the fastest film, a fairly open landscape would require from 5 to 10 minutes. A scene with dark foreground needs twice this amount, whilst snow, or the very distant view, might reduce it by about one-third.

If you include the moon itself in your pictures, you'll find that it becomes an elongated blur due to its movement. Photographing it while there is still some daylight to help shorten exposure time will overcome this, but you will be very disappointed with its smallness. Nearly everyone has an exaggerated idea of the moon's size, perhaps because artists have always treated it generously. To make the moon look the way songwriters describe it, use a very long focal length lens to photograph it rising through the trees or over a roof top. If you want it to look large and imposing in your photography, but have no long lens, you must have recourse to a little faking. When enlarging from the negative, place a coin (a farthing, sixpence or halfpenny) on the appropriate spot on the bromide paper, and you will have a clear circle on the print.

Its clean-cut outline is apt to look hard, but this can be remedied by supporting the coin on a tiny piece of plasticine so that it is half an inch or more above the paper. This column of plasticine must be as slender as possible. For the finishing touch, a trace of retouching medium or dye may carry a cloud faintly across it. Don't expect such a picture to get past the judges of photographic exhibitions and competitions though! It is strictly for amusement only.

The dodge can be used in the case of pictures made during the day-time, too, by increasing printing time so that an over-dark print, simulating moonlight, results. Alternatively, pseudo moonlight pictures are easily made during sunset, the film being deliberately under-exposed. With this method the sun may be

Opposite page:
At the circus. 1/250 at $f/2.8$ with Tri-X film. Leica M4 with 3.5 cm. Summilux lens.

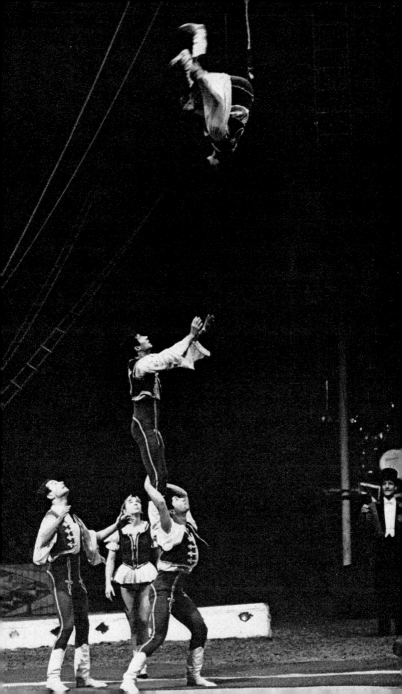

Bauer unit is typical of small high-performance electronic flash units employing rechargeable ni-cad (nickel cadmium) batteries, and providing 30–50 flashes per overnight charge.

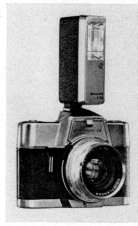

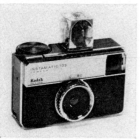

Tiny flash cube provides four quick-sequence flashes. This one revolves automatically on Kodak Instamatic 133 as film is wound on.

Minicam TT–100 electronic unit is light but very powerful, takes rechargeable batteries and has provision for a second flash-head on an extension lead.

Tiny Minicam 'sync-slave' unit is plugged in to a second flash unit, which it fires when its cell is affected by light from another unit. This does away with inconvenience of trailing leads.

Minicam ring-flash electronic unit surrounds lens and provides completely shadowless light. Invaluable for medical and technical photography, but not ideal for pictorial close-ups unless a second flash is used to provide modelling.

Tiny Agfalux packaway flashgun with folding reflector occupies corner of gadget bag, weighs 3 ozs., and is always available for recording objects and places of interest in dim light. Two or three packs of AG1B bulbs are equally light and small. The best bet for the photographer who seldom needs flash.

Braun F270 electronic unit is small but very powerful. Though light from tiny PF1B bulb is as bright, electronic flash will stop far more action. Both guns have easy calculator dial to give right aperture with various types of film.

Depth of field is needed so that near and far objects are equally sharp. This calls for small lens aperture which, in turn, calls for slow shutter speed. As the subject here is static, no problem is posed. Medium-speed film, 1/60 at $f/11$.

included, to become the 'moon' in the dark print subsequently made.

Lightning

Sheet lightning is not a good subject for the camera but forked lightning will produce impressive pictures. It is just as easy to photograph as fireworks, and the same procedure is used, except that it is normally more convenient and comfortable to put the camera and/or tripod at an open bedroom window. More than one flash can be recorded on a single negative; sometimes it is an advantage to work at full aperture for added brilliance. Should there be sheet lightning while you have the lens open, it is best to waste that frame and wind on to the next, otherwise you will get a 'half-light' sky background for the forked lightning when it comes.

Photographing Indoors

It isn't essential to use flash (dealt with in the next chapters) for indoor pictures. Photoflood lamps are so convenient and efficient, that with fast film it is possible to take hand-held snapshots at $f/4$ if two or more of these lamps are suitably placed. In fact, in a well-lit room, if the film is developed in a maximum energy developer, an aperture of $f/1·8$ will allow shutter speeds from 1/30–1/60 second, with no supplement to the ordinary room lighting. It is possible to use photoflood bulbs in household lamp-holders, but the heat they generate will quickly scorch any fabric shade. If no shade or reflector is available you must place them so that they do not shine directly into the lens, e.g. put them behind some article of furniture or behind the camera.

We have seen in Chapter Seven (Portraiture) that one light alone is seldom satisfactory, even when a white cloth reflecting surface is used to help lighten the shadows. The same balancing principles must be applied when arranging the lighting for *any* indoor picture.

Distance of Lamps

Again, as with portraiture, the distance of the lamps not only affects modelling and contrast, but exposure as well. Any radical changes in positioning these during a photographic session will

mean adjusting the exposure accordingly, bearing in mind that when you move a lamp from, say, 4 ft. to 8 ft. away, the exposure required will be not doubled, but quadrupled.

Rooms with light walls naturally spread the light more than do those with dark ones. Make sure that light is not reflected back into the lens from polished surfaces, pictures and mirrors. Try to avoid dark, hard shadow shapes being thrown on to the walls unless they can be excluded from the picture or form a pleasing pattern. If you direct the light on to the ceiling you will get an all-over softly diffused lighting which is often effective. At least two photoflood lamps in metal reflectors should be used for this, or exposure times will be considerably increased. Alternatively, diffusers made from butter-muslin stretched on wire hoops, and attached an inch or two in front of the reflectors by spring clothes-pegs, will soften the lighting. Increased exposure is again necessary. Never have lengths of flex dangling across chairs, etc., especially when children are around, or there may be an accident.

Subjects

What to photograph? Apart from moving subjects, which need flash, there is plenty of scope. Family gatherings, parties, children's activities – all are possible with a little judicious posing and co-operation. Challenge a child to keep still longer than you do – make a game of it, and half you problem, i.e. movement, is solved. It only remains for you to ensure that expressions and attitudes are not strained and unnatural, as they will be if you take too long before releasing the shutter.

Although it may make for convenience in operating camera and lights, do not restrict your subjects to round-the-table, in-the-chair routines. Children, in particular, are well portrayed on the floor, playing with their toys, the family pet, or busy with the scissors, drawing, etc. With a little care in keeping chair-legs from cluttering up the background, some interesting studies can be obtained. In most instances it is advisable to keep the camera at a fairly low viewpoint. Try the shot of a child peeping round the edge of a sofa or half-open door.

At the other extreme, an occasional shot from a high viewpoint will bring variety and freshness to your collection. Get your camera as high as possible by putting the tripod on a table or, if you are holding it, using the household steps. The same technique can be successfully adopted for photographing children going upstairs to bed. the camera being at the top of the

114

stairs, the children half-way up. Shades of Christopher Robin and Pooh Bear! Have the child looking upwards, though not at the camera, or you will just get the top of his head. The normal hall-lamp can be replaced by a photoflood (remove shade!) and a second photoflood lamp in reflector near the camera. Or the child could peer down from between the topmost balustrade at the camera low down in the hall.

There is no need to confine your picture-making to the living-rooms. The kitchen, and all the chores associated with it will yield lots of pictures – and lots of fun. Youngsters love emulating grown-ups, and there'll be no lack of co-operation when it comes to posing for such things as washing-up, stirring the pudding, ironing (cold iron, of course), pastry-making and so forth. Try a floor-level viewpoint of a child with large scrubbing-brush, pail, and lots of bubbly suds.

It will involve posing in some cases, but properly encouraged – and not excited – the average child can do this without appearing tense or awkward.

If you take pictures in the bathroom, watch out for condensation of steam on the lens, and make sure that all metal parts are dried immediately afterwards. *Do not have flex and lighting equipment anywhere near the bath.* This warning cannot be too strongly stressed. Water is an excellent conductor of electricity, and all water pipes are earthed metal conductors. A frayed or worn flex, or a loose connection, is all that is needed to produce a shock which can be fatal in such surroundings. By earthing all metal lighting stands and fittings, any electrical fault will blow the fuses, but even then it is better to take no risks. Keep *all* wires and stands outside the open door – a damp floor is highly dangerous, too.

Replacing the ordinary ceiling lamp by a photoflood, and putting a second photoflood just outside the door, exposures with fast film and these two lamps will be approximately 1/60 second at $f/2.8$.

Firelight

'Firelight' pictures of two or more people seated round the hearth are best taken by putting a photoflood lamp in the empty grate, and arranging for a friend to shield its direct rays from the camera. Another photoflood is placed near the camera, but to one side of it. Choose a low viewpoint. To photograph by true firelight would mean extremely long exposures, and offer no pictorial advantages.

The same applies to candlelight where exposure time is concerned, but there is no denying the charm and softness of this form of lighting. Hand-held, lighted candles need one photoflood to augment them, but use your eye to judge that the candle flame, and the light it casts on the face, is stronger than the fill-in light of the photoflood.

Interiors

Interiors of buildings, rooms, halls, can be photographed by their normal artificial lighting. Concealed or well-shaded lighting is helpful in that lens flare due to rays striking the lens is unlikely, and there is no blocking-up on the negative of the light source, which would then conceal detail in fittings, hangings, etc. But when this does occur, considerable improvement is effected by giving these highlights extra exposure during enlarging, by means of the technique described in Chapter Eighteen.

Small lens stops, $f/11$ to $f/22$, are advisable to secure maximum depth of field and detail rendering. Choose a viewpoint slightly diagonal to the room rather than square-on to the opposite wall. If a wide-angle lens is used, don't have articles of furniture too near the camera. Keep the camera as upright as possible, even if this means losing some interesting ceiling mouldings. Remember that you are really engaging in architectural photography, and that you need a camera with special movements for that.

Circus, Theatre

These subjects are the province of the miniature camera, with its fast lenses and great depth of field. Apertures less than $f/2·8$ are of little use, even with very brightly lit shows. As a rough guide, exposures may be in the region of 1/250 second at $f/2·8$ with fast pan film if well spot-lighted. Coloured lighting can be deceptive in its strength. A good seat is a first essential – one to the side is the best in the case of stage shows.

It is a useful dodge to take up the slack of the neck-strap round your wrists, so that at eye-level the camera is tightly pressed against your face. This helps to prevent camera-shake.

Circus photography is usually permitted by the management, but some theatres display notices forbidding the use of cameras, except at special performances for photographers.

116

You may be lucky, however, with some of the holiday shows, and amateur theatrical companies are often glad to be photographed. At full-dress rehearsals you can pick the most interesting scenes and get the cast to hold their poses for short time exposures with the camera on a tripod. In this way, quite modest equipment can secure excellent results, and the increased depth of field obtained by the small apertures which can be used has obvious advantages. Flash on the camera kills the normal stage lighting effect, and is therefore best avoided if possible. (It could not, of course, be used during an actual performance.)

Flash Photography

Nowadays even simple and inexpensive cameras are internally synchronised for flash. The modern flashbulb is simple, reliable, safe and a very convenient means of getting pictures anywhere – at any time. With it, you can be completely independent of existing lighting conditions, no matter how poor these may be.

In appearance, a flashbulb resembles an electric light bulb, but but instead of the normal filament, it is filled with metal wire and oxygen. Electric current from a battery ignites a priming compound inside the bulb, which in turn ignites the wire. This burns very rapidly in the oxygen, with an intense flash of short duration. The whole process takes place in the fraction of a second, during which your camera takes the picture. Although to the eye the flash seems to occur immediately electrical contact is made, this is not, in fact, the case. There is a time lag between contact and the full intensity of the flash, and different types of bulbs vary in their light characteristics.

These technical niceties need not deter the beginner from using flashbulbs. It isn't *essential* to know the whys and wherefores in order to take flash pictures. Exposure is determined by the type of bulb used (amount of light), its distance from the subject, and the size of the lens stop.

The bulb will give only one flash, and is then discarded; the amount of light depends on the quantity of wire inside it. Bulbs are made in several different sizes: one of the three smaller

sizes will give all the light most amateurs are likely to require. The capless ones are cheap and can be obtained anywhere.

Equipment

If you intend to take only an occasional picture by flash, you can buy a small flash unit for under a pound. There are many on the market. They consist simply of a battery case and reflector, and are quite suitable for this kind of work.

Most of these little units use a small 22·5 volt hearing-aid battery to charge a built-in capacitor which, in turn, fires the flashbulb by means of a very intensified discharge of current. The choice of models is large.

It is often an advantage to be able to fire two or even three bulbs, placed in different parts of the room, simultaneously, but to do this your flash unit must have one or two outlet sockets, into which you plug leads from extension flash heads. A bulb is placed in each extension head as well as in the flash unit, and when the latter is fired all the bulbs ignite simultaneously.

Even when a capacitor flash unit has been used many times, the discharge of current remains constant, because the drain on the battery is very small. One battery will fire several thousand bulbs and should continue to give reliable service for at least twelve months.

Operation is simplicity itself. Assuming that the camera has a synchronised shutter, the lead from the flash unit is plugged into the flash socket on the shutter. Releasing the shutter automatically fires the bulb, and the picture is taken.

Most units have an ejector for the used bulbs, so there is no risk of burned fingers; very often they also embody a built-in flashbulb tester.

A flash unit with one extension head can provide very professional lighting effects. The bulbs can be positioned as if they were photoflood lamps, as described in the chapter on Portraiture. It is a good idea to have a 10 ft. or 12 ft. trigger lead running from the flash unit to the camera. In this way, the two bulbs can remain where you position them, leaving you free to move around your subject. In the past, much of the criticism levelled at flash photographs was concerned with the soot and whitewash appearance they presented – faces and flesh-tones were chalky-white, shadows were black and empty. Such criticism is not justifiable with present-day technique and materials, but flash *can* still produce harsh effects if the equipment is wrongly handled. Flat, undiffused frontal lighting, over-exposure and over-develop-

ment all contribute to this. Any one, or any combination of them, can spoil the result. This is why it is best, even when using a single flashbulb, to remove it a little to one side of the camera by means of a long trigger lead.

Flashbulbs and Your Camera Shutter

Bulbs are made in several different sizes, to give much or little light as maybe required, and they are also divided into three broad classes, viz.: 'M', 'S' and 'FP', according to their time-lag or firing delay. The time-lag is the time in milliseconds (thousandths of a second) which elapses between contact and the peak intensity of the flash. This has an important bearing upon the type of camera or synchronised shutter for which any particular bulb is suitable.

Cameras with 'X' and 'M' shutter settings offer two kinds of synchronisation; the 'M' position brings a small built-in delay mechanism into operation, thus taking care of the flashbulb time-lag and enabling all shutter speeds to be used. The 'X' setting is used for synchronising high-speed electronic flash, about which more will be said later in this chapter. This setting can also be used with Class M flashbulbs provided the shutter is set to 1/30 second or slower. The inexpensive fixed-focus, snapshot type of camera has X flash synchronisation only.

The amateur need not concern himself with clear flashbulbs, which are still used for certain purposes, mainly by professionals. The blue-coated bulbs are now recommended for black-and-white as well as colour photography.

Exposure

Obviously, it isn't possible to use your exposure meter for determining exposures in flash photography. Since, however, the *quantity* of light given by any particular flashbulb is known beforehand, and the speed of the film is also known, the relationship between these and lens aperture and shutter speed can be correlated to the only other factor: i.e. distance of flash from the subject.

To make this clearer: flashbulb manufacturers supply easy-to-use 'guide numbers' which, when divided by the distance in feet, indicate the lens aperture needed. For example: for a bulb with a guide number of 100 and a subject 12 feet away the lens aperture would be $100 \div 12 = f/8$. When you use two similar flashbulbs close together, you find the aperture required by calculating it for one bulb and then using the next smaller stop. If,

however, one of the bulbs is merely a subsidiary light, used to lighten the shadow areas, calculate the stop for the main or modelling light. The distance, by the way, is not that of the *camera* from the subject, but of the *flashbulb* from the subject – not necessarily the same thing. This system is easily memorised, particularly if one size of bulb and type of film are used regularly. In very small rooms with light walls one stop smaller can be used, opening up to one stop larger for outdoor shots at night, also indoors whenever the subject and surroundings are particularly dark (see GUIDE NUMBERS TABLE below).

The light output of a flashbulb is expressed in lumen-seconds, thus a bulb giving, say, 20,000 lumen-seconds gives twice as much light as one rated at 10,000 lumen-seconds. A reflector, besides directing as much light as possible on to the subject, also serves to protect the photographer's face should a bulb burst, which seldom happens. Furthermore, as an additional precaution in the event of a burst, most bulbs have a safety coating of lacquer and some have an indicator spot, which is normally blue but turns pink if the bulb has been damaged and rendered unsafe. Check the colour of the spot before using the bulb. If you fit a clear, protective cover over the reflector (especially when taking close-ups) safety measures are complete. Take care not to knock a bulb or handle it roughly.

As a working guide for what to give in the way of exposures, here is a table for shutter speeds of 1/30 second; it shows what stop to use with certain films and bulbs at various distances from the subject.

FLASH EXPOSURE GUIDE

Stop (Aperture)	Atlas Type 1B, Philips PF1B, G.E.C. No. 1B, Mazda No. 1B				Philips PF5B, G.E.C. No. 5B, Mazda No. 5B				
	Royal-X	Tri-X, HP 4	Veri-chrome Pan, Plus X FP 4, Selochrome	Pana-tomic X Pan F	Royal-X	Tri-X, HP 4	Veri-chrome Pan, Plus X FP 4, Selochrome	Panatomic X Pan F	
f/22	10	7	5	2½	16	11	9	4½	Approximate distance between bulb and subject.
f/16	15	10	7	3½	25	16	12	6	
f/11	21	14	10	5	36	23	18	9	
f/8	30	20	15	7	50	32	25	12	
f/5·6	42	28	21	10	70	45	35	17	

Using Flash

The easiest way of using flash is to mount the flash unit on the camera. This is the press photographer's way, because it is

Night photography calls for the use of a good tripod if fine quality and depth of field are required. This was taken by available street lighting, using medium-speed film. 15 seconds at *f*/6·3.

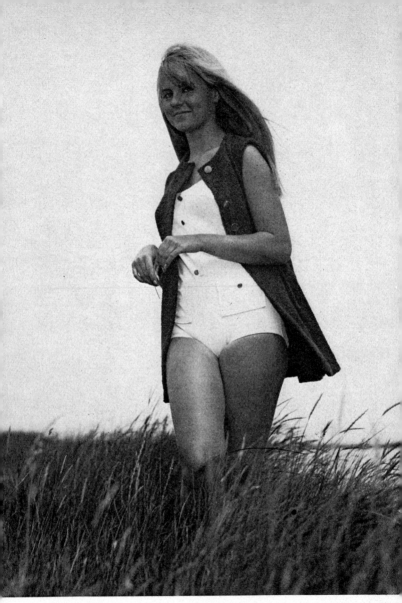

A pretty girl in a cornfield — a classic combination for glamour. However, with the girl turned away from the sun to avoid harsh shadows, the skin tones are dull and poorly separated.

Here, the girl has been turned towards the sun, and a flash has been used to lighten the heavy shadows. This is known as fill-in flash, or 'synchro-sunlight'. Both pictures taken on Kodacolor negative film.

Over-head trough lighting at wrestling and boxing matches is very contrasty. This shot was taken on the Leica M4 with wideangle Summilux, 1/250 at f/2·8, using Ilford HP4.

Opposite page:
Candid photography in the foyer of Billy Smart's Circus. Tri-X film, 1/30 at f/2.

1/5 second at *f*/5·6 on Tri-X film has captured all the appeal of Christmas decorations in London's Regent Street, plus an appreciable amount of shadow detail.

For black skies and dramatic contrast, try a red filter. A 5X red filter used with Pan-X film, 1/30 at *f*/8, aids this composition of logs and snow.

This beautiful windmill was literally surrounded by trees, so the right view-point meant quite a search. Luckily, the position of the foreground blossoms coincided with an aspect where the sun gave good modelling to the windmill. Every moment spent studying the viewfinder before pressing the shutter release will pay pictorial dividends. FP4 film with 2X yellow filter, 1/125 at *f*/8.

so quick and convenient for on-the-spot and candid photography. From the point of view of modelling and lighting it is not the best; it is dead-frontal, and subjects are flatly illuminated.

The best plan is to regard the flashbulb as if it were a photoflood lamp, and always to think out your lighting arrangements with that in mind. Just as you would position a photoflood or two photofloods, so you should position your flashbulb and reflector. *Before you take a single picture by flash or photoflood,* it is wise to experiment with first one and then two, ordinary household bulbs, and study their modelling effect on your subject's face. This will do much towards teaching you the art and application of lighting, which is the basis of all photography, be it flash, photoflood, or daylight.

All that has been said about lighting-angles, distances, heights, and diffusion in Chapter Seven (Portraiture) is applicable in the case of flashbulbs. Be careful, though, with 'deep' subjects! Remember that light intensity falls off very rapidly with distance, giving light foregrounds and dark backgrounds in such cases. An extention lead will allow the distant placing of a second bulb, which should preferably be identical in type so as to ensure that synchronisation is not upset.

Bounced Flash

A popular technique for even and soft illumination is to direct the flash towards either the ceiling or a light wall, and so photograph by reflected light only. This is termed 'bounced' flash, and it can be most useful for large groups, all hard shadows being eliminated. The efficiency of this method is dependent upon the size of the room, i.e. proximity of the walls and ceiling to the subject, and their lightness of colouring.

As the light is reflected, it is naturally less strong than direct light and this loss of light must be compensated for by opening up the lens and/or using a larger flashbulb. A practical test is the best way of ascertaining the correct stops to use in the various rooms of your own home. Assuming that the rooms are not un-

Opposite page:
With fast-moving sports pictures, it is easier to focus beforehand (pre-focus) on a certain spot, then release the shutter when the subject reaches the spot. Here, the photographer waited until the second runner reached the pre-focused spot. With the lens stopped down to f/11 there was adequate depth of field to cover even the farthest runner. Tri-X film at 1/500.

Fig. 16. Flash reflector is pointed upwards so that a large area of well-diffused light is reflected from ceiling. Known as bounce-flash, the effect is like natural room lighting.

usually large and that they have white ceilings and light-coloured walls, two stops larger than indicated for direct flash at 10 ft. will be about right. Thus, if the guide number for the bulb is 100, that would be about $f/11$ at 10 ft. for direct flash. Now aim the bulb at ceiling or light-coloured wall, and open the aperture of your lens two stops, to $f/5.6$. Whether you approach somewhat closer to go farther from your subject will have no effect on the strength of the bounced light, so the aperture need not be altered.

Synchro-Sunlight

It is a growing practice to use synchronised flash in conjunction with sunshine outdoors. This is not so odd as it may at first seem, because properly handled, flash can lighten those dark shadows which very bright sunshine produces. Thus it is particularly useful for against-the-light (back-lighting or *contre jour*) subjects.

The chief danger to guard against is getting an unnatural effect, the flash becoming more obvious than the daylight. For this reason it is best to use small bulbs, and even then at close distances it may be advisable to cover the bulb and reflector with a white handkerchief to reduce the light. Always remember that when used outdoors the flash is simply a 'fill-in' light and *not* the main source of illumination.

With focal-plane shutters working at high speed outdoors, special FP (focal plane) bulbs are necessary, in order to get even

synchronisation. These must be plugged into the FP socket of the camera.

With most modern focal-plane miniatures, however, it is possible to use M-type flashbulbs outdoors at shutter speeds of 1/125 second to 1/250 second, provided that the trigger lead is plugged in to the FP socket of the camera. No manufacturer goes so far as to recommend this procedure, but it works with most cameras. The slightly uneven lighting which might be apparent on an indoor subject, is not noticeable outdoors in sunlight, where the flash plays only a supporting role.

Electronic Flash

If you intend to take quite a few flash pictures, a small electronic flash unit can work out more economically than flashbulbs. Even the most sophisticated of the smaller electronic units, containing rechargeable nickel-cadmium batteries, seldom cost more than twenty pounds. Others, providing just as much light, but operated by replaceable dry batteries, cost as little as six or seven pounds.

The former are recharged after every thirty flashes or so, and the latter require new batteries (costing about three shillings) after a similar number of flashes. A penny a flash isn't bad value.

Electronic flash is created by a high voltage discharge through a gas-filled tube which will operate for at least 10,000 flashes of very short duration; some models flash at 1/500 second, others at 1/1000 second, and a few are even faster than this. Many models can also be operated from the mains, thus saving the batteries.

Electronic flash is thus capable of arresting quite fast movement, and the cost of each flash is extremely low. It is ideal for indoor photography of children and pets. Animals are not at all disturbed by the flash because it is so fast. (They generally completely ignore it.) Further, the colour of the light approximates to that of daylight making it very useful for colour work. Light output is rated in joules, and the average small equipment corresponds roughly to that of a small flashbulb.

Exposure may be calculated in the same way as for flashbulbs, but all modern electronic units have a built-in calculator, usually on the rotary principle. Merely align the ASA rating of the film in use against the distance, and you can read off the correct aperture setting.

More than one flash-head can be fired simultaneously by some models, thus increasing the scope of application. Synchronisation

with camera shutters is easily effected, on the X setting. There are no hot flashbulbs to eject after flashing – the flashtube remains cool to the touch and there is never any danger of it exploding. With all these advantages, there is little doubt that it is the flashlight of today, and in time may replace the flashbulb entirely.

Professional studio flash units have special heads which also contain 'modelling lamps' to give continuous low-power lighting, thus simplifying the placing and balancing of the light.

CHAPTER FIFTEEN

The Fun of Photography

Photography can be complicated and absorbing. It can also be great fun – according to how you approach it. Oddly enough, although a camera may record many happy moments, *humour* in a photograph is a very fugitive quality. It is generally agreed that a really funny photograph is a rarity very difficult to achieve. When it does happen, it is usually through good luck! The fun lies not so much in striving to be funny, as in getting away from conventional picture-making and trying something a little different.

The Story Sequence

A series of pictures which tell a story is well within the scope of the average camera; true, the fast-working miniature may simplify and speed up the actual taking, but much depends on the nature of the subject. The secret of success, in most cases, lies in careful thought and preparation, and in being able to anticipate actions.

Children and animals, either together or individually, are natural subjects for a story sequence. Give a child some novelty, or let it do something it has always wanted to, but has never been allowed to do, and the alert cameraman will get lots of good pictures. Festive occasions, such as birthday parties and Christmas (eve and morning) are obvious opportunities.

Plan your procedure well in advance. For example, a Christmas sequence might begin with: (1) a picture of the child or children in pyjamas, peering enquiringly up the chimney; (2) asleep in bed with Santa note pinned to the stockings; (3) same shot,

but with array of toys, parcels, etc., around sleeping child; (4) child opening presents next morning (if you're up early enough!); (5) the Christmas meal; (6) pulling crackers at Christmas tree.

Only one lamp is needed for Nos. 2 and 3, because the white bedclothes act as a reflector and so lighten the shadow areas.

If you wish, your story sequence can be lengthened by shots of the child going upstairs, being bathed and dried, and similar actions. Outdoors, the scope is limited only by your own resourcefulness and imagination. The series may be hanging out washing, putting up a tent, helping in the garden, feeding the pets – anything, in fact. Remember to get the camera down to the child's level whenever possible. If you don't complete your story in one day, make sure the child is not dressed differently when you resume operations.

Animals are also splendid subjects for a picture series. Food and titbits constitute the bait. Two or more young and playful animals can be particularly rewarding – if you can handle them. Always be prepared to take many more pictures than you are likely to need. It is easier to construct a series from, say, 24 exposures than it is from 9 or 10; and it does not always follow that consecutive shots will make the best continuity. For example, exposures 1, 2 and 5 might be more smoothly arranged as 1, 5, 2. Take your pictures first, sort them out afterwards.

The Amusing Picture

If the comic picture is hard to come by, the happy one is a more hopeful proposition. Humour forced is humour lost. Natural reactions and unexpected situations are better than planned clowning. The unexpected situation can be created for your unsuspecting victim, and subsequent expressions and actions caught by a fast shutter. In this vein there have been pictures of children soaking each other with the garden hose or about to tickle a sleeping parent with a feather or piece of string.

The practice of dressing up animals in hats, spectacles, etc., with a view to getting a funny photograph, cannot be too strongly deprecated. Usually the result is more pitiable than amusing, and it is never funny for the animals.

Another popular target for the camera, which seldom succeeds in its purpose, being more quaint or puzzling than mirth-provoking, is the mis-shapen vegetable or fruit. Odd-looking potatoes are supplemented with matchsticks and beads in attempts to caricature some human form or creature.

Contrasts

Quite an amusing note can be introduced when making up an album by pairing contrasting subjects. This technique has been widely exploited by well-known publications which may depict, for example, a person in a particular attitude, and on the opposite page, an animal, vegetable, gargoyle, etc., exhibiting similarity of form and feature.

The process is limited, a large number and range of photographs from which to choose being obviously needed. A little ingenuity can help, however. Suppose you have a photograph of your cat yawning or stretching; a co-operative youngster or adult could repeat those actions.

Contrasts in real life can be interesting, too. A very young kitten and a tame bird, a rabbit, a mouse, each with the other, can provide splendid picture material. Shutter speeds need to be as fast as possible. Electronic flash, if available, is ideal for such subjects.

Double-Exposure

If you want a picture of someone giving himself a cigarette, sitting chatting to himself, or in other words appearing twice in one picture, you resort to double-exposure. A dark, plain background, preferably black, is essential, and it must be free from folds or creases which might catch the light. The subject should be dressed in light or bright clothes, and the camera placed on a tripod or firm support such as a table.

Arrange the lighting so that the background is in shadow (i.e. side-lighting) – it can be done with ordinary room lighting if you don't mind the longer exposures needed. Get your subject well to one side in the viewfinder, and have him offer a cigarette to an imaginary someone on the other side. Make a normal exposure after focusing, but *do not wind on the film*, and be careful not to move the camera.

Now get him to move so that you see him in the other side of the viewfinder, but this time he pretends to be taking the cigarette. Make sure that no overlapping occurs, keep a small space between the two poses and try to get height of arm in appropriately matching position. Now make a *second* exposure on the same film, and you have done the trick. With careful placing, a number of exposures can be made. Using the delayed action device on your camera, you can take twin pictures of yourself in this manner, if you wish.

Most good cameras nowadays have interlocking film wind and

shutter tensioning, which normally prevents double exposures being made. Cameras like the Rolleiflex have a 'wind-back' device which allows the shutter to be re-cocked without advancing the film, A trick on most 35 mm. single-lens reflex cameras, is to make the first exposure then advance the lever *while keeping the rewind button depressed*. This will re-set the shutter without advancing the film. If the re-wind button is so placed that the camera must be removed from the tripod, be sure to study the viewfinder carefully first – so that the camera can be replaced in the same position.

The double-image trick is also easily produced by the use of a mirror. Set up the camera slightly to one side of the mirror and have the subject towards the other side, but close to it. He or she should now look into the mirror so that you get profile and full-face in one exposure instead of two. This treatment is particularly effective for portraits of women. Have them seated at a dressing-table, or holding a small hand mirror, and applying make-up. For focusing, you must *add the distance between the subject's face and mirror to the distance between camera and mirror*, and not just simply focus on the mirror itself.

Table-top Photography

By putting a supplementary portrait attachment on your lens, so that it will focus fairly closely, or by using a long-focus lens, you can have great fun with table-top photography. Amusing models, toys, scale models and cut-outs are the basic subjects, in settings contrived from all sorts of materials; the scope is limited only by your own ingenuity and imagination. The 'rules' of composition apply exactly as for full-size subjects, and, at such close distances, lens apertures of $f/8–f/22$ are necessary for adequate depth of field.

Lighting is of first importance. If you are simulating sunshine, two sets of shadows, created by using two lights, should never be allowed. Ordinary household lamps are quite suitable for lighting and may be used in conjunction with a portable stand, a reading-lamp or anglepoise, with reflector, shade or diffuser, according to requirements. A focusing spotlight is a most useful accessory for putting light exactly where it is wanted.

Fundamentally, the art of table-top photography is to create in miniature some scene which has its counterpart in reality or fairy-tale whimsy. It can be symbolic in theme, abstract, fantastic or natural. But whatever the theme or intention, too much detail of a complex setting will lessen its chances of success.

Outdoor scenes can be imitated by using the following materials: sifted soil, spread to make the ground; rocks, small pieces of the real thing; roads and pathways from sifted sand poured on to cardboard coated with adhesive. Smooth lawns, from velvet of a colour that will photograph in similar tonal register to grass. Trees in leaf are difficult to produce. Crêpe paper crumpled and draped around bare twigs, or trimmed portions of evergreens suitably wired are often used. Bare trees can be simulated by the stalks from bunches of grapes. Little twigs will also serve if carefully selected and trimmed.

Snow can be common salt or caster sugar. Water: 'Cellophane', dry-mounting tissue or muranese glass – these need back-lighting; buildings, from cardboard and cardboard tubes, distempered or coated with poster paint.

Sky backgrounds (kept out of focus) can be cardboard sheets, appropriately painted, or an enlargement from a suitable cloud negative. Figures, scale models, dolls, etc., can be introduced as desired. 'Plasticine', wires, thread, small pieces of wood – all are useful materials to have on hand.

Sometimes a very shallow depth of field assists the impression of realism in a scene, and it is then best to use a larger lens aperture. Correct scale, viz.: size-relationship between figures, objects and settings, is essential.

Another way of constructing these miniature scenes is to place the objects on a sheet of glass supported at the four corners so that it is some distance from the background below it. The camera viewpoint is from above this set-up, pointing downwards, and by using more sheets of glass at varying distances below the first, and varying the lighting, the effect of receding planes can be achieved.

Trick shots of falling playing-cards, breaking crockery (similar to those genuine shots obtained by electronic flash) are possible by careful arrangement on the glass, and the technique is very useful for shadowless photography of small objects.

Stereoscopic Photography

Stereoscopic photography, or '3-D', as it is now popularly called, is great fun. Any camera can be used for this if the subject is completely static. You use a stereo slide which allows of a sideways movement (about $2\frac{1}{2}$ in.) of the camera on a tripod, and so produces two separate exposures, one after the other, from slightly different viewpoints.

Moving objects and everyday scenes need an attachment on

the camera lens which produces two separate pictures side by side on the film in one exposure. Thus with 35 mm. cameras you get two such pictures, which go to make one stereo pair, size 18 × 24 mm., on one frame. Cameras made solely for stereo work, are also obtainable, but since these are in reality two cameras in one, they are inevitably expensive.

Stereoscopy is based on the principle of binocular vision, i.e. one eye sees objects at a slightly different angle from the other, thus, conveying the sense of depth, roundness and solidity to the brain. A camera with its single lens cannot do this unless it is moved sideways within limits approximating to the separation distance between the human eyes. Alternatively, a 'double' camera (not to be confused with the twin lens reflex) or a device to attain the separation optically is needed.

In order to ensure that the left eye does not look at the right-hand picture and vice versa, a viewer is also required. The ultimate effect of naturalness is obtained by stereo pairs on colour film. These must be accurately mounted in masks between glasses. Any tendency for one transparency to be set higher than the other, or slightly skewed, will spoil the effect and make for discomfort in viewing. Aligning the transparencies in the masks when making up the slides is best accomplished by means of a stereo mounting jig. This little piece of apparatus will save much time and frustration.

In taking these stereoscopic pictures, it is a good plan to have some object in the near foreground, because this adds to the feeling of depth. A fairly close approach to your subject also helps. Any object or limb which stretches out towards the camera will have a marked stereoscopic realism. Near viewpoints covered by a wide-angle lens can produce pictures which are strikingly stereoscopic, but you must beware of distortion.

Only one person at a time can see the pictures in a hand-held stereo viewer, but special projectors are available which throw stereoscopic transparencies on to a screen, the viewers wearing spectacles fitted with polarizing filters. This system is similar to that which was adopted in many cinemas for 3-D films.

Colour Photography

If you have never taken a picture in colour, there is a great thrill awaiting you. No doubt you were delighted when you got back

from your photographic dealer your first roll of black-and-white film with prints. That fascination and delight will be even greater when you see the first colour film you have taken yourself.

A whole new world of photography will be opened up, bringing with it greater realism, fresh fields to conquer, and limitless subjects. All this is made possible for the owners of quite modest camera equipment, because colour photography today does not call for special apparatus or specialised knowledge. The film is used in much the same way as monochrome film; you load it into your camera, focus, and expose just as before.

But exposure must be accurate. Colour film has not the same latitude as ordinary film, so an exposure meter, preferably photo-electric, may be a necessity under certain exacting conditions, and is always helpful.

Don't let this lead you to think that colour photography in practice is both difficult and complex; it is neither. The intricacies have been attended to by the manufacturer, and there is no need for you to study the theoretical aspect unless you intend to do a lot of colour work.

The Principles

The important thing to grasp is that the entire principle is based on the use of coloured *light*, not coloured *objects* or *pigments*. Daylight, which is called 'white' light, is composed of the three primary colours, red, green, and blue. Now, if you mix paints of these colours, the result will be very far from white. Mixing *light*, therefore, is a very different thing from mixing pigments. For instance, red and green light mixed together produce *yellow* light! Red and blue light give shades of mauve, purple and magenta, while green and blue light give green-blue to blue-green shades.

Although all the scenes and objects around us are full of both bright and subtle colourings, we are looking at *reflected daylight*. None of the objects *produces* or *emits* any special light of its own, but all *absorb* certain rays of the spectrum while *reflecting* others. It is this reflected light which gives things their colour.

A leaf, for example, absorbs the red and blue rays, reflecting back only the green; a red berry absorbs green and blue rays, reflecting back red; a grapefruit absorbs blue rays, reflecting back the mixed red and green rays, which, as previously stated, produce yellow light.

All the subtle colourings and shades between these primaries are simply proportional variations of the mixtures. If we can

130

record the various *amounts* of red, green and blue light contained in any particular colour, we can evolve processes which reproduce that colour.

Modern Colour Films

Today's colour films are of two basic types: *reversal*, which gives natural colour pictures on the film itself for viewing or projection, and *colour negative* film which is printed on to special paper to produce colour prints. Most negative films are for use in daylight and/or electronic flash, blue flashbulbs and photoflood lighting (with appropriate filter); some are also usable in artificial light without a filter. Reversal colour film in 35 mm. size is the most popular among amateurs; the purchase price usually includes processing – the transparencies being returned card- or plastic-mounted ready for projection. Exceptions are Ektachrome and Ferraniacolour; home-processing kits are available for these. Alternatively, your dealer will get them done for you. Colour prints *can* be made from transparencies, too.

The structure of a reversal film is the type known as 'subtractive' because the dyes subtract from white light the colours which are not required, and it works in this way: it is coated with *three* emulsions, each sensitive to *one primary colour*. The top emulsion is sensitive to blue, the middle one is green-sensitive, and the bottom layer is red-sensitive. As *all* photographic emulsions are sensitive to blue light, a yellow filter is incorporated in between the top and the middle emulsions to prevent blue light affecting any but the top layer. When the film is exposed and processed, the three images formed in these emulsions combine to present a picture in natural colours.

Exposure

Reversal colour films do not possess the latitude (margin of error in exposure) of black-and-white films, so exposure must be accurately calculated. Over-exposure has the effect of producing washed-out colours, and under-exposure gives dense, heavily coloured results with what is known as 'over-saturated' and degraded colours. In both cases the colour-balance will be incorrect and unacceptable.

It *is* possible to use exposure tables provided that lighting conditions are simple and straightforward. Strong contrasts, backlighting, etc., must not be attempted without a reliable meter, but

this does not mean that the film is incapable of dealing with such lighting.

Here are the speeds of some reversal type colour films:

	ASA		ASA
Agfacolor CT 18 .	50	Ektachrome-X . .	64
Agfacolor CK 20 .	80	(Daylight)	
(Artificial light)		High-Speed Ektachrome	160
Kodachrome II .	25	(Daylight)	
Kodachrome-X .	64	Kodachrome A	
		(photoflood light) .	40

All colour films have an instruction leaflet with exposure guide tables enclosed in the carton; followed sensibly, these tables will give you a remarkably high percentage of successful results in 'average' conditions. As with monochrome films, the faster ones have more latitude and less contrast than the slower; they are also grainier and slightly less sharp.

It must be pointed out that personal taste influences 'correct' exposure to a certain extent. In black-and-white photography, some people like a thin negative, while others prefer a rather more dense one. So it is with colour transparencies, a tendency to pale pastel shades often being considered preferable to vivid, bright colourings. This *depth* of colour required should not be confused with subject matter; many subjects would look obviously wrong in strong colouring, and there are others which would look unnatural in pale colours.

Another factor which arises is that camera shutters (unless scientifically checked) and exposure meters are seldom identical in performance even though they are of the same make. Once you have become accustomed to a certain film and its behaviour in *your* camera, calculating exposure with your meter should create no serious difficulties, and consistently good results should be obtained.

Once a colour film has been exposed, it should be processed fairly soon. Two or three weeks' delay is not likely to have any adverse effect, but it should not be stored for 6 or 8 months after exposing, as this will upset the colour balance. Processed film, of course, is stable, and reasonably permanent if carefully stored out of the light.

Using a Meter for Colour

If you have been getting good results in black-and-white by using some form of calculator, with an occasional bit of guess-

work, you are advised not to follow the same procedure for colour. Colour film is more critical regarding exposure than black-and-white, and a tolerance of half a stop under- or over-exposure is all you should allow yourself – not even that, if possible.

Correct use of a good photo-electric meter is a must if results are to be of a consistently high standard. Never make the mistake of giving 'a bit more for luck'. Use the meter accurately. If the important part of your subject in which you wish to show good detail and colour rendering is dark, approach closely so that the meter will not be influenced by surrounding, brighter parts. If the general view is very light in tone, stick to a general reading and ignore small, dark areas. If highlights are over-exposed, the colour transparency will have no colour at all in those parts; it will simply appear as clear (or nearly clear) gelatin. Under-exposure leaves traces of dye throughout the three emulsion layers, giving heavy and degraded colours.

Don't regard pure white or black as *colours*; the former is the sum total of all colours, and the latter is minus colour. Pure black is seldom encountered in nature. White, on the other hand, may be pure in itself, but the chances are that it will be reflecting, to a greater or lesser degree, any nearby colour. This phenomenon is known as colour cast. If we photograph a girl lying with her face close to the grass, our eye may fail to tell us the truth. We *know* she has a creamy complexion, and to an untrained eye that is all that is seen. The film, on the other hand, will see the green cast reflected from the grass and give us a truthful, but unpleasant, portrait. In such cases, a white towel, or even a newspaper placed on the grass just out of sight of the viewfinder, will serve the double purpose of keeping the skin tone pure and reflecting light into the shadow areas.

A white flower, for example, if near to lightly coloured blooms, will exhibit a tendency towards their colourings, and in any event, shadows between the petals will be slightly tinged with blue from the sky.

With experience, speedy analysis of the relative colour content and balance of a subject and its effect on colour film becomes more or less systematic, and you will readily recognise the best areas in which to take your meter readings. Simply pointing it at a scene from the camera viewpoint is *not* the way to success in colour photography. Remember that due precaution regarding shading the meter cell from too much light from the sky must still be observed.

Other Methods

In the case of close-ups, particularly, one of the best ways of determining exposure for colour film is to use an incident light meter. This is pointed *towards* the camera from the subject position, and is very accurate for colour work, especially in artificial light.

Whichever method you adopt, if you wish to get a high percentage of successful results, use a colour-film for a series of test exposures, keeping detailed notes, then you can arrive at practical information for use with *your* meter, and decide on the speed rating to produce the sort of transparencies you prefer. One film exposed in this way will teach you a good deal about its characteristics, and what happens when you over- or under-expose, besides providing a reliable basis for all future working.

Even when you are accustomed to colour film, if you come across a particularly tricky or important subject, it is often advisable to make three exposures: one as per meter reading, one half a stop *less* in aperture, and a third, half a stop greater. One of these three should turn out to be the right one.

Accessories

In addition to a meter, your accessories should include a lens hood, tripod, and flexible cable release. There will be many occasions when the exposures will be long enough to require a tripod, and it is advisable to use one with a miniature camera whenever shutter speeds are slower than 1/30 second, even if you can hold a larger camera steady. In any event, make 1/30 second the slowest hand-held speed, *and hold the camera still*!

Normally, filters are not needed with colour film in sunlight, but in certain circumstances the colourless UV (ultra-violet) filter may be used with advantage. It should be used wherever the ultra-violet contents of the light is high, such as in coastal areas, on beaches and seafronts and for snow scenes. At high altitudes it is essential, also at sea, and when photographing in the shade, even on a sunny day.

This filter reduces any tendency to blueness or cold colouring effects due to scattered ultra-violet light, to photographing in the shade, or in cloudy weather. No exposure increase is necessary. It is a good idea to keep a UV filter permanently in place over the lens, especially if you own an expensive camera. It will not add appreciable warmth to a sunny subject, will remove excess blue from colder subjects, and will always protect the delicate surface of that expensive lens. After an accidental knock, or a

few years of imperfect cleaning and polishing, it is far cheaper to replace the filter than to have the lens itself treated.

Before investing in an optical glass UV filter, why not buy a cheap gelatin one from the Kodak range (Kodak Wratten 1A). Mount this in a piece of card or a filter holder, and take a few comparison shots in sunshine and shade, and on a sunless day. Repeat each shot with and without the filter, and if you like the result, you can then buy the more expensive item. Gelatin filters, if mounted without stress, will perform perfectly, but they are delicate and easily marked.

For taking colour photographs in artificial light, e.g. photoflood lamps, a special bluish correction filter must be used with daylight reversal films. This requires an exposure increase; a tripod or firm support is therefore necessary.

Although hardly an accessory, a white reflector card or cloth (or even paper if it can be supported) is a great help in many close-ups, and extension tubes can be used, too, just as they were for black-and-white close-ups. A coated lens is not essential, but is an advantage because it helps to preserve brilliance of colour rendering.

Approach to Colour

When you load up with your first roll of colour film, you're almost certain to look for the most brightly coloured scenes you can find on which to expose it. Practically everyone does at first. The more vivid the colour, and the more colours there are, the greater the temptation. Perhaps it is a reaction from the limitations imposed by monochrome film, or it may be an urge to see if colour film is as good as the manufacturers say it is.

After a while the novelty of colour for colour's sake wears off, and you discover that brilliant variegated beds of flowers and 'fruit salad' do not necessarily make the best pictures. You will also find that the film tends to reproduce colours slightly brighter than they really are. But in a good transparency this extra brightness is negligible, and the result when projected may be regarded as being reasonably faithful and certainly very acceptable.

It does not follow that subjects of pale, even colouring are best. It is all a question of discrimination and taste. Simple colours, harmoniously blending, yet with small areas of saturated colour to give 'lift' and interest to the whole, provide the safest material. Remember that brilliant colours have a more telling effect in small quantities than in violent splashes. Too much is likely to give you merely a pretty-pretty picture.

Most people are relatively unobservant where colour in everyday life is concerned; only those who have trained perception, such as artists, readily *see* the colour content of a scene. The man-in-the-street does not easily accept the fact that shadows have colour, even if he could be persuaded that reflections are colourful. Confronted with a transparency for the first time, he would probably consider it too highly coloured.

It takes time, experience, and sensitive perception to appreciate the more subtle aspects of colour, but at least the beginning can steer clear of subjects which produce startling colour effects.

Reflected Colour

Remember that childhood game of picking a buttercup and holding it under a playmate's chin to 'see if he liked butter'? This probably represented your first awareness of the fact that colour can be *reflected* from nearby surfaces. Shiny, bright and light surfaces reflect bright colours to a marked degree, and the nearer the colour is to such surfaces, the stronger the effect. Faces, arms – any bare flesh – can become tinged by reflected colour, as we have already said.

These coloured reflections from other objects can be quite disturbing in colour photography unless they are carefully handled. Another instance, if you photograph a child in a white dress, sitting on the grass in bright sunshine, green light will be reflected on to the dress and certain parts of the face. You may not notice it at the time of taking, because the eye accepts these things without conscious awareness, but the colour film will record it, and you may then question its truthfulness. You may even think that something has gone wrong with the film.

Sit the child near water, and see how it reflects the blue sky into those same areas. Let her hold a bright red scarf, and note how dress and face become tinged with pink. A coloured dress, if at all bright or light (there is a difference), will throw some colour under the chin.

Reflected colour is particularly unacceptable when the coloured object directly responsible for it is not visible in the transparency. Thus, if the red scarf was not shown, its coloured reflection would be very puzzling, and the transparency would be considered faulty.

Colour of Light

Although daylight is termed 'white light', at certain times and in certain conditions, its colour balance varies considerably. In

early morning and towards evening, red predominates slightly. Winter light is more blue than summer, while blue and ultra-violet become very marked at the higher altitudes, e.g. in mountains.

Direct sunlight is always warmer in colouring (redder) than the light in shady areas. So if you take a portrait in full sunshine, and then move your model to a shaded spot and take another (measuring exposure carefully in each case), you will find the second portrait to be much bluer and colder in colouring than the first. Similarly, cloudy, dull days tend to produce slightly bluer colourings – hence the advice to use an ultra-violet filter in these conditions.

Pictures taken at sunset, and landscapes and general scenes taken in late evening, with the sun's rays at a very low angle, can be most attractive; but not portraiture. The mellow, reddish-yellow rays will play havoc with fleshtones. Your model will reflect those rays, and look reddish in consequence. On the other hand, a model silhouetted to offset a sunset, late evening, or early morning scene, can be most effective.

Weather changes greatly influence the colour of lighting. After an April shower, for instance, the sunshine can be startlingly bright and yet 'cold'. Its brilliance produces harsh shadow pockets, all strongly reflecting cold blue light, often accentuated by surrounding puddles and general wetness. Later in the day, another shower will provide lots of yellow lighting; later still, lots of red. Sometimes these colours are obvious, sometimes so subtle that they are not noticed until after a colour picture has been taken. If you want to photograph that rainbow, it can be done successfully if it is fairly strong in colouring and exposure is slightly shortened.

Don't be frightened of such 'unconventional' lighting, though. Experiment with it, because from time to time it will produce one of your most treasured transparencies.

Kind of Light

The conventional kind of lighting for outdoor colour pictures is soft sunshine, slightly diffused by the lightest of clouds. This gives even illumination and modelling without creating harsh contrasts and shadows. Bright sunlight, providing there is not too much expanse of blue sky, will give almost as good results. With really deep blue skies it is advisable to use the UV filter (or the very similar 'Haze' filter, as some manufacturers call it) to reduce the blue influence.

Since colour film has little latitude, harsh sunlight is best avoided unless some special dramatic effect is required. Unusual lighting, such as accompanies or precedes a storm, can be most effective with the right kind of subject, e.g. open landscape, street scenes, etc.

Mixed lighting (i.e. daylight and artificial) is quite unsuitable, no matter how balancing is attempted. This is because their *colour* (usually expressed as 'colour temperature') differs greatly. At night, photoflood lighting or flash can be used, in conjunction with the manufacturers' recommended filters, or else with the appropriate type of colour film.

Direction of Light

When you first use colour films, it is wise to take subjects in more or less frontal lighting, then you won't have any difficulty with deep shadows, as these are thrown *behind* the subject. In monochrome photography this arrangement would be bad, because of the lack of modelling, but colour contrasts and varying depths of colour now save the day. Flat, frontal lighting facilitates determination of exposure, for the sun is practically behind the camera, i.e. right on the subject.

As you gain experience, and progress to more ambitious subjects, so you can vary the lighting angles. Some photographers will tell you that colour film cannot cope with strong contrasts, but this is not so. After a time you will find you can successfully take subjects in back-lighting and strong side-lighting – it is all a question of being able to assess the suitability of the subject, and calculating the exposure in respect of colour and lighting balance. Such lighting is well worth seeking because the projected transparencies appear almost stereoscopic in their realism.

White or pale cream reflectors should be used whenever possible with side- or back-lighting, to throw light into the shadow areas. Probably this will only be possible in the case of close-ups and semi-close-ups, because at greater distances the reflectors would need to be of considerable size to have any appreciable effect. Some colour films have a contrast range of 1–50; this means that the darker parts of a subject should not need more than 50 times the exposure required for the lighter areas. In practice, however, this range may be doubled, i.e. considered as 1–100, without seriously upsetting the result.

Back-lighting is tricky with semi-opaque subjects such as flowers and leaves. The best way of dealing with these is to hold the exposure meter within an inch of the subject (almost touching it),

138

so that the sun's rays come *through* the flower or leaf before reaching the meter. Use the reading without alteration in the case of light blooms, open up half a stop larger for dark flowers.

Don't be afraid of trying difficult lighting if you have a reliable meter, but, if you haven't one, stick to the conventional angles. If you remember that lighting should be softer than for black-and-white film, and avoid large areas of dark shadow, all should be well.

Composition in Colour

Composition, or the arrangement of your subject in the picture area, presents problems in colour different from those encountered in monochrome photography. Colour is the all-important feature; directional or leading lines, disposition of balancing masses, patterning, are now subservient to it.

This does not necessarily imply that the fundamental principles of pictorial composition can be cheerfully ignored, but neither does it mean that by adding colour we greatly increase the difficulties and complexities of composition. Briefly, it now becomes necessary to study the effect of *colour contrast* as well as lighting contrast. We must beware of colours which clash when near each other, especially if they are at all brilliant. Bright red and green side by side can easily become too assertive, as can yellow and blue, while vivid red next to vivid blue can be positively glaring.

Even worse effects are produced when blue-green is close to blue, or vermilion close to magenta. Some people have a flair for colour, and can sense subtle blendings, contrasts and clashes more readily than others.

Whereas in black-and-white photography differential focusing (i.e. keeping only the subject sharply in focus and throwing background and setting out of focus) was a useful trick to aid composition by forcing the interest onto the one sharp area, this cannot always be resorted to with colour. A brightly coloured object which is out of focus is most irritating to the eye. With soft, darkly coloured areas the effect is less troublesome.

Thus we have seen that composition in colour is influenced by: *(a)* colour-contrast and depth, *(b)* blending and matching, *(c)* focus. Of equal importance is the *grouping* of the colour masses, i.e. their disposition in the picture area. Don't have a vivid colour near the edges of your picture, for it is certain to pull the eye in that direction. In monochrome photography the effect could be

subdued during enlarging by giving extra exposure in that part, but nothing can be done about it on the colour transparency.

We also come up against another snag – one of our own making this time. Having trained ourselves to ignore colour the better to sense compositional balance for black-and-white pictures, we now have to go into reverse, and put colour before all else. And this is something which cannot be accomplished overnight; it takes time and application, but you *can* train yourself to do it.

If you are working with two cameras, one loaded with colour and the other with monochrome film, you may well find that the technique for the one is apt to become fused into that for the other, with disastrous results for both. Remember, you have to discipline yourself until perception becomes as automatic as gear-changing is for the experienced motorist. Many top photo-journalists simply refuse to cover a story in both black-and-white and colour at the same time. Entirely different thinking is required and it is not possible to switch back and forth quickly. Take a tip from these experts – it is always possible to get a black-and-white print, if necessary, from a colour negative or transparency.

The placing of a salient feature of a scene on a 'third' of the picture area, the balancing of shapes and masses, etc., still hold good in colour photography. Try to arrange things so that the warmer colours are in the foreground, while the colder (blue-green) ones appear in the background. Such placing is satisfying to the eye because in nature the more distant scenes and objects appear progressively bluer as they recede. Reverse this order and the result is bound to look odd.

A background colour should never be brighter, more saturated, than that of the foreground subject. Obviously you cannot re-arrange the everyday scene to comply with all these ideals, but knowledge of them will almost certainly help in the selection or rejection of a scene.

Portraits in Colour

The very faithfulness with which colour film is capable of depicting flesh tones can become a handicap in colour portraiture. In its honesty, it will record every tiny blemish and personal characteristic in a way which may be considered unflattering by the subject, particularly with head-and-shoulder close-ups. For ladies, therefore, make-up with a good covering base is essential.

Strong sunshine causes frowns and wrinkles, yet if you move

140

your model into the shade, you are liable to get a cold bluish colouring. The remedy is to take the portrait in hazy sunlight, using white reflectors to lighten the shadows if necessary. Don't stand the model close to foliage, or any brightly coloured objects unless they have red-to-pink tendencies which will blend as reflected light with the flesh tones. Blossom fulfills this function naturally, and its reflected light can be actually helpful.

Against-the-sky portraits are effective only if there is no deep blue or many fussy clouds.

Since it is a fiddling business to cut out unwanted parts of a colour transparency by masking, try to fill the frame to the best advantage at the time of taking, whatever the subject. A long-focus lens is helpful in this respect.

Indoors, use photoflood lamps or studio lamps with artificial-light type colour film; or blue flashbulbs or electronic flash with daylight-type colour film. There is no need to remove the UV filter from the lens, and with those electronic units that have a tendency to blueness, the filter may actually be a help.

Exposures for two photofloods (No. 1) used in reflectors between 5 to 8 ft. from the subject (one as main light the other as fill-in for the shadows) are around $\frac{1}{2}$ second at $f/2.8$ with Koda-chrome II 'A'. Ordinary electric light bulbs not only give insufficient light, making exposures with colour film rather too long to be practicable, but their light produces reddish tints, falsifying the colour rendering.

Keep lighting contrasts soft and flat, and make sure that the sitter is not getting reflected coloured light from nearby walls. Coloured wallpaper will reflect light of its own colouring. The technique outlined in Chapter Seven (Portraiture) is also basically applicable to colour portraiture. If a coloured background is desired, it must be carefully chosen to suit the sitter's colouring and clothing; a neutral one is usually safer. And it is advisable to have an additional lamp lighting the background, which may otherwise look dead.

Owing to the relatively long exposures required by photoflood lighting, pictures of groups or children indoors are more easily taken by flash.

Landscape and General Scenes

The countryside around you will spring to life when photographed in colour. Don't try to crowd in everything, and be very wary of deep blue skies devoid of clouds. These lighting conditions create blue light, and cause the sky to dominate the pic-

ture. Too much haze, on the other hand, is likely to upset things in an open view.

As in monochrome photography, exposures should not be made between 11 a.m. and 3 p.m. during June, July and August because of overhead lighting. Don't have empty foregrounds, or the suggestion of distance will be largely lost. Early spring and autumn are ideal times for photographing in woods and copses. Manufacturers often suggest a pale blue filter (such as the Kodak Wratten 82A) to counteract the yellowness of sunlight in early morning or late evening scenes. Whether one does this or not, is a matter of choice. Although theoretically correct, the effect is largely to alter the lighting to that of noon sunlight, and it is, after all, the unusual light effect that probably attracted us to the scene in the first place.

The rules of colour grouping and contrasting still apply. If you try to crowd a field of mustard, poppies, pasture, cattle and beautiful cloudscape all into one picture, you will produce a kaleidoscope of novel, rather than pictorial, pretensions. Keep it simple, and you're half-way to success Don't think it a waste of film to take snow scenes in colour. Heavily laden branches, fences, etc., make splendid subjects.

Homes, Gardens, Flowers

These are, of course, admirable subjects for colour film. Calculate interior exposures by taking readings near the window and again in the deepest shadow parts and using the mean exposure of the two. Don't include the window(s) in the picture if you can help it – the incoming daylight will only 'burn out' the details of the frame and curtaining.

If contrasts are still too great, a blue flashbulb or electronic flash can be used to supplement the daylight in the shadowed areas. The lens aperture must be stopped down sufficiently to ensure that all the room is sharply in focus, so a brief time exposure will probably be required.

Outside, keep the gate half or fully open when you photograph the house and front garden. It will look much more inviting than if the gate is shut. Naturally you will choose a time when the flowers are at their best.

The garden itself is often more effectively photographed in portions than in its entirety. Keep bright colours in the foreground. Even spreads of colour look better than multi-coloured borders, so select your viewpoint accordingly. If the camera is too high, you will dwarf small flowers into insignificance; if it is

too low, only those in the foreground will be seen, unless the plants are systematically banked. Tall flowers such as hollyhocks, sunflowers and standard roses, look well against a sky that is not *too* blue.

Close-ups

The subtle textures and delicate structure of small things like individual blooms, buds, insects and fungi are superbly rendered in close-ups with colour film. Supplementary or long-focus lenses, or better still, extension tubes on a single-lens reflex, will record these tiny details in a surprising way. Projected, or viewed at magnification, these are among the most attractive of subjects.

Flat or frontal lighting will destroy texture; 45° lighting with a white card reflector to fill in shadows is more suitable. The meter must be held very close to the subject, but not so close that its own shadow affects the reading. For imparting the utmost brilliance to the subject, a black card background may be arranged. Focusing must be strictly accurate and a small aperture used. Make allowance for parallax error, and for the exposure increase required if the lens is extended. A tripod and cable release are essential items.

Live insects such as butterflies, bees, etc., alighting on flowers are chancy things to take, and a great deal of patience is required.

Other Subjects for Colour

Colour film can be used for practically every subject mentioned in this book, provided that adequate exposure can be given. Even street scenes at night can usually be taken in colour if you have a tripod. Either daylight or artificial light type colour film may be used for this purpose. The former will give a much warmer, but quite pleasant, result. Water colours and oil paintings can be faithfully copied. Double-exposure tricks are possible against a black background, and a story sequence of children or animals can be most attractive. A misty day can produce charming effects. Foggy days in town, with mixed lighting, are a challenge.

Once you get the 'feel' of colour, don't stick to frontal lighting and safe techniques. Experiment, try ambitious subjects and unusual angles! Stereoscopic photography in colour is amazingly life-like: by using an attachment on your camera, stereo colour, with all its realism, can be yours for the taking.

Processing Colour Film

If you would like to try your hand at processing colour film, home kits of ready-prepared chemicals can be obtained for Ektachrome, as mentioned previously; you will find it fascinating. Processing is not complicated, a developing tank, measure, film clips, thermometer, and jugs or containers constituting the equipment needed. (I find inexpensive household jugs most suitable.)

Stainless steel tanks and reels (Nikor, Kindermann, Brooks) are particularly helpful, as it is easy to rewind the wet film after making the 'second exposure'. In fact, stainless steel reels are so made that this operation can be carried out without removing the film from the reel at all. Laboratory conditions are not required, but accurate control of temperature calls for a high-quality thermometer. Full instructions for use are included with the processing kits; everything is labelled.

Protecting Transparencies

The processed colour film, when dry, needs careful handling or it will soon be ruined by scratches, to say nothing of dust and fingermarks. Roll film and 35 mm. film alike should be protected by binding up between glass. This seals them completely from damage.

Of course, the majority of colour film users send their films away for processing, and the transparencies are returned ready-mounted in card of plastic slides. These are fine for viewing, though in projection the transparencies have a tendency to 'pop out' of focus as they warm up. Important slides should be protected between cover glasses. Some firms (Perrocolor, etc.) provide special aluminium mounts in which the transparencies can be mounted, by means of a special jig, between 'no-ring' glasses. These have an invisible raised pattern on the inner surfaces, which prevents the formation of Newton's rings, those troublesome little coloured marks which sometimes occur when film and glass are pressed together. They are, however, rather expensive.

If you wish to mount your transparencies by more traditional (and cheaper) methods, cover glasses are obtainable in three standard sizes: 2×2 in. (for 35 mm. transparencies), $2\frac{1}{4} \times 2\frac{1}{4}$ in. The most reliable ones are cut from best quality selected thin, or extra-thin glass.

Black paper or aluminium-foil masks are used to frame transparencies for comfortable viewing, the picture being presented in a little cut-out window. These masks are of the same dimen-

The figure stands out clearly because the background is out of focus. This very colourful subject loses half its charm in black-and-white, but is still an attractive shot for the family album. Made from a Kodacolor negative, 6×6 cm. size.

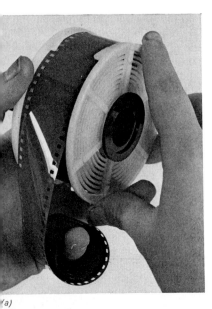

(a)

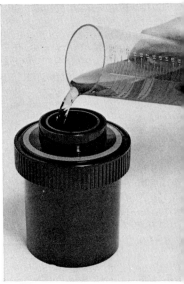

(b)

(d)

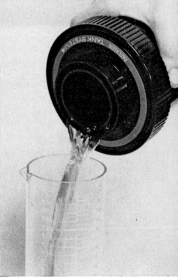

(e)

c)

)

Processing tank: *(a)* film is loaded into spiral in dark. This easy-loading nylon Paterson reel has ratchet-action which draws film into spiral as top and bottom of reel are rocked back and forth. Once reel is in tank and lid closed, developer is poured in *(b)*. Temperature of solution may be checked during processing, as variations will alter correct development time *(c)*. With cap in place on lid, this tank can be inverted once a minute *(d)*, so that fresh solution flows across surface of film. At completion of developing time, developer is poured out *(e)* and stop-bath or rinse water poured in for half a minute. This solution is then poured out and replaced by fixer. Occasional agitation should be applied in fixer as well as developer. After washing, film is wiped down with film tongs or squeezed-out chamois, and hung to dry on film clips *(f)*.

Negative-Positive: Print made on normal grade of paper from thin negative (left) is flat and lacking in contrast. The same grade of paper gives rich tones and good contrast from negative of normal density and contrast (centre). A softer grade of paper is required to obtain a normal print from harsh, contrasty negative (right).

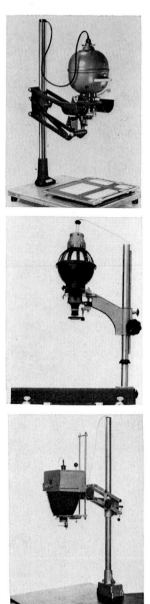

Top left: Leitz Focomat 1C enlarger stays automatically in focus as enlarger head is raised. 35 mm. format. *Centre left:* Small Russian enlarger is focused manually and packs away neatly in suitcase-type container. Ideal for occasional work where space is at a premium. *Bottom left:* Lines & Jones enlarger with coldlight head gives superlative quality from larger negative sizes. Parallelogram action and extremely long bellows extension allowing reduction as well as enlargement of image. *Top right:* J35 enlarger is small amateur model in Durst range of enlargers. Light reaches negative by reflex optical system, which has several advantages, especially coolness and evenness of illumination. *Bottom right:* Inclined column of this fine Opemus IIa enlarger gives good baseboard clearance for big enlargement.

Good styling and performance are features of this popular Perkeo J50S Automat projector. Amateurs who make many colour slides will find a projector just as important as a camera.

Kodak Carousel S provides highest possible quality and performance. Slide magazine drops transparencies by foolproof method (gravity feed) into gate. Optical quality of projected image is faultless.

This Aldis Mini projector will accept a stack of slides which need not be specially separated in a magazine, and gives good home performance at around £30.

Metal frames and anti-Newton Ring glasses provide perfect means of mounting transparencies in permanent form. Special mounting and illuminated transparency cutter are part of this Perrocolor outfit. These are expensive.

Less expensive are click-together plastic mounts such as these excellent ones from Rank Elektra.

A good foldaway screen for home viewing is far better than relying on a plain area of wall — and much brighter.

sions as the cover glasses, the window, of course, being smaller. The sandwich of film, masks, and glasses, is held together by binding tape round the edges, after the manner of *passe partout* picture-framing. Tape for this is supplied in gummed rolls and strips. There is also self-adhesive cellulose tape but, in time, slides bound with this stick together and are difficult to separate without breaking the glasses.

Viewing Transparencies

You may be satisfied to view the larger-sized colour transparencies just as they are, simply holding them up to the light, but the 35 mm. size is too small for comfortable viewing without some form of magnifier. A typical little device for this purpose is the hand viewer, which usually has a focusing eyepiece and diffusing screen behind the slide holder to provide even illumination.

More convenient still are the compact, illuminated viewers which are operated either by batteries or from the mains. Various models are available, some for 2×2 in. and others for $2\frac{1}{4} \times 2\frac{1}{4}$ in. slides. The battery-operated ones can be had small enough to slip in the pocket, while mains models generally are intended to stand on the table. Their magnified pictures are bright and evenly illuminated.

Projectors

The best way of viewing your colour slides is by means of a projector, producing brilliant large-sized pictures in full colour on a screen. Subtle detail and colouring are revealed in a way that no other method of viewing can equal. But a projector which gives an indifferent performance through inadequate illumination or other causes can easily mar the quality of your transparency, or even damage it through too much heat. So get one which combines maximum illumination with minimum heat, and with an optical system capable of providing *even* lighting and sharpness of picture right to the edges.

There are many from which to choose, ranging in price from under £10 to over £100. The inexpensive ones are suitable for use in small rooms or whenever a fairly small picture is satisfactory. Medium-priced models often have electric fan cooling, more powerful quartz iodine lamps, and provide bright pictures 4 or 5 ft. wide. 'Luxury' projectors are fully automatic, with remote control for slide changing *and* focusing, magazine load-

ing, etc. In fact, you can literally sit back and see the show with your audience, operating by means of the remote control cable.

The Screen

You can project your slides on to a plain white wall, but a cream or stone-coloured one will not serve; or you can use a large sheet of white cartridge paper, or a crease-free cloth. But these arrangements are all make-shift. Invest in a proper screen for the job! It need not be expensive – there are some low-priced models which have side struts to ensure even tension on the screen surface to keep it perfectly flat. Others are semi-automatic for speedy erection, closing down into a box base for easy storage; the most useful are those which have their own tripod stand.

The silver-surfaced screen is usable for colour projection but it tends to 'grey' the colours. Matt-white surfaces are slightly less brilliant in their reflecting powers than the glass-beaded variety, but have the advantage of being non-directional, providing as bright a picture for anyone sitting at an angle to the screen as for anyone sitting centrally. Choose a square shape, because even if your slides are not square, you will have both upright and horizontal ones to deal with, and a screen designed for cine projection will limit the height of your upright shots.

Monochrome Prints from Transparencies

If you want to make black-and-white prints and enlargements from your colour transparencies, you first make a negative on panchromatic film by contact-printing in a frame. Slow pan film (or plate) is best, and in complete darkness the *emulsion* sides of both are put into contact in the frame, and a short exposure made by the light of a 60-watt bulb. Several trials may be needed before correct exposure is found; at about 6 ft. from the bulb it may be in the region of 1 to 2 seconds for 40 ASA film.

After exposure, the pan film is developed, fixed and washed in the usual manner, and when dry, placed in the enlarger *emulsion side up*. If it is the other way, the print will be laterally reversed.

Storing Transparencies

Whether you keep your transparencies unbound in translucent negative bags, or bound between cover glasses as slides, they must

146

be stored in a place where they will not be subjected to heat, moisture or strong light. Kept in this manner they are reasonably permanent – as permanent that is, as dye-images can be. I have some which are 'as new', yet they were made nearly twenty years ago.

A biscuit tin, or similar, is a very good means of storage, provided there is no trace of rust in it. Never leave slides lying about exposed to strong sunshine, or the colours will fade. You might consider getting specially fitted slide boxes with grooves and numbered index if you wish – a popular-sized box is one which accommodates 100 slides of the 2 × 2 in. size. It certainly facilitates the handling of separate slides when you are operating the projector.

Colour Negative Films

So far, we have been concerned with reversal films which give transparencies for direct viewing or projection, but if you are chiefly interested in colour *prints* and do not wish to buy a projector, you should choose a *negative* type colour film. Most of these have the added advantage that they can be exposed in daylight, tungsten (artificial) lighting, or flash without any form of correction filter being required. This is made possible because any colour balance correction which may be necessary can be applied when the actual printing is carried out.

When you buy a colour negative film, its price does not cover the cost of processing also. Special enlargements or contact prints are undertaken by certain colour laboratories.

It should be clearly understood that colour negative films are virtually of no use until they are printed; you will get little satisfaction from holding them up to the light for viewing as you would a reversal type colour film. The reason for this is not difficult to grasp if you regard their characteristics as being basically similar to those of the ordinary black-and-white films. These, when developed, reproduce tonal values completely in reverse, thus everything which was white or light in the subject photographed is rendered black or near-black, and vice versa. In other words, the films in question are just *negatives*, an intermediate stage towards the ultimate picture.

Now let's see what happens to your colour negative film. When it has been exposed in the camera, it is processed in a colour-forming developer. This not only gives negative images (i.e. dark highlights, light shadows) as in black-and-white photography, the *colours* are reversed too, and become complementary to those in

the original subject. So we have blue skies appearing as brownish-yellow, green grass as magenta, yellow objects as blue, and so on.

The structure of a colour negative film consists of three emulsions one upon the other, each sensitive to certain sections of the visible spectrum. In effect, therefore, a single exposure on it is made to do the work of three colour separation negatives, and is literally three-colour-separation-negatives-in-one. A much more convenient arrangement. Available colour negative films are Kodacolor-X, and Agfacolor CN17 and CNS.

Colour Prints

Colour negatives are printed on to paper which has three colour-sensitive emulsions coated on it; these are similar to the three emulsions of the film itself. From top to bottom they are colour sensitive in the reverse order from that of the film, the layers having colour formers incorporated when the paper is prepared. Resembling double-weight bromide paper (but generally slower in speed), it is of course sensitive to light of all colours and has to be handled only in the light from a special safelight.

As exposures are often fairly long, negatives should be held between glass to prevent possible buckling and consequential shift in register. Filters are employed to give correct colour balance in the final print – a necessary procedure since perfect balance and matching in emulsion, dyes, etc., is not practicable in manufacture. Each of the three layers coated on the paper is exposed separately through the appropriate filter during printing.

Commercial Colour Prints

The colour rendering and general quality of the standard prints supplied commercially are surprisingly good, considering the outside influences which cause variations. Things like incorrect exposure, storage and lighting conditions can have marked effect. Besides, each make of film has its own particular characteristics; some are 'warmer' than others.

Automatic machines with a continuous band of paper produce colour prints about $2\frac{3}{4}$ in. wide, the length being determined by the proportions of the negative. EN-prints are also made on paper of fixed width ($3\frac{1}{2}$ in.), so users of cameras giving a square picture will get prints smaller than those made from the longer, oblong negatives. This is not the case, however, where special enlargements are concerned.

By the very nature of things no colour print on paper can ever

equal the luminosity and range of a colour transparency. The print, when viewed, is dependent upon light *reflected* from its paper base, whereas the transparency is viewed by *transmitted* light. Therefore, if you have previously used reversal film and become accustomed to transparencies, you will probably be a little disappointed when you first try colour negative film and receive the prints. Similarly, any colour print made from a (positive) transparency cannot match the quality of the original. To minimise this loss, some prints are made on a cellulose acetate or white opaque base instead of paper.

Judged on their own merits, colour prints can be very satisfying and rewarding. Many enthuse about them. They are easier to handle, and can be passed around among friends, mounted in an album or framed. One more thing must be borne in mind: colour prints and enlargements are not as sharply defined as those from black-and-white negatives (all other things being equal), because *three* emulsions are involved in both colour film and its special paper. This creates additional thicknesses through which the light is scattered, and the dye images tend to 'bleed' slightly.

Getting Good Results

Recommendations regarding exposure, lighting conditions, subjects, etc., are always included in the printed instruction leaflet packed with the film. The advice is based on sound technical knowledge of the behaviour of the film in question, and should not be glossed over.

It is a maxim among experienced workers that negative colour film can always stand 'a little more' exposure unlike transparency film, where the meter reading must be strictly applied. In fact, a colour negative exposed strictly in accordance with the meter reading will produce a perfect print; as will one that has been given an extra one or even two stops. Under-exposure, though, leads to washed-out colours in the final print.

It is the *final print* which restricts the brightness range when you use colour negative film, and not so much the film itself. But since the print is the end-product you are interested in, you must abide by the limitations it imposes. Whereas with reversed colour the intensity of the highlights largely determines the exposure required, for negative colour the depth of shadow and shadow detail are more important. These factors are taken into consideration in the manufacturers' printed exposure guides. When using your photo-electric meter, stick to the old rule quoted for ordinary black-and-white film, and 'Expose for the shadows'. It's

149

easy to avoid confusion if you remember that this applies to *all* negatives, whether in colour or monochrome.

Lighting

When the sunshine is so bright and harsh that it makes you squint and shade your eyes, the chances are that the lighting is too contrasty for satisfactory results. At the coast, or wherever large expanses of water are near, the actual *contrast range* may be conveniently lessened by reflectance, although light intensity is high. Generally speaking, medium-bright or hazy sunshine are preferable for most outdoor subjects, and the beginner is advised to stick to frontal (i.e. the sun shining directly on to the front of the subject), or near-frontal lighting.

Nearby subjects in side- or back-lighting are almost invariably verging on excessive contrast in bright sunshine conditions, and some form of white reflector or fill-in flash should be used to lighten the shadows.

With the exception of Kodacolor-X, no filters are needed for pictures by artificial light (Photoflood or tungsten). It is still essential, however, that you do not mix light sources of different colour quality in any one photograph. So if you are photographing people indoors in daylight, don't go switching on domestic lights or photoflood lamps to boost illumination. Similarly, for fill-in flash outdoors, use blue flashbulbs or electronic flash, both of which give light of the right colour quality (colour temperature).

You *can* use colour negative film for outdoor subjects on dull and sunless days, but you are not likely to be very happy with your prints. Cloudy, bright conditions can be acceptable with colourful subjects; scenes with soft, subtle colourings tend to become somewhat 'flat' and uninteresting. Wet days mean bluish pictures, and there's little you can do about this, unless you get sunshine between showers.

Colour Temperature

No doubt you will get lots of successful colour pictures without bothering about the technical niceties concerning *colour temperature*, but it may be as well to include a brief explanation of it in these pages. When you switch on an electric fire, the wire element undergoes changes in colour from its original grey-black, through dull red to bright orange. If the heat was sufficiently strong, the wire would eventually become 'white'

hot. Virtually the same thing occurs with the filament of an electric light lamp, only very much faster.

Obviously the quality of the light emitted changes with the temperature, so we have red radiations at the low end of the scale, and as we proceed higher, the light becomes whiter and more evenly distributed. On reaching the highest colour temperatures, radiations are rich in blue; this may cause confusion, as blue light is commonly described as 'cold'.

Since colour films are sensitized to give a true colour rendering with light of certain colour temperature, light quality is most important. Its measurement is expressed either in degrees Kelvin (°K), or by *mired* value. The mired value of a light source is arrived at by dividing its colour temperature in degrees Kelvin into 1,000,000. Colour temperature correction filters for perfect colour balance are available in specified mired shift values. The name 'mired' is derived from a contraction of the words: 'micro-reciprocal degrees'.

Some typical light-sources and their approximate colour temperatures are listed in the table below.

The Sixon, Sixtomat X3 and Sixtry photo-electric exposure meters embody a colour temperature indicator; special meters solely for determining colour temperature are also made, chiefly for the specialist and professional user.

COLOUR TEMPERATURES OF VARIOUS LIGHT-SOURCES

Light source	Colour temperature (approx.)
60-watt household lamp	2,800°K
100-watt household lamp	2,850°K
500-watt projection lamp, type B Photo-pearl lamp	3,200°K
Photoflood lamps, Nos. 1, 2 and 4	3,400°K
Clear flashbulbs (wire or foil-filled)	3,800° to 4,000°K
Daylight fluorescent tube	6,500°K
Mean noon sunlight	5,400°K
Blue flashbulbs	5,500°K
Electronic flash	6,000°K
Overcast sky	8,000°K (up to)
Blue sky	12,000 to 18,000°K

The Size Factor

Although it would not be true to say that you are not restricted in choice of subject-matter when you use colour negative film, success or otherwise is indirectly influenced by size limitations imposed by the paper print. Open, panoramic scenes on reversal film, for instance, having plenty of distant detail, can be effective when seen on the screen; picture-size can be varied at will (within reasonable limits) simply by moving the projector farther back.

Now, a sizeable colour print can be costly, and most people are content with the 'standard' prints supplied. Since these are from the whole area of the colour negative (except perhaps the extreme edges, which may be masked slightly in printing), it follows that moderately close and close subjects are best. In other words, it's a case of 'fill the viewfinder' once again. Don't leave too much space round the actual subject, but don't cut things so fine that the masking just mentioned takes off important parts.

Really close shots have impact if taken in the right lighting. Don't point your lens towards windows when taking interiors during daylight; the tonal range of a paper print, just won't accommodate inside and outside detail adequately, unless the exposure is made for the exterior, and flash used to raise the brightness of the interior. For sunlit snow scenes you need *reversal* colour film, the projected transparency will put the sparkle on the screen, whereas paper cannot reproduce such a brightness range.

Reciprocity Failure

In theory, if you expose a film for (say) 1 second to a given light-source, the result should be identical to that obtained by exposing for 100 seconds to a light-source 1/100 as bright. In practice this is not so, an unequal response results, known as 'failure of the reciprocity law'. And when you expose colour film – reversal or colour negative type – prolonged exposure may tend to induce blueness or other faults.

Different makes of colour film vary in their reaction to reciprocity effects, those intended for use in daylight generally give of their best when exposed at 1/60 to 1/250 second, and those for tungsten lighting at 1/15 second. This response weakness need not unduly worry the beginner, however; it is more important that he should not let too much time elapse between exposing the film and getting it processed.

Using Fill-in Flash

Colour-film manufacturers often advise the use of flash in daylight when lighting contrast is excessive, especially to lighten heavy shadow areas when you are photographing people. This fill-in flash or synchro-sunlight (page 122) technique can produce most attractive pictures if it is carefully done. Before you try it, first read the printed leaflet enclosed with the film; Kodacolor-X for instance, needs blue flashbulbs *only* for fill-in flash outdoors. Although I have already mentioned this, it cannot be stressed too much, because colour film is expensive.

With close subjects in strong side- or back-lighting conditions, you won't get detail in the shadow areas unless you direct light into them. The following guide applies to 'general' subjects in bright sunlight, using 27° Sch. colour film:

FILL-IN FLASH DISTANCE FROM SUBJECT (125 ASA film)

Daylight exposure	Flashbulbs No. 1B, PF1B	Flashbulbs No. 5B, PF5 B	Flashbulbs No. 22B, PF60 B
1/30 sec. at *f*/16*	4 to 7 ft.	7 to 12 ft.	11 to 18 ft.
1/60 sec. at *f*/11†	5 to 9 ft.	9 to 15 ft.	14 to 25 ft.

* Simple cameras set at '1'. With adjustable synchronisation, use 'X' or 'F' setting.
† For use with 'M' setting.

For close-ups, put two thicknesses of white handkerchief over the reflector, or use an extension lead to keep the flash at the proper distance.

Here is another method of ascertaining suitable balance. First, take a daylight reading with your meter, then see what aperture should be correct for your flashbulb at that distance *in a normal room*. Referring to the meter scale, choose the shutter speed that goes with that aperture, and expose accordingly. *Example*: you are at ten feet from your subject, your meter indicates 1/250 at *f*/8 (also 1/125 at *f*/11, etc.), and the guide number for your flashbulb is 110, i.e. *f*/11 at 10 ft. in a normal room. Using that aperture, your meter indicates 1/125 second, which is what you use.

Outdoors, where there are no reflective surfaces, your flash will in effect be under-exposing about one stop, which is all right because here it is only supplying fill-in illumination. This gives a ratio of 1 : 2. If less fill-in light is preferred, use one stop less than indicated for the flash-subject distance (interior) and use the shutter speed indicated by the meter for that aperture. Ratio 1 : 4.

Fig. 17. Reflected light reading is made by pointing meter at subject, and thus measuring brightness of light *reflected from* the subject (left). Incident light reading is taken by pointing special incident light meter (or reflected light meter with incident light attachment) from subject position towards camera, thus measuring brightness of light *falling on* the subject.

Some Common Faults in colour transparencies

Veiled highlights, dense shadows: under-exposure.

Washed-out highlights, weak shadows, thin results: over-exposure.

No picture: lens cap not removed, flash synchronisation failure, camera incorrectly loaded.

Excess tinge of yellow or other colours: filter for black-and-white film left on lens.

Excess overall blue tinge: picture taken over water, on dull or 'blue' day, or type A (reversal) film exposed in daylight without filter.

Small areas of incorrect colouring with other parts correct: film exposed in mixed lighting, or subject affected by light reflected from nearby coloured objects.

Dark shadows in back-lit or side-lit pictures: no reflector or fill-in flash used, or normal (frontal lighting) exposure given.

154

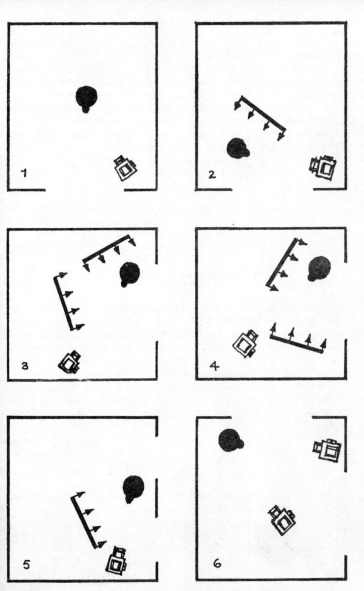

Fig. 18. 1. Frontal light provided by window. 2. Better modelling with sitter oblique to window and using reflector on shadow side. 3. Variation, using two reflectors gives strong sidelight and controlled fill-in. 4. Variation on 3. Different sitter and reflector positions should be studied in relation to window. 5. A second window provides rear light, one reflector near camera provides fill-in. 6. With sitter still, alteration of photographer's own position will change lighting effect on the sitter.

Straight streaks with coloured edges, clear areas: light leaking into film cassette or camera.

Thin highlights or heavy shadows, good medium tones: lighting contrast too great, range of subject brightness excessive.

Overall orange tinge: daylight exposures made in evening or early morning, daylight type (reversal) film exposed without suitable filter by tungsten light.

Whole picture slightly unsharp: camera moved during exposure, incorrect focusing.

Spots, specks, etc.: camera interior needs cleaning.

Irregular coloured splotches: film processing plant requires angry letter.

Developing Films

You do not need a proper darkroom in order to develop your own films. Modern developing technique for 35 mm. and roll film is by the time-and-temperature method in a small 'daylight' tank, so you do not need to be able to watch the film developing.

Everyone has some corner where the film may be loaded into the tank in total darkness; a cupboard, the bathroom blacked out at night, etc., and once the film is on the reel and the lid of the tank securely in place, all operations can be carried out by room lighting.

Most tanks incorporate a centre rod in a light-trapped port, which engages with and spins the reel in the solutions at regular intervals. This movement, called agitation, is normally required for five seconds every minute. The best tanks have a completely watertight cap, and agitation is then effected by inverting the tank once a minute – a far better method.

Requirements

(1) Developing tank. (2) Thermometer. (3) 20 oz. measure with $\frac{1}{2}$ oz. graduations. (4) Film developer. (5) Acid-hardener-fixer. (6) Film clips. (7) Viscose sponge or fine wash leather for wiping down film after washing, or film wiper with rubber blades.

To these basic requirements may be added, if desired; acetic

acid (for intermediate stop-bath, instead of plain water rinse), wetting agent (to promote scum-free drying), and a Paterson film washer (to ensure even circulation of wash water in the tank).

The process is simple: *(a)* Load film in tank in total darkness. *(b)* Develop. *(c)* Stop-bath or rinse. *(d)* Fix. *(e)* Wash. *(f)* Hang to dry. (See art section following page 144.)

The Developing Tank

There are many types to choose from, but all are made from either plastic or stainless steel. The latter are more expensive but will last a lifetime. Another advantage of stainless steel is that it is a fine conductor of heat. If the developer is poured into the tank and found to be a degree or so below the correct processing temperature, it can be placed in half a bowl of warm water for a few seconds and the heat will be rapidly transmitted. Stainless steel reels load from the centre instead of the edge (as with plastic reels) and a certain knack is required to achieve this, but special loaders can be had with certain models (Kindermann, Nikor) which make this job easy. An advantage of stainless steel reels is that they allow very free passage of the solutions across the surface of the film. This was a definite advantage in the days when plastic reels tended to have very narrow spirals but in the modern type the spirals are fairly widely spaced.

Paterson tanks are among the best plastic ones available, and in stainless steel, Kindermann, Nikor (both with hand-loaders available) and Brooks. All types are available in sizes to take one or more films at a single loading.

The process is neither complex nor tricky, and a lot of pleasure is to be had from it. There are other advantages of doing your own: if you know that a roll of film has been slightly under-exposed, you can put matters right by slightly increasing develop-ment; you can choose any developer you fancy, produce negatives of just the density you prefer, and you don't have to wait three or four days for them as you do when you get them developed commercially.

The smaller the negative, the greater the care and cleanliness required in processing, because even the smallest specks of dust will be greatly enlarged. The man who wishes to take full advant-age of the precision qualities of a miniature camera must be prepared to be *fastidious*, never neglecting to filter all working solutions, and doing everything to ensure utmost cleanliness at

every stage. Miniature technique must *never* be slipshod. This may seem irksome at first, but it very quickly becomes routine.

Loading

Make sure that your tank is perfectly clean and free from dust, but don't use a cloth duster – it will leave tiny fibres behind. If you have an adjustable plastic reel, set it for the size of film you are using. Next, *wash your hands* – yes, even if they are clean! The skin holds grease and moisture which must be removed by soap and water.

The tank must be loaded in *complete* darkness, and any room or cupboard that is perfectly dark will serve. If you do the job at night, check that no chinks of light show through the edges of doors and windows. Wait for a few moments until your eyes become accustomed to the darkness, and you will more easily see stray chinks of light. If there *are* any, stop them up.

When you are satisfied that no light in entering, unroll the film and separate it from the backing paper. If the two are joined by a strip of paper, this must be torn off, or cut with scissors just clear of the attaching strip; this is not difficult to do by 'feel'.

In the case of 35 mm. film trim the edge of the film as shown in the diagram, then switch out the light before removing the film from the cassette. It is always a good idea to wind the film completely back into the cassette for at least an hour before processing, as this will counteract any tendency to backward curl that could make loading into the spiral more difficult.

Holding the film by the edges only and with the spiral in the other hand, insert the lead edge of the film into the outer groove and carefully feed it in by pushing the film gently forward. If the tank has a 'roto-feed' device, either two little claws or ball bearings, you may have to pull the lead edge of the film through the slight obstruction this forms. Once two or three inches of film are in the outer groove, the two flanges of the spiral are rotated back and forth alternately, while the 'roto-feed' device will automatically wind the film into the grooves.

At the point where the film enters the outer groove, light pressure is applied to the film first with one thumb then the other. This stops the film slipping backwards, and is far simpler in practice than in print.

When the end of the film is past the 'roto-feed' device loading is complete.

Place the reel in the tank, lock on the lid, and switch on the light. The lid must not be removed until after fixing is completed.

Processing

Having selected and prepared the developing solution according to the instructions given with the developer, measure out the quantity required for the size of the film being developed. This solution *must* be used at the temperature recommended (usually 68° F.). The jug containing it can be stood in a bowl of warm water until correct temperature is reached; in very hot weather it may be necessary to cool it with cold water containing a little ice.

Now note the time by your watch or darkroom clock, and quickly pour in the developer – at correct temperature – through the light-trapped hole in the lid, and insert the stirring rod. Twist the rod quickly in a clockwise direction for ten or twelve seconds; this, with the automatic up-and-down movement produced by the ratchet cam in the base, dislodges any air bubbles which may have formed.

If using a tank which has provision for inversion agitation, this method is to be preferred. Agitation is repeated for five seconds every minute, which prevents uneven development.

Just before development is completed, have to hand the water rinse or stop-bath (2 per cent acetic acid solution), ready for immediate use *at the correct temperature*, 68° F.

When development time has elapsed, pour the developer into the jug without removing the lid, tip tank back and forth to remove final drops, and quickly pour in the rinse or stop-bath, agitate for a few moments and then pour away. Quickly pour in the acid-hardener-fixer *at the same temperature*, and agitate, repeating agitation occasionally during the fixing time. Less time is needed with rapid fixers, which usually contain a hardener also.

At the end of the correct time (given in instructions supplied with the fixer), pour the fixer back into a bottle for future use. Label the bottle clearly and write on it the number of times it has been used; there is less danger of over-working it then. Do the same with the developer. Pour the first wash water, at the same temperature, into the tank.

Washing

So far, the developer has blackened those grains of silver which caught the light when you took the picture, and the fixer has rendered the rest of the silver halede grains soluble in water, without affecting the blackened ones. Thus, although the image is no longer sensitive to light, thorough washing for 15 minutes

is necessary in order to remove all trace of fixer and soluble silver. If this is not done, the negatives will deteriorate, and processes such as reduction and intensification become hazardous.

Simply placing the tank under a running tap seldom gives a steady change of water round the whole film; indeed, the inner coils towards the base are barely affected. Unless you are prepared to empty the tank completely (removing the lid) and refill with fresh water at least 6 times during the 15 minute period, with regular agitation, the tap-water must be led into the centre

Fig. 19. In Paterson tank, water enters down central stem and floods upward between film spirals, providing efficient washing.

hole by a length of hose acting like an inverted fountain through all the coils of film. Washing is carried out in this manner by the Paterson film washer, a neat little device.

Note the temperature of the wash water, especially at the start. Any sudden change in it subjects the gelatin emulsion to great strain, and it is then apt to form into an orange-peel pattern. This is known as 'reticulation', for which there is no cure; so, if it is not possible to have running wash water at 65°–70° F., gradually reduce the working temperature by several successive changes, each two or three degrees cooler until it is the same as the tap water. If this is below 60°F., washing time must be increased by 10–15 minutes, but avoid the necessity if you can. A good hardener in the fix makes reticulation far less likely.

After washing, add a few drops of wetting agent to the last tank of water and allow the film to soak for one minute. The wetting agent causes the water to drain off more rapidly, preventing globules and drying marks.

If you have not used an acid-*hardener*-fixer, and value your negatives, it is advisable to use an anti-scratch solution before hanging them up to dry; full instructions are supplied with it. It toughens the emulsion against abrasion marks during handling.

Drying

Never attempt to pull the film out of the reel; it should be removed in one of two ways: slightly curve the end outwards, thus lifting it out of its groove. Hold it carefully in this curved position, and revolve the spiral between thumb and finger of the other hand, so unrolling and removing the whole film.

The second method (which is probably more convenient with full-length 35 mm. film) is to stand the spiral right way up, hold the lower section, release the top adjusting spring, and remove the top section. This leaves the film standing in the grooves, to be lifted out and clipped up to dry.

Two stainless-steel clips are needed, one to fasten the film, and the other to weight the free end. I advocate wiping both sides of the film very gently with a wrung-out wash leather or viscose sponge; alternatively, use a proper film wiper which does both sides simultaneously. The leather or sponge must be kept scrupulously clean and free from particles of grit. Some photographers prefer not to wipe their films at all because of the danger of scratching.

Drying must take place in a dust-free room. The bathroom is

as good a place as any when the household has retired for the night. Suspend the film from a string, clear of the walls, and away from open windows or ventilators. But if you can hang it overnight in a very clean cupboard, so much the better.

Plates and cut film are developed in plate tanks. They are wiped down after washing and plates are stood on edge in drying racks to drain and dry.

The foregoing is the recommended technique for miniaturists, and all who wish to get the very best results. If you are not prepared to lavish such care, and are content with contact prints alone, you may use a water-rinse instead of a stop-bath, and forgo the anti-scratch precautions; you may even dispense with the wetting agent. But why do half a job, when the full job is just as easy?

Developers

If you use 35 mm. or 120 size film, fine grain developers are needed to allow of subsequent enlargement of fair size. Such developers can be purchased ready for use in liquid or powder form, and printed instructions are issued with them. Typical ones are: Kodak D.76 and Ilford ID. 11 (same formula); Acutol and Unitol, and Resofine 2-B (a two-bath developer).

May & Baker's Promicrol and Ilford's Microphen give between half and one stop extra film speed with fine grain.

There are literally dozens of developers on the market, each of which has its adherents, but one of the above developers will provide excellent results if the instructions are carefully followed, especially with regard to time and temperature.

Life of Solutions

Provided they are kept in air-tight bottles, away from the light, most developers will keep for several months. Oxidation sets in once a developer has been used, and some have better keeping properties than others. Information about this is usually given in the printed instructions enclosed with the developers.

Each repeated use generally necessitates an increase in the development time. It is asking for trouble to try to squeeze an extra film out of any working solution, be it developer or fixer.

Any sediment which may form after use, preparation, or storage, should be filtered off. Never add extra chemicals or solution in an attempt to extend the life of a well-used fixing solution; make up fresh and discard the old.

162

Most advanced workers nowadays use a dilution, or 'one-shot', technique, which ensures consistency from film to film, and gives a sharper image with certain developers. The technique is certainly to be recommended, especially for 35 mm. films, as it 'takes the edge off' the effect given by a full-strength solution. The method cannot be used with certain compensating and maximum energy developers, but works well with developers such as D.76. A dilution of 1 : 1 (one part full-strength developer with an equal volume of water) normally requires an increase of 50% over the standard developing time. There is little advantage in diluting more than 1 : 2 (one part full-strength developer with two parts of water) other than the doubtful one of solution economy.

Developer Formulae

In this age of labour-saving devices and crowded leisure time, few photographers go to the trouble of making up their own developers. All kinds of developers, fixers, and other formulae are available ready packed as powders or concentrated solutions. Occasionally, however, the more advanced worker may wish to alter the ingredients of a particular developer to suit his own purposes. For those who are prepared to purchase a chemical balance, here is a short list of representative formulae:

In each formula, chemicals should be dissolved strictly in the order given. Wait for each to dissolve fully before adding the next.

D-23

A soft-working developer of simple formula giving normal emulsion speed. Good for technical, portrait and commercial photography. Works well with both small and large film sizes.

Metric	*Avoirdupois*
7·5 grammes 'Elon'	265 grains
100 grammes Sodium sulphite (anhyd.)	8 ounces
1,000 cc Water to make	80 fluid ounces

Use without dilution and develop for times recommended for D.76 developer.

D-76

A medium-contrast finegrain dish or tank developer for obtaining the maximum effective emulsion speed and shadow detail. Suitable for all films.

Metric	Avoirdupois
2 grammes 'Elon'	70 grains
100 grammes Sodium sulphite (anhyd.)	8 ounces
5 grammes Hydroquinone	175 grains
2 grammes Borax	70 grains
1,000 cc. Water to make	80 fluid ounces

Except where otherwise stated, use without dilution.

Developing times in D.76: at a temperature of 68°F., with five seconds agitation every minute:

Tri-X 35 mm. and 120 – 6 mins.
Plus X 35 mm. and 120 – 4½ mins. (120 Verichrome Pan – 5 mins.)
Pan X 35 mm. – 4½ mins. (120 size – 7 mins.)
HP4 35 mm. – 7½ mins. (120 size – 9 mins.)
FP4 35 mm. and 120 – 6 mins.
Pan F 35 mm. – 6 mins.

D-163

Normal contrast developer for papers of all kinds. May also be used for larger negative materials.

Metric	Avoirdupois
2·2 grammes 'Elon'	80 grains
75 grammes Sodium sulphite (anhyd.)	6 ounces
17 grammes Hydroquinone	1 ounce 160 grains
65 grammes Sodium carbonate (anhyd.)	5 ounces 80 grains
2·8 grammes Potassium bromide	100 grains
1,000 cc. Water to make	80 fluid ounces

FOR BROMIDE PAPERS: for normal results dilute one part of the above stock solution with three parts water. Develop 2–3 minutes.

FOR CHLORO-BROMIDE PAPERS: for normal warm-black tones dilute one part of the stock solution with three parts water. Develop 2–3 minutes.

SB-1

A stop-bath recommended by Kodak for papers.

Metric	Avoirdupois
1,000 cc. Water	80 fluid ounces
(to the above, add)	
13·5 cc. Acetic acid (glacial)	1 fluid ounce 38 minims.

At double strength, the above formula is suitable for films.

F-5

Acid hardening-fixing bath suitable for films and papers.

Metric	Avoirdupois
240 grammes Sodium Thiosulphate (hypo crystals)	19 ounces 90 grains
15 grammes Sodium sulphite (anhyd.)	1 ounce 90 grains
13·5 cc. Acetic acid (glacial)	1 fluid ounce 38 minims
7·5 grammes Boric acid (crystals)	265 grains
15 grammes Potassium alum	1 ounce 90 grains
1,000 cc. Water, to make	80 fluid ounces.

Films and plates will be fully fixed in ten minutes in fresh solution, or in double the time it takes for film to clear, i.e. lose all trace of its creamy appearance.

Note: Don't mix chemicals in the same room in which you are going to develop and print. Put down plenty of newspaper and vacuum-clean bench, floor and surroundings after the weighing is done. Floating specks of dry chemicals cause spots and discolorations on films and printing papers. All chemicals should be dissolved in the order given; ordinary tap water may be used.

Handling and Storing Negatives

Even if you have toughened the surface of a negative by means of a hardening agent during or after processing, care in handling and storage is still necessary.

When you unclip your dried film, whether 35 mm. or roll, *don't* roll it up tightly. It may get scratched if you do, and you will find it difficult to get the film flat again for printing or enlarging.

Always hold the film by its edges, and never with damp hands. Before cutting, inspect it for any traces of drying marks, such as an occasional trace of lime deposit (often noticeable in hard water districts). A light rub with methylated spirits or carbon tetrachloride on a soft cloth will generally remove them (they usually occur on the back of the film).

Roll films should be cut into strips of three or four negatives, 35 mm. film into strips of six or four, according to the storing system you decide to adopt. To put *any* negatives unprotected in a container or box is to invite abrasions and finger-marks. Loose negatives rub against each other, and in a very short time their sharp edges and corners cause abrasion marks; and it is always likely that dust and grit may get between them.

It is also risky to place them in a partitioned box with a piece of paper between each, card-index fashion, unless you use chemically pure paper completely free from hypo. This is the paper (a translucent material) used in the manufacture of negative wallets and bags. The smaller the negative, the greater the care which must be taken to keep it spotless.

The more photographs you take, the more necessary it becomes to keep some sort of recording and indexing system. Albums are available for keeping negative in book form in numbered compartments, with a correspondingly numbered index in the front. These storage albums are made for various sizes of negatives, including 35 mm. strips.

Or you can buy translucent negative sleeves for roll-film negatives and arrange your own numbering and indexing, and folding wallets to take one 36-exposure miniature film in strips. For the enthusiast, there is a very efficient filing system consisting of negative album(s), print fill, and index. Full details of exposure, date, place, film, filter, etc., can be recorded, enabling any particular negative to be quickly found.

You might like to keep a 'contact book', i.e. a foolscape book with contact prints of all your negatives stuck on alternate pages, each complete film being given a filing number. Most 120 size films are frame-numbered. If they are not, or the printed numbers are too faint, numbering can be done with Indian ink and a fine mapping pen – there is plenty of room in the margin. Thus numbered, there is little danger of important negatives being wrongly filed or indexed. All miniature film is frame-numbered and even on this small size there is adequate space to use a mapping pen if the numbering is too faint. I contact print one complete 36-exposure 35 mm. film, or one 120 film, on a sheet of soft grade 8 × 10 in. glossy paper, and file this in an ordinary spring-clip box-file. Each sheet is numbered to correspond with the film wallet, kept in a separate file.

Printing and Enlarging

There is a lot of satisfaction and a great deal of fun to be had from printing your own negatives. Many people imagine that it

is a complicated and messy business, requiring lots of expensive apparatus and a properly fitted darkroom, but this is certainly not the case with contact printing. The process is simple, requirements are few, and a darkroom unnecessary. Neatly filed or pasted in an album, $2\frac{1}{4}$ in. square contact prints are big enough to be enjoyed as such, and the best of these can be enlarged. Although too small for unaided viewing, 35 mm. contact prints look surprisingly good under a desk magnifier in a good light. Usually, however, their main purpose is to provide a means of selecting suitable frames for enlarging.

Contact Printing

For this you require a wooden or metal frame with a mask which slips into it for producing white margins on your prints. The frame presses the negative and printing paper in close contact against a sheet of glass.

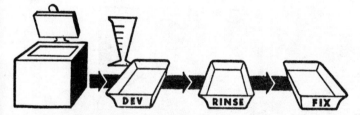

Fig. 20. The sequence in developing contact prints: from contact printer— to developer — to rinse, or stopbath — to fixer. Then, of course, to wash water and dryer.

Three photographic dishes are needed. Strong plastic dishes, light, rigid, and inexpensive are obtainable in sizes from $4\frac{1}{4} \times 3\frac{1}{4}$ in. up to 10×8 in. Choose a dish somewhat larger than the negatives you use; I recommend 5×4 in. or $6\frac{1}{2} \times 4\frac{3}{4}$ in. for comfortable working. A 4-oz. measuring glass completes the equipment required.

Only two chemicals are needed: paper developer (supplied in powder or liquid form, with full instructions) and acid-hypo fixing salt. The same kind of fixer you use for your films will do. Contact paper, still known as gaslight paper, is used for printing by artificial light. Special home printing outfits, containing all you need except paper, are available from all dealers.

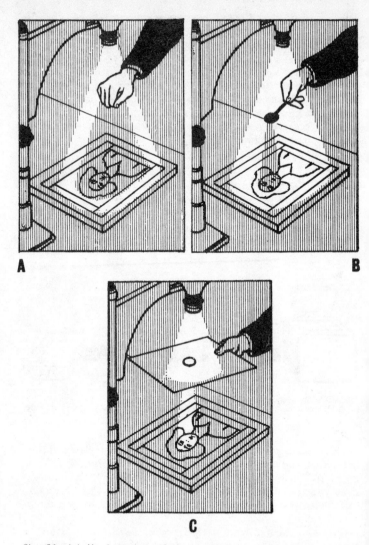

Fig. 21. (a) Hand used to shade portrait image, while more exposure is given to darken upper corners of the background. *(b)* A dodger, simply made from card and wire, is used to 'hold back' a face in shadow, while more exposure is given to the rest of the print. *(c)* Here the face was over-exposed and is being 'burnt in' through a hole in a card. Dodgers and masks should be kept moving slightly during exposure, to avoid hard edges.

How to do it

Contact (gaslight) paper must not be handled in daylight, but it is safe in ordinary electric lighting if you keep in one corner of the room, work quickly, and shade it with your body. It is made in various grades to suit different negatives. Use *normal* grade with normal negatives, *soft* grade with hard (contrasty) negatives, and *hard* grade with soft (flat) negatives.

Place the three dishes side by side, the first containing the developing solution as per instructions on the label, the second containing clear water, the third the acid-fixing solution – again as instructed by the label. If you can arrange to have the developing solution at $65°-70°F.$, so much the better. Also, if you invest in a yellow safelight, you can work more easily.

Place negative and printing paper in the frame and wrap up the rest of the paper immediately, putting it back in its packet or box for safety. Now put the frame, glass side up, about 2 ft. below a 100-watt bulb; switch the lamp on for 8–10 seconds, switch off and remove exposed print.

Now slide the print under the surface of the developer and rock the dish gently for about 1 minute, during which time the picture will build up. If it is too light, longer exposure in the frame is needed; if too dark, give less exposure. You're unlikely to get it right first time.

After this development, which will produce stains if continued longer than 2 minutes, rinse the print well in the water in the next dish and then transfer it to the acid-hypo in the third dish. Rock for the first few seconds and allow it to remain for the recommended fixing time, preferably face down, moving the print from time to time so that the solution acts evenly on the emulsion. After two or three minutes, it is quite safe to inspect it near a light.

You have now fixed the print (made it permanent), and all that remains to do is to wash it in running water for half-an-hour, then dry it on photographic blotting paper or in a proper flat-bed drier and glazer. The chemicals will not harm the skin, but wash your hands well before you touch a fresh sheet of paper, particularly after using hypo, as this will quickly mark the printing paper. Handy print forceps (little tongs of 'Perspex' or stainless steel) are a good investment. Use one for developing and one for fixing. Your hands are then kept dry and there is no risk of contaminating solution or paper. Neat contact-printing boxes are obtainable combining frame, safelight, and printing light in one compact unit; these are most convenient and speedy in use.

Remember: *never* leave the printing paper unwrapped!

Fig. 22. A bathroom darkroom incorporating a hinged board and a rubber-lined wood tray. The enlarger can be placed on the left-hand board instead of, as here, a contact printing frame. Extreme care should be taken with electrical wiring and earthing when working near water.

Drawing courtesy of Ilford Limited.

Enlarging

Enlarging from your own negatives is one of the most enjoyable and interesting of the photographic processes, and is not nearly so difficult or complex as many people imagine it to be. If you have never tried it, you are missing most of the fun of photography. It need not necessarily be expensive, either. Modern enlarging equipment is obtainable in a wide price range, and the bathroom is easily converted into a darkroom. There is not even any need for special black-out arrangments if the work is done after dark.

Enlargement enables you to exercise *control*, and so bring out the best in a negative. Frequently a portion of a negative will make an attractive picture in itself, or one face only in a group can be enlarged without any difficulty.

The process is similar to contact printing, dishes, measure, and chemicals you used for that being used in precisely the same way. But if you managed without a thermometer before, you'll have to get one now, and a safelight, too. The simplest safelight is a

special type of coloured electric bulb which fits in ordinary household lamp-holders in place of the normal light. Don't put red or orange cellophane round an ordinary bulb, or make shades of coloured glass – they are unlikely to be safe enough or dim enough. Photographic safelights are scientifically dyed for safe working, and it's surprising how much light they will give. The distance the light should be from the enlarging bench is generally specified by the makers.

Another simple safelight is a coloured fitting which goes over an ordinary household lamp, it being the work of a moment to fit or remove. Then there are fitments which can be fixed to a wall, ceiling or bench, and will pivot in all directions. They embody safelight filters from 4×5 in. to 10×12 in. in size, of a colour to suit the various enlarging papers. These are the kind the professionals use. You do *not* use a deep red light.

In brief: an enlarged image of your negative is projected on

Fig. 23. A corner darkroom can be set up in a spare room. Even within a space of 8 ft. square available, careful planning will provide a set-up in which truly advanced work can be done.

to printing paper (bromide or chlorobromide paper) for a certain time, then the enlarger is switched off, and the paper developed, rinsed, fixed, and washed – just as in contact printing.

The Enlarger

Modern vertical enlargers are sturdy instruments which take up very little space. They consist of a lamp-house containing the lighting system, a holder for the negative, and a lens so mounted that the distance between the negative and lens can be varied for focusing. The unit is mounted on an arm which can move up and

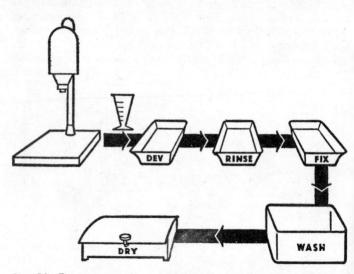

Fig. 24. The sequence in developing enlargements: from enlarger – to developer – to rinse, or stopbath – to fixer – to wash – to dryer.

down an upright column so that the distance between this and the printing paper (which is placed on the wooden baseboard) can be varied also. The base of the upright column is securely clamped to the baseboard.

Lighting systems are usually condenser type (a single or double condenser with an opal lamp is universal for small negative sizes), diffuser type (ground or opal glass between lamp and negative) or a combination of the two. Condenser systems shorten the exposure times required but give more contrast than diffused lighting; and they show up marks, scratches, and grain more than

172

the other types. Hence the modern compromise of an opal bulb (diffused light) and condensers. The whole of the image would not be illuminated evenly by just putting a bulb alone behind the negative. The negative image is projected by the lens on to the baseboard and can be sharply focused there. The higher up the column the lamphouse head is moved (i.e. the farther from the baseboard) the larger this projected image becomes.

Image size is also dependent on the focal length of the lens used. The focal length of the enlarging lens normally corresponds to the 'normal' camera lens for the film size in use, i.e. 5 cm, for 35 mm. negatives, 7·5 cm. or 8 cm. for 2¼ in. square, etc. Some enlargers can be converted to take different sizes of negative. Make sure the model you use stands firmly and rigidly and that the movements are smooth.

Certain enlargers have the added refinement of *automatic focusing*, ensuring that the projected image is always perfectly sharp within the limits of the swing of the lamphouse, others embody coupled rangefinder focusing.

The Lens

The lens is the eye of the enlarger, and although it is possible to get results by using your camera lens (provided it is interchangeable), it is far better to get a lens which has been computed specially for enlarging. Don't be content to make do with any old lens. Why buy a camera with the very best lens you can afford, and then nullify its performance by using a poor enlarging lens?

They are obtainable in standard mounts, of different focal lengths and apertures. The better kind have 'click stop' apertures in multiplying exposure sequence (i.e. 2X, 4X, etc.) and are capable of the highest quality work. As with camera lenses, enlarging lenses usually give their best performance when stopped down about two stops. This also tends to correct any tendency to uneven illumination. Let your dealer help you in your choice.

Choice of Paper

Contact paper is too slow for enlarging – you must use bromide or chlorobromide papers. The latter give a warmer-toned image by direct development and offer wide variations in image colour when used with special developers and differing exposure times. They need about 1½ times the exposure of ordinary bromide

papers, but are very popular because of their gradation, range, and latitude, as well as richness of tone.

All enlarging papers are graded according to their contrast characteristics: Soft (No. 1), Normal (No. 2), Hard (No. 3), and Extra Hard (No. 4) are the most commonly used varieties. As with contact-printing, normal grades are intended for normal negatives, soft for *hard* negatives, hard and extra hard for *soft* negatives.

Surfaces range from rough to glossy, and between those extremes comes such varieties as Lustre, Stipple, Half Matt, Velvet, and Matt. Ivory and cream papers are available, as well as white. Glossy papers have the longest tonal range, and matt the shortest. This tonal range has no bearing on contrast grade. Most papers can be obtained in two thicknesses, single-weight and double-weight.

Snow scenes should not be printed on cream papers. Portraits are apt to look cold on glossy. Small enlargements look woolly and coarse on very rough-surfaced papers.

Popular paper sizes are:

$2\frac{1}{2} \times 3\frac{1}{2}$ in
$3\frac{1}{2} \times 4\frac{1}{2}$ in. (or $3\frac{1}{4} \times 4\frac{1}{4}$ in. i.e., $\frac{1}{4}$-plate)
$3\frac{1}{2} \times 5\frac{1}{2}$ in. (postcard)
$4\frac{3}{4} \times 6\frac{1}{2}$ in (half-plate)
$6\frac{1}{2} \times 8\frac{1}{2}$ in. (whole plate)
8×10 in.
10×12 in.
12×15 in.
16×20 in.

Procedure

When you arrange bathroom, kitchen, or wherever you intend to do your developing and printing, place the dishes in the order in which they will be used: from left to right, enlarger, developer, rinse, and fixer dishes. Temperature of the development solution should be between 65° and 70°F., and that of the fixer should not be below 60°F. Thermostatically controlled heating plates are obtainable, but in winter perhaps the best idea (and certainly the most comfortable) is to raise the room temperature to about 65°F.–68°F. half an hour before you start processing. The orange glow of a small electric fire will not affect the printing paper, but the elements should be kept well away from the wet-bench.

If a stop bath of 1 per cent acetic acid is used instead of the plain water rinse, risk of staining is reduced, development is immediately arrested, and the life of the fixing bath is prolonged. Plain hypo solution can be used for fixing, but acid fixer is better.

Place the negative in the enlarger carrier, emulsion side towards the lens, and switch on the enlarger. Lay a piece of white paper on the baseboard or in the paper holder so that the projected image can be seen clearly. Then move the enlarger head up or down until the desired picture size is obtained (you may not want to print the whole of the negative) and the image sharply focused. Stop down the lens aperture one or two stops and then switch off the enlarger, or, if one is fitted, the red filter may be swung in front of the lens.

By the light of the safelight only take a sheet of bromide paper from the packet, and cut it into several strips. These, which you will use for exposure tests, are known as test strips. Guessing exposure won't work until you are an expert! *Always make a strip test.* The white paper is removed from the baseboard and one of these strips put in place of it. Make sure the sensitive side of the paper is uppermost, of course! Usually this has a smooth sheen, but if the rough-surfaced papers leave you in any doubt, lightly touch a corner with a moistened finger – it will tend to adhere slightly to the sensitive side. Naturally, your hands must be clean and free from chemical contamination before you make this test.

Hold a piece of opaque card (ordinary carboard will do) in one hand, and switch on the enlarger or, if one is fitted, swing back the red filter with the other. After 5 seconds, cover one-quarter of the strip with the card, after 10 seconds cover half, at 20 seconds slide the card to cover three-quarters, and at 40 seconds switch off the enlarger. (An enlarger time-switch will help here.)

Now develop the exposed strip for 2 minutes, gently rocking the dish continuously. *Never be tempted to remove test strips or prints from the developer until the 2 minutes have elapsed.* If after 2 minutes development the print is too light, continue development an extra minute.

Next, rinse and place the test strip in the fixer. Gently rock for 1 minute, then examine it by ordinary light. If the entire strip is too dark or too light another test must be made, decreasing or increasing the exposure times accordingly, but always doubling the exposure at each successive step. Thus, alternative times could be 2, 4, 8 and 16 seconds or 8, 16, 32, and 64 seconds.

The Developed Strip

The developed test strip is not only a means of ascertaining correct exposure, it is also a guide for correct choice of paper-grade. If all the strips exhibit a soot-and-whitewash effect, with hard blacks and no gradations in the highlights, the paper is too hard and contrasty for that particular negative, and another test must be made, using paper of a softer grade.

If the test strip is full of grey tones, with no full blacks or white highlights, the paper is too soft, and a harder, more con-trasty grade must be substituted. Sometimes things aren't so easily remedied, and the negative seems to require something in between and not one whole grade difference. A paper which is slightly too hard can be given a fraction more exposure and the development time curtailed slightly, which will have the effect of producing a softer print. This can only be done *slightly*, as really shortened development will fail to produce a good black.

Correct exposure lies in that section of the test strip where the deepest shadows are black, but still hold detail, and highlights are white but full of detail, with gradation between these two ex-tremes. This is perfection, and it may be that your negative is unable to give it; then it remains for you to select exposure and grade of paper to suit the circumstances.

The test strip must include a *typical* portion of the subject, If, for example, it included the sky area only, it would give no indication of correct tonal range for the foreground. Test strips for portraits should include eyes, nose, and mouth.

Making the Enlargement

To get a white border to the print and ensure correct position-ing on the baseboard, use a masking frame. You can get them in postcard size but larger, adjustable ones are better.

Having exposed the full-size sheet of bromide paper, accord-ing to the exposure indicated by the test strip, follow on with

Fig. 25. Masking frame with adjustable borders.

development, rinse, fixing, and washing. Seldom, however, does straightforward exposure produce the best result of which the negative is capable. Great improvement is often effected by varying the amount of exposure on certain parts of the print.

For example, a sky might look more pleasing if given 20 seconds exposure instead of only 10 seconds as demanded by the ground portion of the picture. So you shade (i.e. cover) the lower half by means of an opaque card after the initial 10 seconds exposure until the sky portion has received an additional 10 seconds. The card is held an inch or two above the paper,

Fig. 26. This enlarger timer switch can be cut into the electrical circuit. Precise timing helps you become a better printer and cuts down on paper wastage.

and it must be kept slightly moving all the time, to avoid any hard edge showing.

Sometimes a small highlight area, or a face in a group, needs more exposure than the rest of the subject. A hole in the centre of the card will allow of this while protecting the rest of the bromide paper from the enlarger's rays. As before, it must be kept constantly moving.

Quite often certain areas could do with *less* exposure than the rest, if they are not to become darker than required. In this case you fix a little disc (or oval, according to the shape required) of cardboard on the end of a piece of stiff wire, and hold it so that it casts a wavering shadow on the area. These cardboard shapes are called 'dodgers'. The farther away from the paper they are

177

held, the larger the area they shade, and the softer the edge. Shading is quite a simple operation.

Converging verticals (making tall buildings, etc., appear to be falling backwards) caused through tilting the camera, can be corrected to a degree by tilting the masking board until the lines are again parallel, but at full aperture it is no longer possible to keep the image sharply focused all over. So you focus at the centre and then stop down well. Some enlargers allow the negative carrier to be tilted to give this effect in a more convenient way.

Don't systematically enlarge the whole of every negative. Frequently a portion only will produce a much better picture. Experiment by slewing the masking frame occasionally. A portrait, for example, usually gains interest if the head is at a slight angle so that the eyes are not dead horizontal. Merely twisting the masking board can give you that effect even if the person *did* sit quite upright.

Keep the enlarger as dust-free and clean as possible; a plastic cover affords valuable protection. See that condenser surfaces do not collect dust, and always go over your negative lightly with a camel-hair brush before putting it in the enlarger. Any specks of dust, hairs, etc., which remain on it will mean lots of patient handwork on the print.

Fixing and Washing

After exposure, the bromide paper is developed, rinsed, fixed (preferably handling it with forceps) and then washed. Never allow prints to bunch together – or float face uppermost – the solutions will not be able to do their work properly. Give them individual attention from time to time, to ensure that all surfaces are freely bathed and covered.

Fixation and washing must be thorough. During the first 10 seconds in the fixer, each print must be constantly rocked so that both front and back are entirely covered with the solution. After 2 minutes, the white light may be switched on for inspection. Fixation is complete in 10–15 minutes; prolonged fixation in acid fixer tends to bleach delicate highlights. Chlorobromide papers are particularly affected in this way, and 10 minutes should be the maximum fixing time for them. Prints should not be left in rapid-fixers (Amfix, Hypam, AM33) longer than seven minutes or so, for the same reason. Fixers with hardener should always be used when drying is by heat, and to prevent frilling of the emulsion edges in hot weather.

Never over-work the fixer. One pint (20 oz.) will fix 15 whole-plate prints or their equivalent when an intermediate acid stop bath is employed. If plain water rinse is used instead, it will fix 10.

Single-weight prints must be washed for half-an-hour, and double-weight for 1 hour, to clear them of hypo which would otherwise cause eventual fading. Putting them into a bowl and turning the tap on is of little use unless they are circulated by hand, and the water tipped out and refilled at least 10–12 times during this time. Devices are available which fit basins and sinks and do the job automatically. Temperature of the water should not be below 65°F. If it *does* fall below this, washing times must be increased.

Drying

After washing, prints should be swabbed over with a viscose sponge or folded towel. They may then be laid out, face upwards, to dry on sheets of clean newspaper, or placed face downwards on muslin or nylon net stretched across a wooden frame. The best method of drying is by electrically heated flat-bed drier and glazer, which greatly speeds up the operation, and keeps prints from curling.

Glazing

High gloss is produced on glossy paper by pressing the wet print on to stainless steel or chromium-plated glazing plates with a rubber squeegee, and leaving until dry. Alternatively, the metal sheets may be put into an electric drier and glazer.

The wet print is 'rolled' face downwards on the plate without draining, to avoid air-bells forming between print and plate. A flat squeegee completes the contact under light pressure, with final blotting to remove surplus water. Never attempt to pull a print off a plate; it should come off of its own accord when dry.

What Went Wrong?

Prints too light, little detail: under-exposure, developer too cold or under-development.

Prints too dark: over-exposure or over-development. Negative too thin. Developer too warm.

Brown or yellow stain: developer too warm, or exhausted. Insufficient fixing; prints allowed to float on top.

Dirty whites over whole picture: unsafe darkroom lighting, causing fogging. Development too prolonged. Bromide paper stale.

Yellowish whites: developer too weak, exhausted. Under-exposure and forced development. Print not moved when first placed in fixer.

Prints grey and dull-looking: Harder paper needed.

Prints too black/white: Softer paper required.

Summing Up

Temperature of developer should be 65°F. to 70°F., and that of fixer not below 60°F.

Always make a test strip.

Never remove test strips or prints from developer before 2 minutes have elapsed.

Never over-work the developer and fixer.

Wash the prints thoroughly.

And, lastly, don't wear a *white* overall. It can reflect quite a lot of light from the enlarger on to the bromide paper, and during long exposures this may slightly 'grey' the highlights.

CHAPTER NINETEEN

The Finishing Touches

All that has gone before – composing the picture, exposing the film, developing, and enlarging – has been but a means to an end: a print which pleases the eye. Surely, then, it is worth going to some trouble in the finishing and presentation of your work. Contact prints and small enlargements up to half-plate pictures are best mounted in an album, but if your half-plate pictures are family portraits or groups, you may want to frame them. Purely pictorial studies, intended for wall pictures or exhibitions, need to be larger, and mounted accordingly.

Trimming

Trimming a print is a simple matter. It is sometimes difficult to decide *where* the limits of the trim should fall. Never try to do the job with a pair of scissors. Even if you have a 'straight

eye', the results will never equal the accuracy and finish of a properly squared print cut with knife and straight-edge or trimmer.

Place the print on a sheet of ply and use a sharp knife or razor-blade. A scalpel or craft tool is best, and also serves for retouching. Packets of inter-changeable blades are available. A metal straight-edge is used as a guide, after first marking off the parts to be trimmed. Unless your prints are to retain a white border and are therefore already 'squared off', you will need a celluloid set-square for this marking.

But it saves time and trouble to use a print trimmer. This consists of a tempered steel blade mounted edgewise to a cutting plate on a sturdy wooden base and fitted with guides against which the print is placed to ensure a perfectly clean cut at right-angles.

These guillotines range from inexpensive models giving a 6-in. cut, to substantial ones cutting 13 in. or more. Although it is *possible* to cut cardboard mounts with these trimmers, I do not recommend it as a regular practice. Desk-type trimmers are also obtainable, some of which will give a deckle-edge effect.

Where to Trim

Many photographers compose their pictures on the enlarging board, setting the masking frame to the sizes, proportions, and position desired. Considerable experience, however, is required to do this, and it is often better to include a little more than is needed and trim afterwards. The advantage of a slight tilt here, a bit more off there, is far more easily judged in this way.

An old dodge which is a great help in awkward cases is to cut two L-shaped pieces of card, preferably white or cream, and use them to 'frame' your print. By sliding them back and forth over the picture, varying the position and size of the rectangular window they form, the pictorial possibilities of the print and where to trim it are more easily found.

In a portrait, for example, the L-shaped cards may be swung out of the perpendicular so that the subject's eyes are no longer parallel to the horizontal base of the print, but more diagonal to it. This treatment virtually tilts the head and features to give a livelier appeal to the picture. Remember: diagonals are always more compelling than uprights or horizontals, whether in masses or lines.

Once you have found the best area and proportions, mark the

print by running a pencil round the inside edges of the card frame and trim to this. Glossy papers will need a fairly hard pressure with an H or HB pencil to make an indentation; the pencil will 'take' better on other paper surfaces. Make absolutely certain of your compositional balance before you mark and trim – you cannot put back what you cut off!

Spotting

If you wish to produce first quality prints, you must be prepared to spend time and patience on spotting, i.e. removal of the small black or white spots so difficult to avoid in an enlargement. The white specks are caused by particles of dust which settle on the negative during enlarging or, earlier still, while the film was drying (in that so-called dust-free atmosphere!); sometimes they are in the bromide paper itself. Dark spots, which are less common, can be due to particles settling on the film in the camera *before* exposure, dirt in the film developer, and other causes.

It is possible to remove the black spots from the print chemically, but I prefer to scrape them out. This is done with a retouching knife. There is a knack in handling it. Heavy-handed tactics just won't work. The trick is to stroke the paper with the knife point at such an angle that it almost glides over the surface. Never try to pick out the speck -- that speck is in the emulsion surface, *not* in the paper itself.

With practice you will find it is possible to scrape away just enough from a dark spot to match perfectly with the surrounding tone. If you *should* go a little too far, you can put matters right when you come to deal with the white spots.

Always place a sheet of paper on the print to protect it, otherwise finger-marks or grease from the hands may make it difficult for the spotting medium or colour to flow properly.

White Spots

These are filled in with a fine sable brush (size 0 or 00) and spotting medium, dye or water-colour, according to choice. An ordinary saucer will serve as a palette. Put a small blob of the medium or colour in it, then moisten the brush and merely touch this. Gently twirling against the saucer, draw the point across the edge once or twice until the brush is free of surplus moisture and well pointed.

Test for depth of tone on a scrap of paper. It needs to be some-

what darker than that to which you have to bring your white speck, because it dries out lighter. Put the *smallest possible* spot of colour on at a time, filling up the white speck by a series of minute dots. Hold the brush fairly upright – and be patient. To make the retouching less detectable on glossy prints, the moistened brush can be used to take a little gum from the surface of a scrap of ordinary gumstrip. This combines with the medium or water-colour to give a slight sheen or gloss when dry. Don't try to speed up the process by using greater quantities of colour and and mopping it on. Wipe it off quickly with a damp rag if things go wrong.

Martin's Retouching Dye is handled in much the same way. It is available in black, brown (for mixing with the former to match any warm-toned print) and grey shades. I find the grey dye the most stable, but all three have the advantage of sinking right into the emulsion instead of lying on the surface, as colour and medium do. Thus the tone can be readily built up without fear of removing any already deposited, as frequently happens with the other two; and for the same reason, dye is less detectable, even on a glossy print.

In fact, properly applied, it is impossible to detect in small areas. If too much is put on, it can only be removed by washing the print or by carefully scraping with the retouching knife; so work *lighter* in tone than required and gradually build up.

Even if the dye goes dry in the saucer you can still use it. Some workers prefer it this way because it is easier to apply and control – but it is less likely to sink into the emulsion. Try your hand at spotting a scrap print first, then it doesn't matter if you spoil it. As you gain confidence, you might like to extend your retouching of blemishes to strengthening certain details, such as eyelashes in portraits, or adding pale washes in small areas to darken shadows, and so on. The acid test of your skill is: can the work be detected at normal viewing distance? If it can, you need more practice.

Mounting

Good photographs deserve good presentation. It is little use keeping them in a box, to be passed around from hand to hand. Mount the contact prints and small enlargements in an album. You can get these book-shape albums in sizes from $6\frac{1}{2} \times 5$ in. upwards, with transparent photo corners which simply fit on the four corners of the print, and are then moistened on the back to stick on the album page. The print can easily be removed, if

required. Extra leaves can be added to the album as your collection grows. Do not use ordinary gum or paste for mounting prints, for it may cause fading or discoloration. Photographic mounting paste has no harmful effect.

Better still is rubber solution (*not* the kind used for repairing punctures) which is both flexible and clean-working. Spread a thin film of it on the back of the print and wait a few minutes to

Fig. 27. A roller squeegee is a great help in both paste and rubber mounting.

allow this to become tacky before fixing the print to the album page. Thus mounted, it can readily be peeled off should you wish to remove it at any time. For permanent mounting, two coats are applied – one to the print, and another to the page.

The advantage of rubber solution is that any excess which may ooze from the sides of your print during mounting can be completely removed simply by rubbing with the fingertips. It does not mark or harm the album page in any way; indeed, it tends to clean it, so the solution can always be carried right to the edges of the print for perfect mounting. A roller squeegee is a great help in both paste and rubber mounting. Apply pressure evenly and firmly.

Dry Mounting

Dry mounting is the process adopted by professional workers. A sheet of dry mounting tissue, cut to size, is placed between the print and the mount, permanently fixing them together by heat and pressure. The tissue is a thin paper coated on both sides with shellac which melts when heat is applied and so cements print and mount together. The shellac also insulates the print from any impurities there may be in the mount, and so makes for print permanence.

You can get sheet tissue in sizes from $3\frac{1}{2} \times 2\frac{1}{2}$ in. to 15×12 in.

Fig. 28. Mounting styles to suit the subject. *(a)* and *(b)* are good for view pictures. *(c)* and *(d)* are excellent for technical or commercial subjects. *(e)* and *(f)* are good when the size of the subject within the print shape would be dwarfed by using wide mount borders.

in packets ready for use. If you are doing only a little dry mounting, an ordinary household electric iron is suitable; the ideal is a thermostatically controlled mounting press, but it is necessarily expensive. This is the technique:

On the back of an *untrimmed* print place a sheet of tissue, the same size as the print or slightly larger, and lightly stroke the centre with the point of the heated iron. This causes the tissue to adhere to the print so that both can now be accurately trimmed together. If the iron is too hot, it will scorch and spoil the tissue; if too cool, it is liable to stick. Try it first with a scrap print and a small piece of tissue. Between 160°F. and 180°F. is about the right temperature. You may prefer to do the preliminary fixing with a soldering iron or one of the fixing irons made specially for the job.

Next lay the print in place on the album leaf or mount, and cover with a sheet of thin, smooth paper. Press the heated flat-

Fig. 29. Retouching knife is useful for removing dark spots from matt surfaced prints. A gentle scraping action is applied.

iron over the whole print (in successive portions if it is too large for one pressure), holding for a few seconds at a time. *Do not rub.* Prints and mounts must be absolutely bone-dry.

You will probably find that there is a slight tendency to curling of the print immediately after dry mounting. If it does, bend it very gently in the opposite direction and then place it under a light weight (a sheet of glass will do) to cool and flatten. Don't be too enthusiastic with the bending, or parts of the print may be forced away from the mount; or it may cause the print to stretch, with much the same unfortunate effect.

If you haven't trimmed the tissue accurately, it will show round the edges of the print, the heat causing it to expand slightly. The idea, therefore, is to have the tissue the merest shade smaller than the print.

Thermal print mountant is also available. This is spread on the back of the print and allowed to dry. The print is then placed in position on the mount and warm-ironed, just as with dry-mounting tissue.

The Mount

The old-style mounts with intricate borderings and fancy shapes have been superseded by plain, simple borders of straight-forward design. Do not have a cold grey or black tint for the border of a warm-toned paper; one of a warmer shade is needed. Sometimes a subject with masses of light tone right to the edges can be pulled together by a very dark border – this may even be dead black in the case of an ordinary bromide print. Striking effects *have* been achieved with vividly coloured borders, but the chances of their having wide appeal are remote. A great favourite for display and exhibition work is the plain 'Club' mount of white and cream board.

A small print needs a proportionately bigger mount than a large one. For example, a $3\frac{1}{4} \times 2\frac{1}{4}$ in. print looks well on an $8\frac{1}{2} \times 5$ in. mount, where as an $8\frac{1}{2} \times 6\frac{1}{2}$ in. print on a mount of relative size, i.e. 20×14 in. would look rather ridiculous.

Never mount any print so that the top margin equals the bottom one. Top and side spaces *should* be equal, but to pre-serve balance and make the result satisfying to the eye, a wider space is needed below the print. Do not put a cream print on a white mount, or vice versa. A plain pencil line drawn round the print can give a most attractive effect, and is often used instead of a tinted border. Commercial subjects are sometimes mounted with no margin at top and sides, but a fairly wide one at the bottom. This treatment, known as 'bleeding off', can be most effective.

Titling

Beware of adding ornate titles. Fancy or stunt lettering will spoil your picture as surely as will crude, ugly penmanship. Prac-tice lettering with a good plain type, first keeping it the same slope as your natural handwriting. When you have reached a fair standard, make the letters upright. No squirls or squiggles, please!

Better still, use one of the commercial lettering sets, such as Letraset, using only thin, slight letters so as not to over-power or compete with the print itself. Rule two parallel guide lines very lightly with a B pencil, then add your lettering. Stumping with a very soft india-rubber will remove the guide lines without affecting the lettering. (You can touch it up afterwards, if neces-sary.) On dark album pages, use white ink, pencil, or Letraset. Black indian ink does not go with light mounts; sepia or neutral ink looks less cold.

Unmounted prints up to 10×8 in. can be framed in specially

made slip-in frames of standard sizes. Some are particularly suitable for portraits and family subjects, having convex glasses which help to cut out reflections and struts which can be set for vertical and horizontal positions.

In Conclusion

By simplifying some of the problems and pointing the way to success, I hope I have been able to help you to enjoy your photography even more.

To the beginner I say this: don't be discouraged if your first efforts with any particular subject are not up to expectations – there are bound to be disappointments at the start. Get into the habit of *planning* your pictures whenever you can. Study the effect of light and shade in everyday scenes, and (if I may be forgiven for quoting a cliché) learn from your mistakes.

To the enthusiast: you have probably become accustomed to taking only a few subjects – your favourite one, and perhaps half a dozen others. I am not suggesting that this is wrong, but it is all too easy to tire of endless versions of the same thing. Photography is fun, and you're missing half the enjoyment of it, even as an enthusiast, if you never try other subjects.

Good technique is essential, but technique for technique's sake can be dull and boring. Remember: *the picture* is the thing that matters!

To Help You . . .

(Some of the photographic terms in general use)

ABERRATION: Optical defect in a lens.

ACTINIC: Term applied to light which affects the sensitive emulsions of films, plates and papers.

ANASTIGMAT LENS: One free from astigmatism, i.e. inability to focus accurately both horizontal and vertical lines at the same time. Corrected also for other aberrations.

APERTURE: The opening in the lens diaphragm which allows light to pass through. It is expressed in f/numbers.

BATH: A solution for developing, fixing or other use.

BLURRING: Indistinct outlines or double images are termed blurred.

CASSETTE: Container for 35 mm. film, enabling it to be loaded into the camera in daylight. Also called a film magazine.

CONDENSER: Large lens or several lenses used to collect or concentrate light. Chiefly used in enlargers and projectors.

CONTACT PRINT: Print made by placing the negative in direct contact with the sensitive surface of printing paper.

CONTRASTY: Applied to negatives with dense highlights and clear shadows, and to prints with very black shadows and empty white areas. Also applied to lighting conditions which produce these extremes.

COPYING: The photographing of any drawing, painting, document or photograph.

DEFINITION: Sharpness and clearness of image. Good rendering of fine detail.

DEPTH OF FIELD: Distance between the near and far limits 'in focus', i.e. sharply recorded by the lens.

DEVELOPER: Chemical used (in solution form) to produce the visible image on films, plates and paper.

DIAPHRAGM (or STOP): Also called an iris. A series of concentric blades which form an adjustable aperture. It is situated between front and rear lens components. Unlike the shutter (q.v.) it is never fully closed. See: APERTURE.

DIFFUSION: Soft-focus effect. Also, scattering of light by ground glass and similar materials.

EMULSION: Light-sentive coating on films and paper.

EXPOSURE TIME: Period during which films, plates or paper are exposed to light.

FILTER (colour filter, light filter): Coloured glass or gelatine in holders which fit in front of the camera lens, passing light of certain colour, while absorbing light of other colours.

FIXER: Solution which makes soluble the unaffected silver salts in negatives or prints.

FOCUS: The point at which converging rays of light from a lens meet and form a sharp image. By 'focusing' the lens, the image can be sharply rendered.

FOCUSING SCREEN: A sheet of ground glass upon which the image formed by the lens can be focused and the picture composed.

FOG: A deposit of silver veiling all or part of a negative or print. Can be caused by light leakage in the camera, unsafe darkroom light, forced development, stale film or paper and other factors.

GRADATION: Range of tones from highlights to deepest shadows in prints and negatives.

HALATION: Light spreading from the bright parts of the image into the darker parts, giving a halo effect. Caused by reflection from the back surface of the film. Most modern films are anti-halo backed with a dye to prevent this.

HIGHLIGHTS: The brightest parts of a picture, i.e. the dense areas in a negative and the lightest parts of a print.

LATENT IMAGE: The image formed upon a film, plate or paper, invisible until chemically treated by a developer.

LATITUDE (in exposure): The amount of permissible variation in exposure (i.e. under- or over-exposure) without affecting the tonal range of of the negative too much.

OXIDATION: Deterioration caused by the action of oxygen. Affects developers, darkening them in colour. Oxidised developers can discolour negatives or prints.

RESTRAINER: A solution or compound which holds back the action of the developer and checks fog.

SHUTTER: The spring-loaded mechanism which controls the length of time for which the image is allowed to reach the film. Shutters are either concentric blades at the lens position (see also: DIAPHRAGM) or parallel curtains forming a slit which travels across the focal plane.

SPOTTING: The removal or filling-in of spots or blemishes on prints (or negatives if sufficiently large) by spotting medium, dye or colour.